ON LOCATION

SITING ROBERT SMITHSON AND HIS CONTEMPORARIES

Edited by Simon Dell with contributions by Alistair Rider and William Wood

CONTENTS

P.6 FOREWORD

P.8 INTRODUCTION

SPACES
P.12 The Dialectic of Place: The Non-Site
and the Limits of Modernism
SIMON DELL

P.70 1964–1967

SITES
P. 82 Mirrors and Monuments,
Entropy in the Ebb Tide
WILLIAM WOOD

P. 98 1968–1969

INSTITUTIONS
P. 132 Arts of Isolation, Arts of Coalition
ALISTAIR RIDER

P.152 1970–1978

P.182 BIBLIOGRAPHY

P.188 ACKNOWLEDGEMENTS

Foreword

On Location

FOREWORD

University museums are particularly well placed to engage in projects which can both define and question the limitations of the museum itself. Simon Dell's research into the work of Robert Smithson and his contemporaries evolved from his teaching and it offered an ideal opportunity for a collaborative exploration of this formative period in the development of art which was quite specifically created to question the confines of the mid-twentieth century gallery. The project, undertaken in part while Simon held the first World Art Forum Fellowship here at UEA, resulted both in this book and in the exhibition *On Location: Art, Space and Place in the 1960s*, held in the autumn of 2008 at the Sainsbury Centre for Visual Arts.

There is something inherently paradoxical about devoting a museum exhibition to a consideration of such art and a conventional catalogue of such an exhibition seemed somehow inappropriate. Rather, this book stands both as a context for, and an extended exploration of, some of the issues raised in the exhibition itself. The contributions of Alistair Rider, Henry Moore Fellow in the Department of Art History at the University of York, and William Wood, Assistant Professor in the Department of Art History, Visual Art and Theory at the University of British Columbia, extended the collaboration beyond the University of East Anglia and we are particularly grateful to them for their involvement.

Gratitude is also due to Simon's students, to colleagues in the School of World Art Studies and Museology and to UEA's Vice Chancellor, Professor William Macmillan, for his support of the World Art Forum. For the realisation of the exhibition, we are indebted to Sarah Bartholomew and Amanda Geitner and to the Sainsbury Centre's Collections and Exhibitions team. Black Dog Publishing have been a delight to work with and our warmest thanks must, of course, go to Simon Dell, without whom there would have been neither a book nor an exhibition.

Nichola Johnson

DIRECTOR, SAINSBURY CENTRE FOR VISUAL ARTS
UNIVERSITY OF EAST ANGLIA

INTRODUCTION

To 'introduce' is to lead or bring into a place; in this sense it is an act of location. Yet the introduction to a book does not normally draw attention to its status as such. Similarly, a frontispiece does not normally announce its dimensions. However, these acts are appropriate in this instance, for this is a book about the art of the 1960s which made such acknowledgements explicit. Now it is perhaps familiar enough that Modernist art should openly acknowledge its medium, so that painting, for example, should declare its flat surface and the shape of its support. Yet the work explored in this book makes other kinds of acknowledgement, in part as a reaction against Modernist art. This work sought to locate itself in new ways, yet as the three following essays make clear, by the 1960s locating and placing had ceased to involve the enclosure of space or the creation of definite situations. As much was granted by Robert Smithson in 1968 when he coined the term 'non-site' for works which sought to undermine or at least qualify the viewer's sense of place. The non-sites are assemblages of materials drawn from specific locations; so, paradoxically, the non-site is a work visible in a gallery which serves to direct the viewer to an absent and hence invisible site. The play between presence and absence in Smithson's work is a common theme of the following essays but in each case it is developed to different ends. The first addresses the transformation of the art object, the second assesses changes in art practice and the third explores challenges to institutional authority. If these essays suggest that Smithson's work is difficult to locate, they also demonstrate that encountering this difficulty is an opportunity to reconsider some of the larger issues raised by the art of the 1960s.

Interspersing the essays are illustrations of works which also explore themes of presence and absence; these works are defined through exchanges between sites. These exchanges might be between the gallery space and external locations in the manner of the non-sites, however, whilst Smithson's works redefined the viewer's experience in the gallery, other artists went on to reject this experience altogether. Exploiting different media, they began working with sites of reproduction rather than physical sites of display. Taken together, this range of works reveals the ways in which artists sought to redefine the work of art and, with it, the place of the viewer.

Simon Dell

Spaces

On Location

SPACES

THE DIALECTIC OF PLACE: THE NON-SITE AND THE LIMITS OF MODERNISM

SIMON DELL

Nature is an infinite sphere, whose centre is everywhere and whose circumference is nowhere.

BLAISE PASCAL CITED IN MEL BOCHNER AND ROBERT SMITHSON, "THE DOMAIN OF THE GREAT BEAR", 1966.

Man hath weav'd out a net, and this net throwne upon the Heavens, and now they are his owne...

JOHN DONNE CITED IN DONALD BURGY, "SPACE COMPLETION IDEA 12", 1970.

God is the centre of everything, whose circumference is nowhere to be found.

HERMES TRISMEGISTUS CITED IN DONALD BURGY, "SPACE COMPLETION IDEA 14", 1970.

Why should a figure such as Donald Burgy produce conceptual works citing a metaphysical poet and an author of mystical doctrines? What interest did the aspiring artists Mel Bochner and Robert Smithson have in a seventeenth-century mathematician and moralist? A first and rudimentary answer to these questions is that Burgy, Bochner and Smithson took the nature of space to be a peculiarly pressing issue and so turned to authors such as Donne and Pascal, who had formulated ideas of the infinite each by drawing on a different tradition of theology. Yet such a response only begs a further question: why, then, should the nature of space be so urgent an issue for artists in the later 1960s and early 1970s? The answer to this latter question has a profound bearing on the transformation of art practice in this period.

That art practice was transformed in the course of the 1960s is widely accepted. At the time, the changes could be celebrated by figures such as Lucy Lippard and John Chandler as a liberating "dematerialisation" of art.[1] Yet the same changes could also be deplored by Modernist critics such as Clement Greenberg and Micheal Fried as signalling the very collapse of the arts of painting and sculpture.[2] Indeed, the common ground for these conflicting views was precisely the sense that the traditional authority of painting and sculpture had been challenged. And that the challenge was somehow the result of an incompatibility between painting, sculpture and the experience of the modern world was also widely accepted; already at this date many histories of modern art had turned on this theme.[3] In what follows I do not wish to reject these histories but rather to recast their terms, and argue that the challenge to painting and sculpture was the result of an incompatibility between different spaces.

Preliminary to my argument is an account of how images occupy and exploit space. To take the most immediate example: opposite these words is a photographic reproduction measuring 15.5 x 20.5 cm. The reproduction shows a work by Robert Smithson,

1
Robert Smithson, *Non-site* (*Franklin, New Jersey*), 1968. Painted wooden bins, limestone, photographs, and typescript on paper with graphite and transfer letters, mounted on mat board. Bins: 42 x 209 x 261.5 cm. Museum of Contemporary Art, Chicago, Gift of Susan and Lewis Manilow. Photograph copyright Museum of Contemporary Art, Chicago. Copyright Estate of Robert Smithson, DACS and VAGA 2008.

Spaces

On Location

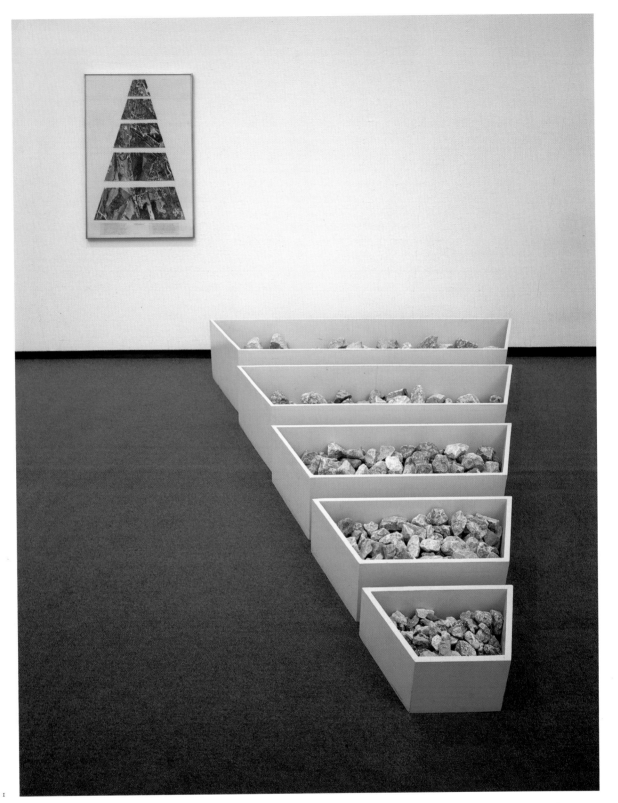

Non-site (Franklin, New Jersey), a work including an arrangement of bins with overall dimensions of 42 x 209 x 261.5 cm. Yet for those habituated to looking at photographic reproductions there is no conflict between the relatively small dimensions of the image and the larger dimensions of Smithson's work. This is a trivial instance of everyday viewing but it, nevertheless, demonstrates an important point: the viewer and the reproduction exist in the same physical space and yet the reproduction, when viewed as an image, establishes a second space, in this case one capable of containing a relatively large work of art. However, it would be a mistake to consider this correlation of spaces simply as a result of a photomechanical procedure, that is, as a result of a technique derived ultimately from a particular Western tradition of picturing three dimensions in two. For the correlation of two spaces in this example is in fact the basic condition of imaging. All physical images, figurative and otherwise, exist in real space and therefore have specific dimensions; yet they also have their own space, for they make things present, rather than merely being present. Making present does not necessarily require any shaping or marking; it simply requires that objects are set in space in such a way that they may be perceived as substitutes. Thus even an unmarked standing stone or a tacked-up canvas may be viewed as an image simply by virtue of the relationship it establishes with its spatial context.[4]

Ultimately, the practices of painting and sculpture, which have come to be identified as central to the Western tradition, are but highly sophisticated practices of substitution. And, as such, they exploit the correlation of spaces. As I shall show, this is also the case for Modernist works, those works which have so often been taken to mark a break with an earlier tradition. It will be my contention that it was this correlation of spaces which came to be incompatible with the experience of modernity.

As painting and sculpture were refined in the Western tradition, and identified as 'fine' arts, so the space of the image and the space in which it was viewed were invested with particular values. The experience of painting and sculpture came to be identified as aesthetic, museum and galleries were established as institutional settings for aesthetic experience, and critics set themselves up as commentators on this experience and its objects. In these contexts, and amongst these commentators, the aesthetic experience was increasingly defined as the unique spatial experience of a relationship between work, viewer and the real spatial context of viewing. And it was this unique spatial experience that came to be incompatible with the various spatial experiences afforded —and imposed—by the modern world.[5]

In acknowledgement of this incompatibility, in the 1960s a number of artists began to produce works which transformed the correlation of spaces. These works occupied spaces within galleries yet referred beyond the gallery walls in new ways. One example of this new practice is Smithson's *Non-site (Franklin, New Jersey)*. This work was one of a series, begun in 1968, in which Smithson introduced raw or salvaged materials from specific locations into the gallery in order to direct the viewer's attention to absent sites. Thus the non-sites have a physical presence but also suggest a scale which exceeds that of the gallery space. These non-sites are not merely representations of place, for they incorporate physical materials drawn from actual sites; yet nor are they reducible to the relatively recent practice of displaying found objects for, in that practice, the location of

finding is largely unimportant, whereas it is central to Smithson's works. And finally, the works cannot be described as site-specific, because they are produced for gallery spaces and are portable. Smithson's works thus establish new relations between the present and the absent and, as such, exist in tension with earlier practices. In Smithson's terms the non-sites moved beyond sculpture to create a "dialectic of place".[6]

The non-sites thus pressed on the traditional relationship of work, viewer and context of viewing which earlier artists had come to take for granted. To the extent that artists working in the 1960s retained this relationship, they may be seen to be working at the end of a tradition; others would come to view the rejection of the relationship as a new point of departure. Whilst the former may be placed at the end of Modernism, the latter moved beyond the Modernist tradition. To frame this transition, my argument has three parts. The opening section surveys the transformations of the 1950s which presented initial challenges to established practice; the longer central section is concerned with Smithson's context, that of the New York art world in the later 1960s; the final section expands from this context to consider works which moved beyond the non-site. At this point I should advise the reader that my account is an essay in diagnosis; it is a description of a transformation, and not an explanation of causes (although of course any diagnosis will imply a set of causes). Many of the protagonists in the account will be familiar to historians of the period, not just Smithson, but also Marcel Duchamp, Clement Greenberg, Michael Fried and Marshall McLuhan. These names in turn will suggest a familiar range of issues, those clustered around the 'readymade', the 'object' and the 'media'. Yet familiarity has frequently impeded understanding (indeed this has been a recurrent theme under Modernism) and I believe it has obscured much that is fundamental to the transformations of the 1960s. Therefore my own point of departure is the basic—but often disregarded—condition of imaging. It is necessary to begin with the correlation of spaces and the persistence of this correlation in Modernist practice if one is to grasp what it might mean to go beyond this tradition of imaging. Beginning with these issues will allow me to move inwards to a closer analysis of Smithson's work and also outwards to the much broader transformations which that work mediated. I hope that this double movement will do some justice to the dialectic of the non-site.

1.THE LIMITS OF MODERNISM

All works of art have multiple histories; the histories that are written depend in large part on the interests of the writer. Thus a history concerned with innovation in the twentieth century might record the various stages in the development of abstraction in painting and this history might be used to establish a break between these practices and an earlier figurative tradition. Yet an alternative account could register that whatever innovations were made on the painted surface, by standing before the canvas the artist was taking a place in a much longer history of easel painting. Modernist accounts may be understood to combine these two histories in a particular fashion, by connecting the innovations on the surface with the broader history of the 'medium'.

Greenberg, as the foremost American proponent of the Modernist account, increasingly came to value not innovation for its own sake but rather the continuity between Modernist painting and sculpture and earlier practices. If Greenberg's earlier theoretical writings had turned on an opposition of avant-garde and kitsch, the later writings are more explicitly concerned with placing Modernist practice in a broader tradition. This was crucial, in Greenberg's view, as a means of preserving the very identity of the newer practices as art.[7] The critic's most trenchant argument for Modernism as continuity is "Modernist Painting" of 1961; in this text Greenberg asserts that the essence of Modernism lies in acts of entrenchment and that within the arts the entrenchment entails each art determining "the effects exclusive to itself".[8] In this determining, it transpired "that the unique and proper area of competence of each art coincided with all that was unique in the nature of its medium".[9]

> The limitations that constitute the medium of painting—the flat surface, the shape of the support, the properties of pigment—were treated by the Old Masters as negative factors that could be acknowledged only implicitly or indirectly. Under Modernism these same limitations came to be regarded as positive factors, and were acknowledged openly.[10]

This is a much quoted passage and taken in isolation it has been subjected to ridicule and misinterpretation; yet as an account of a transformation in the practice of painting it cannot be separated from Greenberg's broader account of pictorial art.[11] In placing an emphasis on the limitations constituting a medium, Greenberg is obliged to distinguish between the relations 'proper' to a medium and those which are 'improper'; that is to say, his account belongs to an ancient genre of writing about art which is organised by models of decorum. What is distinctive in Greenberg's account is the way in which the model of decorum is applied to the medium itself, to establish the limiting conditions of painting, the conditions whereby "pictorial art criticised and defined itself under Modernism".[12] Thus the critic argues that in Modernist painting the depiction of objects became improper not as some matter of principle but because "flatness alone was unique and exclusive to pictorial art" and once this was acknowledged what had to be abandoned was "the representation of the kind of space that recognisable objects can

2
Lucio Fontana, *Concetto Spaziale (Spatial Concept)*, 1957. Pen and ink, pencil, on paper mounted on canvas, with punctures, 139.7 x 200.4 cm. New York, Museum of Modern Art (MoMA). Gift of Morton G Neumann, 1976. Copyright Lucio Fontana, SIAE and DACS 2008. Digital image: Scala, Florence.

Spaces

On Location

16

inhabit".[13] Of course, the abandoning of this space separated Modernist work from a longer history of figurative painting. But this did not mark the end of the tradition. Indeed, Greenberg was at pains to find links between past and present. With reference to Leonardo, Raphael, Titian, Rubens, Rembrandt and Watteau, he concludes: "What Modernism has shown is that, though the past did appreciate these masters justly, it often gave wrong or irrelevant reasons for doing so."[14] For Greenberg, Modernist painters belong in the same tradition as these earlier figures because they continue to create pictures, as opposed to 'arbitrary' objects.[15] Greenberg acknowledged that experiencing "recognisable entities including pictures) exist in three-dimensional space, and the barest suggestion of a recognisable entity suffices to call up associations of that kind of space".[16] Yet he also accepted that these associations could never be fully expunged; "the flatness towards which Modernist painting orients itself can never be an absolute flatness".[17] In fact, he insists that whilst the "heightened sensitivity of the picture plane may no longer permit sculptural illusion, or *trompe-l'oeil*... it does and must permit optical illusion".[18] These illusions now create a space which can be "traveled through, literally or figuratively, only with the eye".[19] For Greenberg, experiencing a work as a picture, as an image, involves a correlation of spaces. It is this which prevents the work from being merely an object.

Whilst "Modernist Painting" is a theoretical exposition without detailed analyses, some brief discussion of a specific example may serve to clarify this last point. An example of painting which approaches the status of the object is perhaps the most useful, and amongst the most object-like works of this period are those produced by Lucio Fontana. His *Concetto Spaziale (Spatial Concept)* of 1957 was made by punching holes through a stretched canvas and as the holes are punched from both sides the materiality of the object is asserted with a particular force [Fig. 2]. Nevertheless, the work may be described as a picture because the viewer may still discern a picture plane; within the overall number of punctures one can observe groupings, and one series which can be described—just—as establishing a four-sided shape. In recognising this as a shape, one is recognising a series of relations between the punctures and thus seeing something 'in' the work. Yet because it is perceived as shape it may be abstracted from the actual dimensions established by the punctures. That is, the work articulates a space which is not reducible to its actual dimensions and in this sense creates a correlation of spaces.[20] Of course, *Concetto Spaziale* is in many respects different from the work of Raphael or Titian but to the extent that it can be viewed as a picture it may be placed in a lineage with such works. For Greenberg, that such different works can be incorporated into a tradition shows its resilience; misguided journalists may hail each new phase of Modernist art as a whole new epoch, nevertheless "each time, this expectation has been disappointed, as the phase of Modernist art in question finally takes its place in the intelligible continuity of taste and tradition".[21] And despite Greenberg's confident assertions by the time these words were written his tradition had been challenged. The challenge was issued not just to the Modernist account but to the principles subtending it, the principles which established the expressive character of 'form'.

2

To grasp the significance of this, one has to extend to Greenberg the simple courtesy of taking his arguments seriously, and viewing his account of Modernist pictorial art in relation to a longer history of the fine arts. As David Summers has demonstrated, this history is closely related to the emergence of formalism, to the emergence of a highly specific sense of what it means to 'form'. Of course the verb 'to form' means simply to shape, 'forms' are the result of this activity, and all works of art, simply by virtue of being artefacts, are accessible to formal analysis. However, there is difference between describing something in formal terms and assuming that its essential properties are thereby disclosed. Yet this assumption has frequently been made; it provides the basis for formalism and it involves more than matters of description. What Summers has shown is that it involves nothing less than the relationship of mind and world.

In this account, relations of mind and world were fundamentally transformed in the eighteenth century, when a new conception of imagination arose. Before the early modern period 'imagination' had been the capacity to bring to mind images; however, with the rise of optical naturalism the 'image' came to be understood as a unified visual field of many forms in light, that is, as a 'picture', and this field of vision came to offer the basis for "a new pictorial definition of imagination".[22] The role of this imagination was entrenched due to what Summers terms the assumption of 'indirectness', the assumption "that we do not perceive things as they are" and should not infer that subjective experience corresponds with actual properties.[23] Indirectness presupposes the

> ... familiar opposition between the 'objective' world of mechanical, mathematically describable nature (including our own mediating bodies) and the 'subjective' experience of individuals, and it was in this context that it began to be argued that the sense we make of the world must be attributed to the structure of the subject, or of subjectivity itself, and in these terms, imagination became the first principle of synthesis of the subject.[24]

Now the mind was understood as constituting its world and doing so by an initial act of imagination. This also came to guide views of how art was made. The arts, now understood as 'fine', were also understood as expressive: "The 'forms' of art in the new aesthetic sense of the word do not simply synthesise what is intuited or 'felt', they also express that intuition or feeling, making it evident, available, and experienceable by a 'viewer', that is, by one also assumed to possess a pictorial imagination".[25] Here, form becomes the indication of the activity of the imagination, that is, it becomes a medium of expression.

Crucially, once the forms of art were understood to be expressive, so arose the assumption that art exists in and as relations of forms.[26] Such an assumption could relegate the imitation of appearance to a secondary place and thus was a prelude to the appearance of abstraction and the art practice which Greenberg would so vigorously defend. Yet, in the period after the Second World War, and (in part) in response to Greenberg's writings, the expressive model came to be rejected, and as this happened the formats of painting and sculpture which had been refined as bearers of expressive relations were of course challenged. These formats were put under pressure as they came to be taken to inhibit, rather than expand, the range of experiences which might be offered to a viewer.

3
Victor Vasarely, *Sorata-T*, 1953. Triptych in engraved slabs, 198 x 457 cm. Copyright ADAGP and DACS 2008. Image courtesy of Editions du Griffon.

This much is suggested by a review of three signal practices which emerged in the 1950s: those of Victor Vasarely, Robert Rauschenberg and Yves Klein. These artists are not often discussed together, and their practices are indeed divergent. Yet each was responding to a venerable tradition and, in this respect, they share common ground. Each came to reject the activity of composition, and the act of expression.

In 1953 Vasarely made the following note in his journal:

> In the final analysis, the painting-object as pure composition appears to me as the last link in the family 'painting', although still remaining... an end in itself. But it is already more than a painting. The forms and colours of which it is composed are still situated on the plane, but the drama which they trigger plays itself out in and in front of the plane. It is thereby an end, but also a beginning, a kind of launching pad for future achievements.[27]

Vasarely now took it as his task to reveal the drama of form and colour more fully by disengaging form and plane. Thus, in the same year as his journal note, he began producing what he described as "deep kinetic works", comprised of transparent planes engraved with designs, either hinged together or mounted a few inches apart [Fig. 3].

As the viewer moves in front of such works, the parallax creates ever shifting effects. And these effects have to be understood as the product of an interaction in physical space rather than as a property of the object. It is in this respect that the deep kinetic

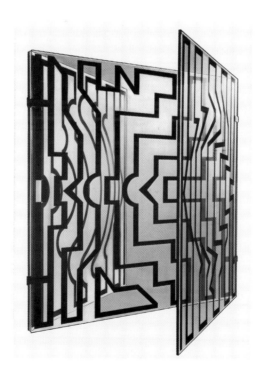

3

work are distinct from sculpture; for a sculpture offers different views from different angles by virtue of its three dimensions, and these various views may be described quite accurately as properties of the object. Thus Vasarely produced a work which was, in effect, neither a painting nor a sculpture; defined not by a conventional format, but by interaction with the viewer.[28]

The year after Vasarely's innovation, Rauschenberg began making "combines", that is, works which combined painting, collage and found objects and as such could not be inserted into the history of a specific medium. And just as the "combines" escaped definition as 'paintings', so they resisted definition as compositions. A work like *Rebus*, 1955, incorporates so many different elements and so many different types of plane surface, of so many different scales, that it is difficult to find a register to order the diversity [Fig. 4]. As an object, the work is assembled from three vertical panels and, running across the centre of these panels, is a series of colour swatches which are also vertical; yet the latter are so small that on moving close enough to examine them, the viewer necessarily loses sight of the work as a whole. In an essay on Rauschenberg published in 1961 by his close friend and collaborator, John Cage, there is a careful description of *Rebus*, in which Cage concludes:

> This is not a composition. It is a place where things are, as on a table, or on a town seen from the air: any one of them could be removed and another come into its place through circumstances analogous to birth and death, travel, housecleaning or cluttering. He is not saying; he is painting.[29]

4
Robert Rauschenberg, *Rebus*, 1955. Oil, synthetic polymer paint, pencil, crayon, pastel, collaged printed and painted papers and fabric on canvas mounted and stapled to fabric, three panels, 244 x 333 cm. Image courtesy New York: Museum of Modern Art, partial and promised gift of Jo Carole and Ronald S Lauder and purchase. Copyright VAGA and DACS 2008.

5
Yves Klein, *Monochrome Bleu*, 1961. 199 x 153 cm. Private Collection. Copyright ARS and DACS 2008.

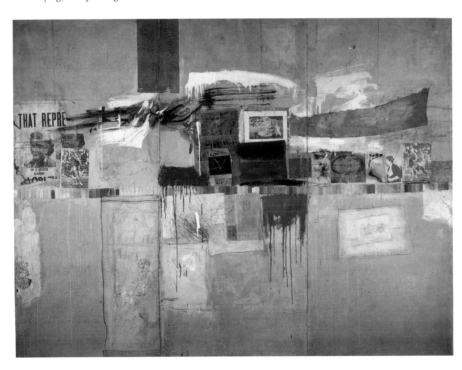

4

5

The work is not a statement; it is not an expression to be decoded. Thus at the end of his essay Cage remarks: "The thing is, we get the point more quickly when we realise it is we looking rather than that we may not be seeing it."[30] In important respects, the key activity lies with the viewer, rather than with the artist.

This shift of agency, in which viewers have to adjust their attitudes towards the work, was also fundamental for Yves Klein's monochromes. The first public exhibition of these works was held in 1956 at the Galerie Colette Allendy.[31] Viewers about to be exposed to Klein's work were, in some small measure, prepared for the experience by a brief text printed on the invitation to the *vernissage*. Here Pierre Restany took care to distinguish Klein's monochromes from their seeming precedent in Malevich's works based on the black square, emphasising that Klein's work rejected even the basic relation of black square and white ground. The monochromes suppressed all internal relations, removing the conditions for composition in order to create "phenomena of pure contemplation" [Fig. 5].[32] As the works suppressed all relations, they cannot be described as pictures. It is true that the works are hung as pictures and so face the viewer. But they face the viewer only in the way that a freestanding wall may be said to do so; that is, even whilst hanging, the work occupies the viewer's space rather than establishing its own space as an image. There is no correlation of spaces. A direct

result of this is that the environment of the viewer assumes a new importance. In acknowledgement of this, in April 1958, Klein held an exhibition at the Galerie Iris Clert which consisted of an empty gallery or, more precisely, a white, empty display case in a white, empty gallery. The concise title of the exhibition was *Le Vide (The Void)*.

For these three artists it would be a simple caricature to say that the work in question was a reaction against the generation of abstract expressionist and *Informel* painting. For this would be to ignore the artists' attempts to move beyond conventional practices of picturing. With Vasarely's deep kinetic pieces the viewer was offered new ways of physically engaging with the work. After looking at Rauschenberg's work and its incorporation of found objects, Cage noticed that the streets were full of presents; here the viewer was offered new ways of addressing everyday environments.[33] And with Klein's work the gallery itself, rather than a set of relations, became the object of contemplation. In each case, to the extent that internal relations are suppressed, the art work comes to be apprehended as an object in the world, as opposed to a representation of a world (whether 'representation' is taken here in the conventional sense as an imitation of appearances or as an 'abstract' presentation of a mental state). This is not to dismiss the considerable differences between these artists. Rather, my point is that the very diversity of their responses is significant. That artists working in different contexts were attempting to move beyond traditional formats indicates the exhaustion of the tradition. A further sign of this is the fact that the new work was—literally—of consequence. In 1960 a younger generation attempted to pursue the logic of Vasarely's work by founding the Groupe de Recherche d'Art Visuel (GRAV).[34] And a generation of Pop artists were indebted to Rauschenberg's ways of working with the everyday.[35] Klein's importance is perhaps the most difficult to summarise as it was so pervasive. For example, in 1957 he exhibited at the Galleria Apollinaire in Milan where he encountered the young Piero Manzoni, who soon responded to the monochromes with his *Achromes*. Later in the same year an exhibition of Klein's work inaugurated the Galerie Schmela in Düsseldorf; subsequently the French artist was to be a motivating force for the Gruppe Zero, formed in Düsseldorf by Otto Piene and Heinz Mack.[36] And in Paris in 1960 Klein became a founding member of the group of Nouveaux Réalistes. Finally, in 1961 a number of these European activities were drawn together for the exhibition *Nove Tendencje*, held at the Galerija Suvremene Umjetnosti in Zagreb; the exhibitors gathered as a *New Tendency* included Manzoni, Piene, Mack and members of the GRAV, as well as members of the Paduan Gruppo N and the Milanese Gruppo T.[37]

My purpose in sketching this range of activities is simply to establish that by the beginning of the 1960s the new practices of the previous decade were securing increasing support, both individual and institutional. In this situation the practices could not be dismissed as a last excrescence of Dada; so whilst the new work did not yet constitute a tradition, it did at least offer a viable set of alternatives. Pierre Restany, the early defender of Klein, drew specific conclusions from this. In the second manifesto of *Nouveau Réalisme* he declared:

> In the current context...Marcel Duchamp's readymades take on a new meaning. They translate the right of direct expression of belonging to an entire organic sector of modern

activity, that of the city, the street, the factory and mass production....The anti-art gesture of Duchamp is made positive. The Dada spirit identifies itself with a mode of appropriating the external reality of the modern world. The readymade is no longer the acme of negativity or polemic, but the basic element of a new expressive repertoire.[38]

If Duchamp's readymades had initially functioned in the context of the art world, for Restany they now functioned in the wider world. And this should be understood as a result of the transformations which led the artwork to be apprehended as an object in the world. That world was itself now available in new ways. Restany acknowledged that 'nature' no longer existed at some remove from the contemporary circuits of capital and it was the task of the Nouveaux Réalistes to reveal this. In the third manifesto of the group of 1963 Restany defined their enterprise as the summoning of "the nature of the twentieth century, technological, industrial, promotional, urban".[39] The Nouveaux Réalistes offered a response to French industrialisation, but it was a response predicated on an expanded role for the readymade.

The full significance of this role becomes clear if one considers two separate but nevertheless symmetrical events. As the readymade became the basic element of the new repertoire, that which had been cleared from the Galerie Iris Clert by Klein could now be welcomed back. So in 1960 Arman—another of the Nouveaux Réalistes— stuffed the same gallery with rubbish. *Le Vide* became *Le Plein (Filled Up)*, and the audience for the work was forced to remain outside on the street. And, in what may be taken as a reversal of Arman's gesture, in 1964 Mark Boyle and Joan Hills organised another occasional display. This took place at Pottery Lane in west London. A number of people were invited to this event: "The party arrived at a dirty back entrance marked "Theatre". They made their way along a dark corridor to a room where a row of kitchen chairs faced some blue plush curtains. Eventually the curtains opened and the audience found themselves looking through a shop window into the street".[40]

This time the audience was not excluded, but nor was it offered a conventional aesthetic experience. The improvised proscenium giving onto Pottery Lane was not intended to establish this particular street as more attractive than any other; Boyle happened to find a shop for sale and borrowed the keys from the estate agent [Fig. 23]. Yet viewers were encouraged in a new form of contemplation, whilst themselves becoming a spectacle for any curious passers-by. This practice was taken to one conclusion when Boyle held an exhibition at the Indica Gallery; for this he issued invitations consisting of cards each with a rectangle removed so that invitees could frame whatever they pleased as a work of art.

Yet Boyle, Hills and Arman were to step back from these uses of the readymade. Arman turned back to the 'accumulations' of detritus and discarded materials he had first experimented with in 1959. And Boyle and Hills redirected their chance method to concentrate on random site studies. The first of these derived from a demolition site they discovered on Norland Road, only a little west of Pottery Lane. Their method consisted in making a frame for a board found on the site, throwing the frame across the site and then, with a grid system, transferring all materials within the frame to the board and fixing them there [Fig. 22].[41] Boyle and Hills would gradually expand the scope of these studies, from Norland Road to Shepherds Bush, finally to embark on a

6–7
Boyle Family, *World Series Map* (details), 1968–1969. 275 x 388 cm. Collection Boyle Family. Image courtesy of Boyle Family. Copyright Boyle Family and DACS 2008. All rights reserved.

6

projected series recording 1,000 sites selected at random from across the globe [Figs. 6–7]. Yet the artists also moved from making assemblages to taking casts of sites in resin.[42] This was an important shift in their practice; whilst they did not alter what was found at a site, and in this sense the resultant work has at least a readymade aspect, in taking casts they returned to a mode of representation. If the practice of figures such as Vasarely, Rauschenberg and Klein gave a new currency to the readymade and thereby created the conditions for the work of Boyle, Hills and Arman, this practice also imposed its own limits. These limits relate to questions of scale.

Readymades do not have scale; Duchamp's *Bottlerack*, 1913, is simply the size it is. If it were not, it would not be a readymade, but a version of a bottlerack. (Duchamp may be said to have acknowledged this property of the readymade when he produced his own miniature versions for his portable museum, the *Boîte-en-valise*.) But without scale, the works derived from the readymade present a correlation of spaces of a very particular order. The accumulation of objects and the taking of casts from sites do not necessarily dispense with the correlation, but make of it a matter of symmetry. The fragments gathered into the works retain their own dimensions. Of course, retaining this scale gives the work an intimate relationship with the world. Yet the price for this intimacy was that the work could be too easily absorbed back into the world. Smithson, for one, was not willing to pay this price. Whilst he was to engage with both accumulations of material and the recording of sites, he was concerned to reassert scale as a salient feature of his work. Indeed, this was crucial for him, for in his view "scale determines art".[43]

7

2. AT THE END OF MODERNISM

In the autumn of 1966 Smithson and his friend, Mel Bochner, published a curious essay entitled: "The Domain of the Great Bear". The essay is unusual for a number of reasons, not the least of which is its ostensible subject, the Hayden Planetarium at the American Museum of Natural History. Nevertheless, the essay reveals some of Smithson's fundamental preoccupations, which are introduced at the very beginning of the piece by the quotation of Pascal's dictum concerning centre and circumference. Smithson and Bochner view the planetarium as the modern result of futile attempts to represent Pascal's infinite sphere; they find an echo of his dictum in a sign above a staircase indicating "Solar System & Rest Rooms". This condensing of space prefigures the experience of the planetarium; its very architecture is an "artistic conception of the inconceivable, it conforms to no outer necessity".[44] "Once such expectations occur, there no longer exist any realities.... The planetarium becomes the same size as the universe, which it is."[45] These thoughts are prompted by the experience of the ambulatory; the reader has not yet been introduced to the domed space of the actual auditorium. "The doors, once closed, expel temporality. Enormous lengths of time are compressed into the room. Light-years pass in minutes."[46] Yet for the authors this is decidedly not a utopian experience; the planetarium is a "chamber of ennui. And fatigue. It is endless, if only the electricity holds out."[47]

The themes announced here are those of a human scale and a human temporality undone. Undone, but not dismissed. Smithson would always remain concerned with what he termed "actual scale problems".[48] He would pursue these problems through a series of works culminating in the non-sites. As he did so he would return repeatedly to Pascal's dictum, both in his writings and in various interviews.[49] A complex set of issues are involved here; a first summary of them might be the following. Pascal's dictum was important to Smithson because it disclosed what the artist described as a dialectic between point and edge; it was a means of undoing what to others was predetermined, including matters of scale.[50] Yet as a dialectic it was emphatically not a means of dispensing with such matters; while Smithson was concerned with avoiding the predetermined, he was also concerned with the setting of limits. Smithson held that "if art is art it must have limits", but he also maintained that artists had to establish their own limits.[51] And these limits could not be those of "the canvas and stretchers", the given limits of a format.[52] Such predetermined limits were problematic because they offered a misplaced sense of certainty, whereas "scale operates by uncertainty".[53] However, Smithson was not interested in this uncertainty for its own sake so much as in its ability to undo the preconceptions and assumptions which obscured "the actualities of perception".[54]

When Smithson refers to actualities of perception he is alluding to particular theories of vision, which I shall deal with in due course. Yet the broader question of Smithson's challenge to preconceptions and assumptions deserves attention at this point. It is

because of this challenge, I think, that there is such a close dialogue between the work of Smithson and that of his contemporaries. For, in seeking to overturn a sense of certainty, Smithson had always to respond to his peers and to their convictions. Of course this could be described in quite different terms as the situation of a producer attempting to secure a market share. Like any specialist producer in a competitive market Smithson had to provide commodities which were distinct from those of his rivals. Yet, they could not be so distinct that the rivalry could not be identified, for this would be to remove himself from the field of competition. However, unlike many other producers, artists may be fortunate enough to choose their rivals. Smithson chose to court a number of artists associated variously with the Green Gallery and the John Daniels Gallery and the galleries of Leo Castelli and Virginia Dwan.[55] As a result, his friend, Dan Graham, recalled the Smithson of 1965 as someone who "was trying to do everybody".[56] This offers an immediate context for Smithson's work, but his relationship to this context was necessarily difficult and overdetermined.[57]

How then is one to understand both Smithson's concerns and his broader context? One answer, at least, may be found in the work of Jack Burnham. Writing in *Artforum* in 1968, Burnham set down the terms for a history of recent art; a history to be written as a series of negotiations between object and environment.[58] According to Burnham these negotiations had now reached a decisive point: "In the past our technologically conceived artifacts structured living patterns. We are now in a transition from an *object-oriented* to a *system-oriented culture*. Here change emanates, not from *things*, but from *the way things are done*."[59] And revealing this becomes the task of contemporary art: "The specific function of modern didactic art has been to show that art does not reside in material entities, but in relations between people and between people and the components of their environment."[60]

In making these observations, Burnham was reformulating some well established propositions. Already in 1966 the critic Peter Schjeldahl had announced the year of the system.[61] Yet Schjeldahl's proclamation was a response to the growing trend of serial production; Burnham's account embraced far more than new techniques. Burnham argued that the 'system' was not merely a challenge to the craft of the studio. For Burnham the object was at most a component within the system and so it would be misleading to identify 'system' and 'technique'. "The scope of a systems esthetic presumes that problems cannot be solved by a single technical solution, but must be attacked on a multileveled, interdisciplinary basis."[62] Burnham registered not just an expansion of practice beyond a series of exhausted formats, he also recognised that this involved an elaboration of the artist's skills.

> Consequently some of the more aware sculptors no longer think like sculptors, but they assume a span of problems more natural to architects, urban planners, civil engineers, electronic technicians, and cultural anthropologists. This is not as pretentious as some critics have insisted. It is a legitimate extension of McLuhan's remark about Pop art when he said that it was an announcement that the entire environment was ready to become a work of art.

> As a direct descendant of the 'found object', Robert Smithson's identifying mammoth engineering projects as works of art ('Site-Selections') makes eminent sense. Refocusing

the esthetic away from the preciousness of the work of art is, in the present age, no less than a survival mechanism. If Smithson's 'Site-Selections' are didactic exercises, they show a desperate need for an environmental sensibility on a larger than room scale.[63]

Whilst Smithson's work may descend from the found object, his site-selections signalled a move beyond the object and such a move would necessarily carry Smithson's practice beyond the limits of Modernism. It is the terrain beyond these limits that Burnham begins to map, albeit somewhat sketchily. Modernists, of course, did not need such maps; the terrain was a *terra incognita* of non-art which did not demand any exploration. Yet Burnham recognised that coordinates are required if one is to understand how Smithson's 'sensibility' differed from that of his precursors.

In his account of the negotiations of object and environment, Burnham duly notes the contributions made by Duchamp and by Vasarely and the members of the GRAV. Yet Smithson's sensibility was more directly shaped by the ensemble of practices derived from the *milieu* of downtown performance. However, these practices have since been divided into the categories of Pop and Minimal, and this has served to obscure some of their common features. It is this section of the map which needs to be redrawn if one is to establish Smithson's position.

The history of performance in New York was shaped in decisive ways by Allan Kaprow, the inventor of the Happening. Kaprow began by redefining the work of Jackson Pollock in terms of the performative, thereby appropriating what for some was a legacy bequeathed to Modernism.[64] In 1958, Kaprow had published an essay on Pollock in which he argued that to respond properly to Pollock's work "it is necessary to get rid of the usual idea of 'Form', ie., a beginning, middle, and end, or any variant of this principle—such as fragmentation".[65] The relationship of elements within Pollock's work cannot take precedence as the "artist, the spectator and the outer world are much too interchangeably involved here".[66] What Kaprow sees is a performance and a response that move beyond the stable correlation of spaces. And so he concludes: "Pollock, as I see him, left us at the point where we must become preoccupied with and even dazzled by the space and objects of our everyday life, either our bodies, clothes, rooms, or, if need be, the vastness of 42nd Street."[67]

The perception that the move beyond the canvas was a move out into the world was to have its own legacy in Kaprow's Happenings, which were to be radical alternatives to existing art practice. Yet whilst they were conceived as alternatives, they also had a profound impact on that practice, perhaps above all through the work of Claes Oldenburg.

Oldenburg had been impressed by Kaprow's essay on Pollock, and had attended Kaprow's seminal event: *18 Happenings in Six Parts*. He went on to produce work in a similar vein, creating the environment, *The Street*, at the Judson Gallery and then using this as the setting for his first performance, *Snapshots from the City*.[68] Oldenburg's performances came to demand large props and the artist developed his giant soft sculptures from these precedents.[69] Later, in 1966, Oldenburg chose to publish some fragments from his notebooks of the years 1962–1964, in which he had tried to establish the context for his work. "Nature is one thing. The city is another. The city is too much. Someone has already been there. The vision is already disordered, but real.

The hallucination is a fact. And your hallucination makes it double. How many natures? How many realities? Too much".[70]

Like both Restany and Kaprow before him, Oldenburg felt confronted by a "second nature: the street, or asphalt nature" and even a third nature: "the store, by which I mean: 1. billboard nature (all forms of advertising, newspaper included) 2. Fake nature: clothes, cakes, flowers, etc. etc."[71] Oldenburg was engulfed and felt compelled to engulf his spectators.[72] In the autumn of 1962 he held a show at the Green Gallery in which his soft sculptures were displayed for the first time. A departure from the artist's constructed environments, these sculptures wrought a further transformation of the experience of viewing. In 1967, Barbara Rose noted that Oldenburg's exhibition was, "to my recollection, the first one-man show of sculpture in which the pieces, meant to impede circulation and to demand a certain kind of inescapable focus, were executed on the superhuman scale that is so familiar today".[73]

The exhibition at the Green Gallery was neither an environment nor a presentation of discrete objects, instead, Oldenburg introduced a new correlation of spaces, in which, according to Rose, the scale and placement of objects began to trouble the normal activity of viewing. Oldenburg proceeded to invert this practice whilst preserving its terms, producing in the *Bedroom Ensemble* of 1963 an installation at the Sidney Janis Gallery constructed according to a vanishing point [Fig. 8]. Elements of the ensemble are physically foreshortened and so here optical effects are made spatial. Viewing was staged. Yet, in Oldenburg's work, it was staged in response to the urban environment, whether it was that of the Lower East Side figured at the Green Gallery or the motel *moderne* of Los Angeles shown by Sidney Janis.[74]

The early career of Robert Morris followed a trajectory with important parallels to that of Oldenburg. Morris was a member of the Judson Dance Theater, which had its venue in the Judson Memorial Church, whilst the neighbouring Judson Gallery had provided the setting for Oldenburg's first performance. And, just as Oldenburg exhibited sculptures which derived from performance props, so Morris' early work in a Minimalist vein was intimately related to theatrical contexts. *Column*, 1962, was a prop from a performance at La Monte Young's Living Theater. So when Morris had his first one-man show at the Green Gallery in 1963, he had made Oldenburg's journey from downtown performance to commercial gallery. Yet Morris' exhibitions at the Green Gallery in 1964 and 1965 went even further than Oldenburg's in establishing the interdependence of the object and its environment. While Oldenburg's work was indexed to specific urban environments, the sculpture of Morris was more directly related to the immediate context of the gallery. However, this is not to say that Morris set out to create environments. Between 1964 and 1966 he became ever more intent on producing works which retained their identity as individual sculptures whilst revealing their spatial context.[75] Taking "relationships out of the work" and making "them a function of space, light, and the viewer's field of vision" became his goal.[76] And thus the viewer's space came to take precedence over any correlation of spaces created by the work.

What was at stake in the development of these new ways of working is clear if one reviews the critical reactions Oldenburg and Morris generated. The positive assessment was given trenchant expression in Donald Judd's criticism, and especially in the essay

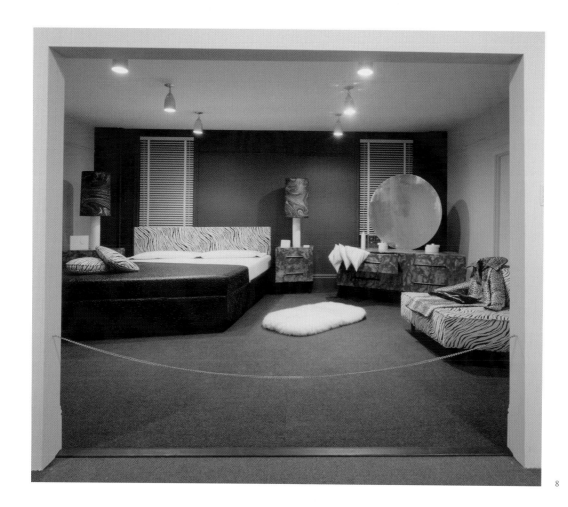

8

"Specific Objects". Judd opens this text with the statement: "Half or more of the best new work in the last few years has been neither painting nor sculpture."[77] For painting and sculpture "are particular forms circumscribed after all, producing fairly definite qualities. Much of the motivation in the new work is to get clear of these forms. The use of three dimensions is an obvious alternative."[78] And, crucially, Judd emphasises of the new three-dimensional works: "They are not diluted by an inherited format."[79] He then discusses a number of artists who sought to disavow this inheritance and, among these, Oldenburg occupies the chief position.[80]

Conversely, and unsurprisingly, the Modernist critics' resistance to Oldenburg's work shares terms with their resistance to that of the Minimalists. In "Recentness of Sculpture", Greenberg protested that "Assemblage, Pop, Environment, Op, Kinetic, Erotic, and all other varieties of Novelty Art" have set themselves the problem of "extricating the far-out 'in itself'", whilst the Minimalists had realised that "the furthest-out usually lay on the borderline between art and non-art".[81] And Greenberg

saw artists such as Oldenburg and Morris as object-makers, nudging their work onto this borderline, a line which now "had to be sought in the three-dimensional, where sculpture was, and where everything material that was not art also was".[82] An art "nearer the condition of non-art could not be envisaged or ideated at this moment"; that, however was the problem: Minimalism "remains too much a feat of ideation, and not enough anything else".[83]

Similarly, in reviewing Oldenburg's Green Gallery show, Michael Fried noted that the artist's "hallucinatory, prosaic environment threatens to overflow" the gallery but nevertheless "seems to exist merely, or chiefly, in order to pose questions of a conceptual nature. Everything depends on what we make of it, on the conceptual framework that, looking at it, we bring to bear."[84] Both as a description and as a reaction this foreshadows Fried's responses to Minimalism as set forth in his essay "Art and Objecthood". Here the critic declares himself vexed by "the obtrusiveness and, often, even aggressiveness" of Minimalism and proceeds to label such work "largely ideological".[85] Fried then pursues this point by developing the arguments put forward in "Recentness of Sculpture"; it is not simply that Minimalist work approaches the condition of non-art, rather, this condition is espoused as "nothing other than a new genre of theatre".[86] This is an aggravation of the state of affairs considered by Greenberg. The borderline between art and non-art has been transformed into the frontline in a war waged between theatre and art as such. Fried argues that Minimalist work is theatrical because it "depends on the beholder, is incomplete without him".[87] Such a reliance "more than anything else is what Modernist sensibility finds intolerable in theater generally".[88] It is intolerable because the work of art is reduced to being merely an object in a situation, and the "beholder is made aware of the endlessness and inexhaustibility if not of the object itself at any rate of his experience of it".[89] This experience is a mark of the failure of the work in question to attain the status of art, the failure to become other than an object, the failure to present a correlation of spaces.[90]

The new work was legible as ideology but could not be experienced as art; it could be 'read' but not 'felt'. Such work was thus inaccessible to critics making the assumption that art was the expressive relation of forms. This assumption was the very foundation of Modernist criticism and furnished the principles for establishing the borderline between art and non-art. But to police this border in the manner of Greenberg and Fried was precisely to impose limits on the work. And it was this which Smithson opposed. He would pour scorn on Fried, seeing him as the St Anthony of art criticism, refusing the temptations of an awful sensibility set out by the agents of endlessness.[91] For Smithson, the views of critics like Fried were marked by a pathetic fallacy and he was determined to reject this and other interpretations of art as expression. In "Quasi-Infinities and the Waning of Space", an essay published the same autumn as "The Domain of the Great Bear", Smithson dissected what he termed "the anatomy of expressionism".[92] The character of this expressionism he glossed in a marginal comment: "Any art that originates with a will to 'expressionism' is not abstract, but representational... Critics who interpret art in terms of space see the history of art as a reduction of three dimensional illusionistic space to 'the same order of space as our bodies'."[93] The citation here is from Greenberg and, for Smithson, the critic is gravely in error. "Here Greenberg equates "space" with "our bodies" and interprets this reduction as abstract. This anthropomorphising of space is aesthetically a "pathetic

fallacy" and is in no way abstract."[94] The failure to achieve abstraction was precisely the result of maintaining a human scale; Smithson's work may be understood as a series of attempts to dismantle both this scale and the sense of self it maintained.[95] In fact, subjectivity was directly challenged in a key early work of Smithson's, the *Enantiomorphic Chambers* of 1965 [Fig. 9]. Enantiomorphic forms are mirrored forms, symmetrical not in themselves but in relation one to another; perhaps the most familiar example of such a relationship being that between the left and right hand. When such forms are brought together they occlude each other, something the *Enantiomorphic Chambers* exploited in a particular way. In a brief description of the work Smithson noted that: "The chambers cancel out one's reflected image when one is directly between the two mirrors."[96] That is, the visual experience central to Modernist accounts is here voided, and with it the viewer's own body. There can be no equation with "our bodies". Yet it was not just that the body disappeared; the human eye was also presented with its own limits.[97] Here there is an important turn in Smithson's relationship to his context.

One might suggest that the qualification of sight in the *Enantiomorphic Chambers* made the work a foreshadowing of conceptual art and its displacement of vision. Indeed, in a photomontage of the chambers Smithson made with the collaboration of Thomas Isbell and Dan Graham, the work is described as a "stopping of sight". Advancing what many would consider the logical conclusion of this "stopping", Graham began to produce works which reduced viewing to the activity of reading.[98] In *March 31, 1966*, Graham registered a series of distances between the edge of the known universe and the retina of the eye [Fig. 10].[99] Of the distances listed, only three could be considered traversable with the eye: the world accessible to human vision is only one part of the larger universe. However, this does not mean that the viewer of the work becomes disembodied. Human sight is clearly addressed: not only through reference to glasses and cornea, but also through a staging of the viewer's relationship with the work on

9
Robert Smithson, *Enantiomorphic Chambers*, 1965 (refabricated 2003). Painted steel, mirrors and two chambers, 61 x 76 x 78.5 cm. The National Museum of Art, Architecture and Design, Oslo. Copyright Estate of Robert Smithson, DACS and VAGA 2008. Image courtesy James Cohan Gallery, New York.

10
Dan Graham, *31 March 1966*, 1966. As published in Athena T Spear ed., *Art in the Mind*, Allen Art Museum, Oberlin: Oberlin College, 1970. Copyright the artist 2008.

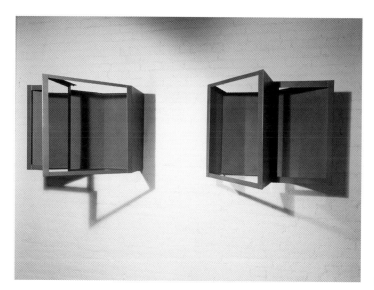

9

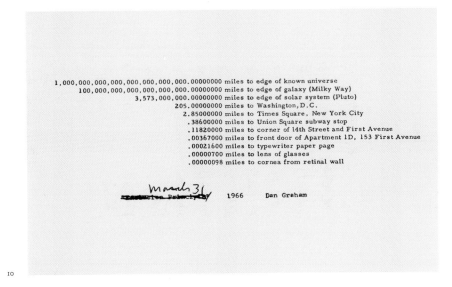

```
1,000,000,000,000,000,000,000.00000000 miles to edge of known universe
  100,000,000,000,000,000,000.00000000 miles to edge of galaxy (Milky Way)
          3,573,000,000.00000000 miles to edge of solar system (Pluto)
                   205.00000000 miles to Washington,D.C.
                     2.85000000 miles to Times Square, New York City
                      .38600000 miles to Union Square subway stop
                      .11820000 miles to corner of 14th Street and First Avenue
                      .00367000 miles to front door of Apartment 1D, 153 First Avenue
                      .00021600 miles to typewriter paper page
                      .00000700 miles to lens of glasses
                      .00000098 miles to cornea from retinal wall
```

March 31 1966 Dan Graham

10

the page. Nevertheless, sight is here once again inadequate, yet not simply because it is limited. Here the banal fact that humans cannot see to the edge of the known universe is less important than the fact that the distances Graham lists cannot be represented within a single visual field. The disparate scales cannot be diagrammed together. Thus in *March 31, 1966* Graham is concerned with both the inadequacies of sight and the related but distinct issue of the inadequacies of visual media.[100]

Smithson of course shared many of Graham's interests, including an interest in the dimensions of the universe sustained through visits to the planetarium. But he was not willing to pursue such interests through conceptual practices. He wanted to retain the tension—present in the *Enantiomorphic Chambers*—between the position of the viewer and the possibilities of vision. And this was what he explored when he finally secured an exhibition at Virginia Dwan's gallery in New York. The exhibition ran from December 1966 to January 1967 and the work Smithson chose to present may be considered as a response not just to pieces such as *March 31, 1966* but also to the Minimalist work which had reached a new prominence that spring with the *Primary Structures* exhibition at the Jewish Museum.[101]

11
Robert Smithson, *Plunge*, 1966. Steel, ten units, 37 cm rising to 48 cm, overall length 853 cm. Collection of Denver Art Museum. Copyright Estate of Robert Smithson, DACS and VAGA 2008. Image courtesy James Cohan Gallery, New York.

12
Robert Smithson, *Alogon 2*, 1966 and *Plunge*, 1966 as installed in a one man exhibition at the Dwan Gallery, December 1966–January 1967. Photograph courtesy of Dwan Gallery Archive, New York. *Alogon 2*, 1966. Painted steel, ten units, from 31.75 cm height by 5.5 cm increments to 91.4 cm height. Collection of The Museum of Modern Art, New York. Copyright Estate of Robert Smithson, DACS and VAGA 2008.

13
Robert Morris, *Untitled (L Beams)*, 1965. Fibreglass, three units, 244 x 244 x 61 cm. Installation view of the exhibition *Primary Structures*, The Jewish Museum, New York, April 27–June 12 1966. Donald Judd, *Untitled*, 1966 (bottom left); Robert Morris, *Untitled (L Beams)*, 1965 (bottom right); Robert Grosvenor, *Transoxiana*, 1965 (top right). Copyright The Jewish Museum. Copyright Robert Morris, ARS and DACS 2008.

12

13

Smithson took *Plunge* to be the centrepiece of his exhibition and gave it pride of place on the invitation to the opening. This work is made up of ten units, each of four blocks inset one with another in a stepped arrangement. When viewed from one angle, the work presents a diminution of units congruent with the effect of foreshortening [Fig. 11]. Under this angle a spatial arrangement and an optical illusion are correlated. A similar correlation could also be found in other works in the exhibition, such as *Alogon 2*. In these works the 'objective' property of the decreasing size of the units could be correlated with the 'subjective' perception of recession, yet this correlation was dependent on the subjectivity of 'point of view', the angle under which the work was seen. Thus the spatial and the optical might be correlated or set athwart each other. Smithson seems to have taken care to ensure that both effects were experienced at the Dwan gallery, as *Plunge* was set against *Alogon 2* [Fig. 12].[102] From one angle the spatial and optical are coordinated for *Alogon 2* but not for *Plunge* and of course from the other end of the gallery, the opposite would be true. Thus the works are not enantiomorphic, but, as installed, the effects they generated were.

As Smithson's works created different effects and at least made available optical illusion, they belong in a category other than that of Judd's specific objects. Of course, by this date, a number of artists had created works or installations which explored the possibilities of point of view and juxtaposition. The L beams Morris showed in *Primary Structures* are a case in point. As physical objects, these works by Morris are identical. However, different dispositions of the beams create different effects [Fig. 13]. For example, a beam balanced on two corners seems more emphatically symmetrical than a beam resting on one side. Yet here the different effects are merely different aspects of the same object. In Fried's terms, the viewer is made aware of the endlessness and inexhaustibility of the experience of the object. In contrast to this, *Plunge* and *Alogon 2* set different experiences against one another. As with Oldenburg's *Bedroom Ensemble*— although in a different way—the optical is part of the construction of these works and Smithson, like Oldenburg, could be said to test the limits of the optical in the spatial. For to the extent that *Plunge* and *Alogon 2* create perspectival effects, they also suggest vanishing points and a larger than room scale. Yet vanishing points are optical and not physical. Thus *Plunge* and *Alogon 2* occupy space and suggest space in different ways; to contemplate these works from different angles is to be made aware of a contingent correlation of spaces. From one angle the work is an image, from another it is merely a collection of objects. And that Smithson created works which entertained such contingency is one further sign of what might be termed his radical antiformalism.[103] Smithson was not simply concerned with providing an alternative to formalism—in the manner of the conceptual practices then emerging—but was instead concerned to issue a direct challenge to it. This is why his antiformalism is properly described as radical.

These comments open onto a much larger set of issues. At this point, I wish to move outwards from the immediate context for Smithson's work, first to the transformation of the status of the museum and then outward again to the transformation of the wider environment through technology. I shall then turn inward to consider the impact of these transformations on the very status of the artwork. This excursus is necessary in order to grasp what is at stake the next phase of Smithson's career, when he moved beyond the object to the practice of site selection.

Smithson's antiformalism of course entailed a rejection of the established formats of painting and sculpture. He was explicit about this rejection in a brief essay for *Arts Magazine*, published in February 1967 with the suitably expulsive title "Some Void Thoughts on Museums". Smithson's essay grew from a dialogue with Allan Kaprow which appeared in *The Museum World*, the *Arts Yearbook* for 1967.[104]) In the essay Smithson declared: "Visiting a museum is a matter of going from void to void. Hallways lead the viewer to things once called 'pictures' and 'statues'. Anachronisms hang and protrude from every angle."[105] Smithson is certain that the formats which had become central to the Western tradition had vanished into the past. And as these formats disappeared, so did the space which arose with them, the space of the museum. The dialogue with Kaprow and its destination in a yearbook devoted to the museum indicate that Smithson was not alone in addressing himself to the fate of this institution at this moment. Doubtless the opening in 1966 of Marcel Breuer's new building for the Whitney Museum of American Art was the occasion for this interest, but it was only the occasion; the larger issue was a perceived crisis of the museum. Of course, as much was easy to predict if the formats of the Western tradition were on the point of collapse. The ascendancy of Pop art in the years between 1962 and 1964 had ensured that the old opposition of avant-garde and kitsch was recast; many now anticipated that the fine arts in their last incarnation were to be levelled with other cultural forms and that there would necessarily be consequences for institutions such as the museum. For present purposes, however, the extent of the crisis is less important than the terms in which critics chose to predict it. These terms were now drawn from analyses of the media.[106]

These issues were given perhaps their most cogent formulation in an essay of 1967 by Everett Ellin, who was at that moment an assistant to the director of the Guggenheim Museum. After a series of opening remarks, which consider the arguments of both Smithson and Kaprow, Ellin proposes to address the contemporary state of the museum by drawing on the theories of Marshall McLuhan. To this end he offers the following summary of McLuhan's arguments:

> He suggests that each new medium of communication—which he defines as an extension of some human faculty, either mental or physical—alters our psychic environment, imposing on us a distinct pattern of perceiving and thinking that manipulates us to an extent we scarcely suspect.... However, the environment created by a new technology—although quite invisible by itself—serves to make visible the preceding environment.[107]

Ellin then extends this account to the museum:

> McLuhan contends that the Middle Ages was the 'late show' of the Renaissance. For example, the content of the printing press during the Renaissance was Medieval writing. The Renaissance did not come into full perspective as an environment until the nineteenth century, when it became the content of the nineteenth century mind and translated into archetypal form. The museum, a creation of the nineteenth century, quite naturally adopted the popular mode of the Renaissance for its content [...]. Although the Renaissance content of the museum medium has been rather obvious from the start, the museum environment per se has evaded our attention. Now, quite unexpectedly, some of those in the vanguard are telling us not only what the environment looks like but how it ought to be.[108]

The very fact that the museum environment has become a preoccupation indicates to Ellin that a transformation is underway, and that the museum is being absorbed into a new medium, and becoming the content of a new environment. Thus, "the museum form is revealing itself for all to see".[109] It is precisely this revelation which led Kaprow to suggest that the Guggenheim should be emptied of its content and simply presented as a work of art, an idea Ellin also entertained.[110]

The "new medium" which had effected this revelation is, in fact, best described as a cluster of media: those dependent on electric circuitry. These media are cogently presented in McLuhan's *Understanding Media: The Extensions of Man*, 1964. Yet this work requires the context provided the author's earlier volume, *The Gutenberg Galaxy: The Making of Typographic Man*, 1962. Indeed, the author of these books believed that they should be read as one, the former preparing the field of the latter. In this fashion, McLuhan was at great pains to present his own work as an exemplification of his thesis concerning transformation, arguing that the very fact he can delineate the world created by Gutenberg and movable type is a sign of its passing. "As we experience the new electronic and organic age with ever stronger indications of its main outlines, the preceding mechanical age becomes quite intelligible. Now that the assembly line recedes before new patterns of information, synchronised by electric tape, the miracles of mass-production assume entire intelligibility".[111]

Having analysed the mechanical age, McLuhan then offers an account of the new environment. "Since our new electric technology is not an extension of our bodies but of our central nervous systems, we now see all technology, including language, as a means of storing and speeding information."[112] For McLuhan this was an extension which would have profound effects on production and communication. "Since electricity, inventories are made up not so much of goods in storage as of materials in continuous process of transformation at spatially removed sites."[113] Thus the discrete object was no longer at the centre of the production process. Equally, with telecommunications, the "source of energy is separate from the process of translation of information, or the applying of knowledge".[114] And this of course is quite distinct from communication by means of physical objects such as letters or newspapers. Such developments did not simply increase the speed of production and communication; McLuhan argued that the new media "abolish the spatial dimension, rather than enlarge it".[115]

McLuhan's arguments served to open a new chapter in the negotiations of object and environment. For if the spatial dimension was abolished, the very basis for a correlation between the space of the image and the space of viewing was now transformed. Burnham was amongst the first critics to grasp the implications of this. It should by now be clear how McLuhan's arguments (and perhaps his gift for aphorism), contributed to Burnham's analysis of a transition from an object-oriented to a systemoriented culture, and to his perception that change emanates not from things, but from processes. Yet Burnham's analyses were not merely parasitic on a fashionable thesis. They were ultimately founded on a careful review of the history of the Western tradition.

For McLuhan, an important way of representing the transition from the mechanical to the electronic age would be with the figure of an arc; in this trajectory, the sense of

14
François Morellet, *Sphère-Trame (Sphere-Texture)*, 1962. Stainless steel multiple, 45 x 45 x 45 cm. University of East Anglia Collection of Abstract and Constructivist Art, Architecture and Design. Photograph: James Austin. Copyright ADAGP and DACS 2008.

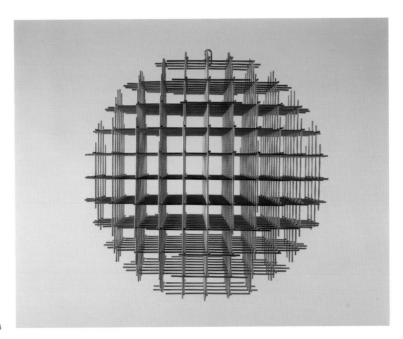

sight rose to prominence through the age of Gutenberg and then descended towards the present. The descent was not only a result of electrical circuitry abolishing the spatial dimension, it was also a consequence of scientific developments in the twentieth century. As McLuhan's collaborator Harley Parker put it: "Parallel to the waning of visual verisimilitude in the arts is the fact that the ten greatest scientific discoveries of the last 40 years cannot be seen. They have occurred in areas of electronics, atomic physics or medicine which are below the level of perception even with the aid of an electron microscope".[116]

Now, it was precisely this set of developments below the threshold of the visible that Burnham took to be central to the crisis of formalism. In his major work of 1968, *Beyond Modern Sculpture: The Effects of Science and Technology on the Sculpture of this Century*, he argued: "The decline of formalism is the decline of a world fashioned to operate on a strictly visual-geometrical level. For the doubtful, compare the inside of a pocketsized transistor radio with the workings of a spring-wound watch. The geometry inside the radio is the orderly assembly of electronic coding and circuit miniaturisation, not causal, coherent relationships as in the watch".[117]

Such comparisons permitted Burnham to grasp the significance of the New Tendency and the suppression of internal relations in works such as François Morellet's *Sphère-Trame (Sphere-Texture)* [Fig. 14]. Burnham was now able to place this work in a broader series of developments. "If formalism had been rendered impotent by invisible principles, the result of scientific investigation, then the New Tendency sought to recover some of this lost power."[118] This entailed a decisive break with Newtonian

mechanical models, and of course this came with its own challenges, as "the mathematician-physicist's new conception of wave packets and/or particles of energy embedded in a variable field where all the parameters were inconstant had virtually nothing to do with the world of sense perception".[119] Nevertheless, this field theory provided at least a model for artists.

> Thus the discrete element, implacably regimented with identical members to its left and right, to the front and back, has become the format of the New Tendency. Crude and distant though this image is from the theories of gravitation constructed by Einstein, it served to bring the invisible world of energy dynamics—those forces which make technological society a reality—back to the level of visual comprehension.[120]

Now, when Burnham was completing his book in 1967, he was forced to concede that tying New Tendency field configurations to Einsteinian mechanics was at best the making of an analogy. Thus Burnham's conclusions had to be speculative. Nevertheless, he recognised the need to look beyond both the weary vocabulary of formalism and the models proposed by the New Tendency. And so, after the demise of modern sculpture, Burnham identified the transition to a systems-oriented culture. In drawing the distinction between object and system, Burnham argued that above all "the object occupies a specific space: it has place, remaining inert and stationary".[121] It is in this respect that the arts of painting and sculpture are arts of place. By contrast, a system is an aggregate of components and the shift to a systems-oriented culture is the shift of focus from the sited object to the interaction of components.

> As a result the cultural obsession with the art object is slowly disappearing and being replaced by what might be called 'systems consciousness'. Actually, this shifts from the direct shaping of matter to a concern for organising quantities of energy and information. Seen another way, it is a refocusing of aesthetic awareness—based on future scientific-technological evolution—on matter-energy-information exchanges and away from the invention of solid artifacts. These new systems prompt us not to look at the 'skin' of objects, but at those meaningful relationships within and beyond their visible boundaries.[122]

Of course, it is this refocusing which is pursued in Burnham's later essay on systems in *Artforum*. As will be recalled, a turning point in this essay was McLuhan's remark that Pop art was an announcement that the entire environment was ready to become a work of art.[123] That the entire environment could become available as a work of art suggests that it has been displaced. This is the achievement of the new media; it is the realization of the transition from the mechanical to the electronic.

For Burnham, the consequences of this became evident in Smithson's practice of site selection. Smithson acknowledged as much in the essay "Towards the Development of an Air Terminal Site", where site selection is linked to both modern technology and modern systems of communication. The point of departure for his argument is a rejection of "the rational categories of 'painting, sculpture and architecture'".[124] He proceeds not from the art object, as in Modernist criticism, but from an alternative set of coordinates, those derived from the technology of the high altitude surveying satellite; this "45-pound object enables surveyors to tie together land masses

separated by more than 2,000 miles of land or water".[125] Transcending the limits of human vision, this technology has direct consequence for mapping "because the world is round, grid coordinates are shown to be spherical, rather than rectangular. Yet the rectangular grid fits within the spherical grid. Latitude and longitude lines are a terrestrial system much like our city systems of avenues and streets. In short, all air and land is locked into a vast lattice".[126]

Now, there are in fact several sets of coordinates in play here. That the world became a new object once viewed from space was, by this date, not unfamiliar. Such a view is implicit in the work by Graham discussed above. And McLuhan had already noted that the "first circumnavigation of the globe in the Renaissance gave men a sense of embracing and possessing the earth that was quite new, even as the recent astronauts have again altered man's relation to the planet, reducing its scope to the extent of an evening's stroll."[127]

And McLuhan would soon gloss this point with reference to the "satellite world" as "an artifact, a man-made environment that goes around the planet. The planet has now become an object contained in a man-made environment. It is no longer nature. It's an old art form".[128]

Smithson chose to explore this 'man-made' environment through an excursus on Alexander Graham Bell. As well as inventing the telephone, Smithson informs the reader that Bell built "kites based on tetragonal units".[129] These he surveyed from a "pyramid-shaped outdoor observation station".[130] And "a grid connection was established by him between ground and air through this crystalline system".[131] Through this grid connection, the "solid mirrored the lattice", in an anticipation of the lattice created by the surveying satellite.[132] For Smithson, Bell's system was intimately related to his invention of the telephone.

> Bell's awareness of the physical properties of language, by way of the telephone, kept him
> from misunderstanding language and object relationships. Language was transformed by
> Bell into linguistic objects. In this way he avoided the rational categories of art. The impact
> of 'telephone language' on physical structure remains to be studied. A visual language of
> modules seems to have emerged from Bell's investigations. Points, lines, areas, or volumes
> establish a syntax of sites.[133]

The telephone abolished the spatial dimension as interlocution no longer required two speakers to be present in the same space; communication across great distances could now be instantaneous. Space was literally translated into the grid of the telecommunications network, creating the syntax of sites. This syntax permits Bell to avoid rational categories; it replaces what Smithson would elsewhere refer to as "the old landscape of naturalism and realism".[134]

In Bell's investigations, Smithson found a framework to organise his own views of linguistic objects. As he set down his observations about Bell, Smithson was also drafting a press release for the Dwan exhibition *Language*. The release was entitled: "Language to Be Looked at and/or Things to Be Read", a manifesto in miniature.

It opens with the statement: "Language operates between literal and metaphorical signification."[135] The literal signification is evident in the manner in which the "scale of a letter in a word changes one's visual meaning of the word. Language thus becomes monumental because of the mutations of advertising."[136] Once again, Smithson demands that one be conscious of the actualities of perception. Yet Smithson was also concerned with language as metaphor, as transference, as carrying across. And this informs his attitude to landscape in the essay on the air terminal site. "All language becomes an alphabet of sites, or it becomes what we will call the air terminal between Fort Worth and Dallas".[137] The airport disaggregates the syntax of sites into an alphabet. The Hayden Planetarium had offered what could be described as a representation of the universe, yet Smithson could understand the airport "as the Universe".[138] Just as the telephone released the voice from the body to carry it over great distances, so aircraft released the body from gravity and redefined what it meant to travel. And thus, as Smithson would note in a later essay, the airport should be seen, "*as an idea*, and not simply a mode of transportation. This airport is but a dot in the vast infinity of universes, an imperceptible point in a cosmic immensity, a speck in an impenetrable nowhere."[139] The airport becomes the contemporary means of realizing Pascal's dialectic of point and edge. In this nowhere, landscape and language are released from rational categorisation.

Yet, in seeking to maintain a relationship between landscape and language, Smithson was once again resisting his context.[140] He was resisting what was, in his view, an incipient reification of practice. This much was evident in the issue of *Artforum* in which the air terminal essay was published, a special number on sculpture which Smithson had helped to compile.[141] Alongside Smithson's essay appeared Fried's polemic against objecthood—which ironically did much to canonize Minimalism—and also Sol LeWitt's announcement of a conceptual art.[142] However, Smithson was to oppose directly what he perceived as the idealism of LeWitt's practice.[143] And this opposition was only to be entrenched as the dematerialisation of art was increasingly celebrated. Yet, conversely, Smithson was also wary of what he termed the materialist practice of Carl Andre, and of the development summarised in Andre's Minimalist history of modern sculpture: form, structure, place.[144] Smithson would come to view such work as imposing "serenification" on the site.[145] Against this, in the air terminal essay the syntax and alphabet of sites keep language and landscape in play, rather than isolating them. The resistance to isolation is stated at the beginning of Smithson's first essay discussing the non-sites, "A Sedimentation of Mind: Earth Projects". Here the artist declares: "The earth's surface and the fragments of the mind have a way of disintegrating into distinct regions of art."[146] Rather than seeking to police the border between these regions, Smithson sought to reveal a dialectic of mind and matter, a dialectic which was crucial to the non-sites.[147]

In the air terminal essay, Smithson had established an equation between the site of the airport and the universe. In the first non-site, another airfield is selected and a different order of equation is established. As the punning designation suggests, the tension now is between that which is available to sight (the materials in the gallery) and that which is not (the actual site). The first non-site was exhibited in Smithson's second show at the

Dwan Gallery, in March 1968; the work consists of sand, a map, a series of aluminium containers, and a text [Figs. 15–16]. The text reads as follows:

A NON-SITE (an indoor earthwork)
31 sub-divisions based on a hexagonal "airfield" in the Woodmansie Quadrangle—New Jersey (Topographic) map. Each sub-division of the *Non-site* contains sand from the *site* shown on the map. Tours between the Non-site and the site are possible. The red dot on the map is the place where the sand was collected.

An important feature of the non-site is that any ordering of its elements will reveal itself as provisional. Any relationship is contingent, elements displace each other. Thus the sand is physically 'of' the site, although it has now been removed. The text directs the viewer to the site, the area where the sand was collected, but this is now reduced to a dot, just as the airport itself became for Smithson "but a dot in the vast infinity of universes... a speck in an impenetrable nowhere".[148] And these dots and specks now lose themselves amongst the grains of sand. The map is also 'of' the site, a representation of it, one governed of course by conventions which preserve a relationship of scale with the site. Yet this scale is displaced; not just because the airport recedes into a dot, but also because Smithson derived the dimensions of his containers from the map, thereby transferring the map's planar relations into three dimensions. But, yet again, these physical dimensions lose themselves. Smithson considered the non-site as "a container within another container—the room".[149] The actual aluminium containers literally diminish in size, as do the units of *Plunge*. Yet just as *Plunge* also potentially expanded, so the dimensions of the containers could also be taken to expand, ultimately to contain the dimensions of the areas of Pine Barrens indicated on the map from which their forms are derived. Finally, the text itself refuses to provide a stable point within the dialectic of the non-site. As a text, it does not establish a visual rhythm such as exists between the dimensions of the map and those of the containers. But it does expand on that rhythm; the viewer of the non-site looks up and down, back and forth between map and containers. The text refers directly to this, moving as it does from a reference to the map to a reference to the containers. But then the text continues: "Tours between the *Non-site* and the *site* are possible." The movement between elements of the non-site in the gallery is expanded to a movement between gallery and site. Yet this is should not be understood as an effective movement beyond the text. I have already indicated how Smithson was concerned with the metaphorical character of language as an operation of carrying across and the construction of the first non-site involves this in the most literal sense, when sand is carried from New Jersey to New York. Here, then, there is the paradox of a literal metaphor. As in Smithson's account of language, the non-site operates between literal and metaphorical signification. For Smithson, the non-site is thus a "three-dimensional metaphor".[150] "A logical intuition can develop an entirely 'new sense of metaphor' free of natural or realistic expressive content. Between the actual site in the Pine Barrens and The non-site itself exists a space of metaphoric significance".[151]

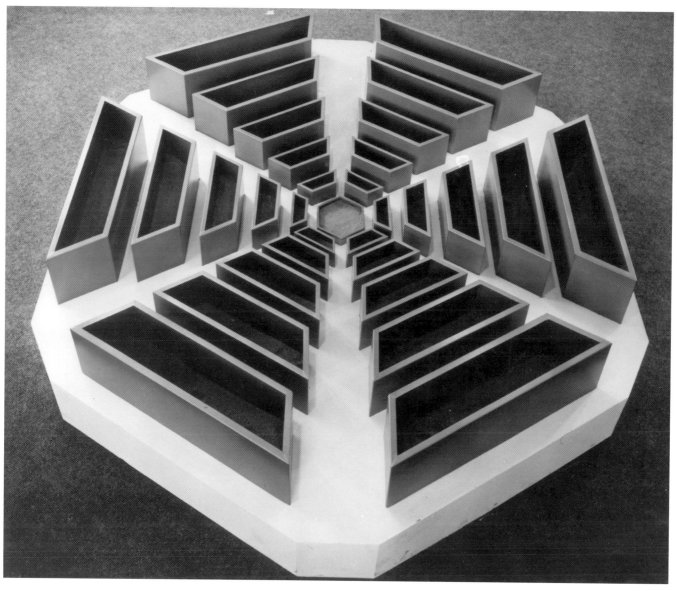

15
Robert Smithson, *A Non-site (an indoor earthwork)*, later retitled *A Non-site (Pine Barrens, New Jersey)*, 1968. Collection of Virginia Dwan. Aluminium with sand, 30.5 x 166.5 cm in diameter. Copyright Estate of Robert Smithson. Licensed by VAGA, New York. Image courtesy James Cohan Gallery, New York.

16
Robert Smithson, *A Non-site (an indoor earthwork)*, later retitled *A Non-site (Pine Barrens, New Jersey)*, 1968. Photostat map and text: map 31.5 x 26 cm. Copyright Estate of Robert Smithson. Licensed by VAGA, New York. Image courtesy James Cohan Gallery, New York.

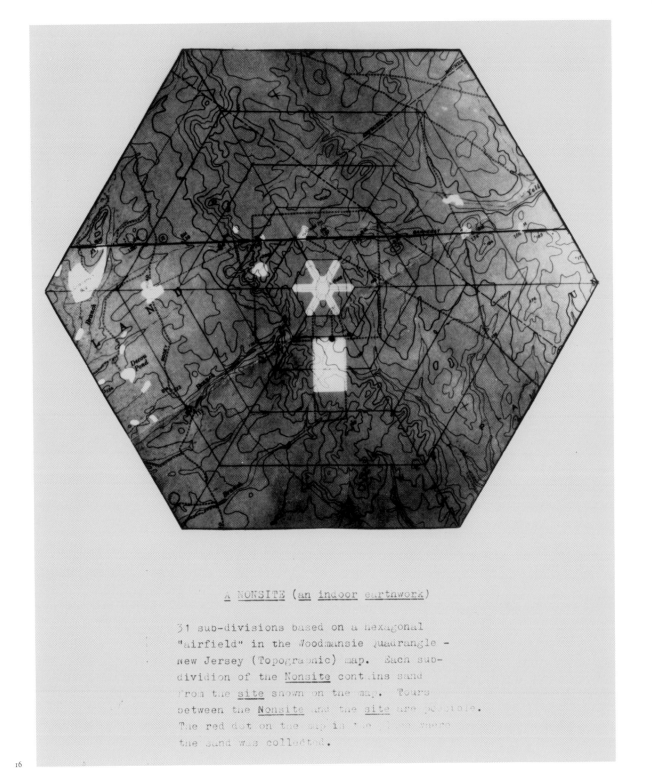

A NONSITE (an indoor earthwork)

31 sub-divisions based on a hexagonal
"airfield" in the Woodmansie quadrangle -
New Jersey (Topographic) map. Each sub-
division of the Nonsite contains sand
from the site shown on the map. Tours
between the Nonsite and the site are possible.
The red dot on the map in the place where
the sand was collected.

Smithson now established his own coordinates beyond the limits of Modernism; his project for an aerial art necessarily carried Smithson beyond the correlation of spaces. Yet it also carried him beyond the specific object. Metaphoric significance was one of the last things Judd would seek in a work.

Smithson went on to produce a series of non-sites, making another 11 in all over the course of 1968.[152] Across the series, he would explore the implications of the three-dimensional metaphor. In some works, such as the *Non-site (Mica from Portland, Connecticut)* and *Non-site (Slate from Bangor, Pennsylvania)* the viewer's attention is focused on the properties of the materials collected. Other non-sites were expansions of the Pine Barrens piece. For the second fully realised work, *Non-site (Franklin, New Jersey)*, Smithson changed both the number of containers and the form of the map [Fig. 1]. Whilst in the first non-site both the map and containers had been given centralised forms, or at least forms with radiating axes of symmetry, in *Non-site (Franklin, New Jersey)* these are replaced by arrangements suggestive of incomplete isosceles triangles. The map of the first nonsite had an occluded centre, and the fact of its exhibition in the same show as *Pointless Vanishing Point* may have prompted viewers to register the occlusion.[153] Nevertheless, for the second work Smithson took pains to emphasise the incomplete and contingent character of the non-site. This character was literally given extra weight here and, in subsequent works in the series, by the use of deposits of a greater physical bulk than the sand of Pine Barrens; whilst the sand was merely collected, the larger fragments suggest activities of quarrying or extraction. In this manner a tension between the crafted containers and the unrefined materials was made more explicit and so was the transition between site and non-site.[154]

Smithson could also expand the range of elements used in the non-sites. For the third work in the series, *Non-site "Line of Wreckage" Bayonne, New Jersey*, he responded to an industrial wasteland by salvaging lumps of concrete, marking a shift from unprocessed to processed materials, although the materials of course are not refined, but "wreckage" [Fig. 17]. The artist also introduced a series of photographs into this work. These are also fragments of the site, fragments of a larger whole. As a series, the photographs shuffle through different views, some more or less panoramic, others tightly framed, focused on shattered debris. Yet, even as Smithson introduced an element of representation into his work, it was displaced by the presence of actual debris. As a site and a sight the littoral of Bayonne is itself wrecked.

So the non-sites create a rhythm, a movement swinging between edge and centre. This rhythm unfixes the traditional relationship of work, viewer and context of viewing which had persisted even under Modernism. This had a number of consequences, as Smithson explained in an interview of 1969. The non-sites address the "scale between indoors and outdoors and how the two are in a sense impossible to bridge".[155] "All dimension seems to lose itself in the process. In other words, you're really going from someplace to no place and back to no place and back to someplace. And then to locate between those two points gives you a position of elsewhere, so that there's no focus".[156] The non-sites show how "place has been abolished".[157]

17
Robert Smithson, *Non-site: Line of Wreckage, Bayonne, New Jersey*, 1968. Painted aluminium, broken concrete; framed map and three photo panels. Cage: 147.3 x 177.8 x 31.8 cm. All panels: 9.5 x 124.5 cm. Milwaukee Art Museum, Purchase, National Endowment for the Arts Matching Funds. Copyright Estate of Robert Smithson, DACS and VAGA 2008.

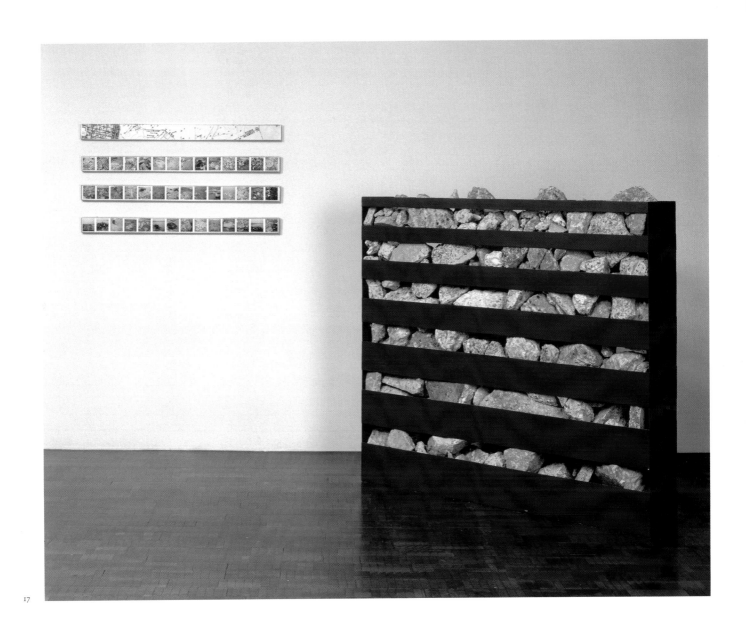

17

Whilst McLuhan had tirelessly documented the experiences of modernity in which the spatial dimension was abolished, a more properly historical account is offered by Summers, in which the transition to modernity involves the negation of a "view of the cosmos as a great, concentric and finite *place*" and its substitution with "the modern idea of universal co-ordinate space".[158] Yet even after this transition, the older arts of painting and sculpture were maintained; the arts Burnham described as the arts of place persisted. Now, however, they were displaced. For the unique spatial experience of a relationship between viewer and work is, in important respects, incompatible with universal co-ordinate space. This incompatibility could be said to define the modern opposition of subjective and objective.

Universal co-ordinate space is beyond the optical and, for this reason, Summers describes it as metaoptical.

> This notional space, the framework against which the behaviour of physical light may be described in the relational terms of measure and ratio, came to be identified with the 'objective' in opposition to the 'subjectivity' of point of view, which is always an optical metaphor. A certain understanding of objectivity entails a certain understanding of the subject; in fact, it may well have given us the idea of the 'subject' taken altogether. The metaoptical is thus beyond the optical in that it presupposes the universal economy of light; and it is also *beyond* the optical in that, although it is defined in relation to light and sight, it is never seen in itself.[159]

The infinitely extendable grid of metaoptical space was generalised from perspectival representations of space. Yet this metaoptical grid is fundamentally incompatible with a perspective generated by a visual angle. For as the grid is infinitely extendable it does not privilege any one point of view. Like Pascal's infinite sphere, its centre is everywhere and its circumference nowhere; thus it is never seen in itself.

The non-sites should be understood as works which acknowledge these conditions of metaopticality; the very title 'non-site' suggests a realm beyond the visual. Of course, Smithson's earlier *Enantiomorphic Chambers* had cancelled the visual by offering a point of view from which nothing could be seen. But in doing so the work also forestalled the possibility of articulating the opposition between subjective and objective. *Plunge* addressed this opposition by offering the subjective experience of the image in the work foreshortened, and also the objective experience of the work as literally a collection of objects. Yet whilst *Plunge* suggested a vanishing point, it was still contained within the space of a room. The non-sites set the "'subjectivity' of point of view" athwart larger spatial conditions. These works have a rhythm which operates at a larger than human scale and serves to redefine the human subject.

The rhythm of the non-sites is one of the central concerns of Smithson's essay on earth projects. Whilst this essay returns to some of Smithson's familiar preoccupations, it has a different tone to his earlier writings. The sedimentation of the mind is described in the language of psychoanalysis, through terms derived from Anton Ehrenzweig's *The Hidden Order of Art*. In this study of the psychology of artistic imagination, Ehrenzweig's aim is to demonstrate that the creation of works of art involves externalising the inner workings of the ego.[160] This process is analogous to the infant's developing

relationship with the mother as described by Melanie Klein. According to Klein, the infant projects into the mother, merges with her, and then re-introjects, parts of the mother being taken back into the child, thereby strengthening the child's surface ego. It is in establishing this rhythm that the ego matures and avoids the neuroses of arrested development. Ehrenzweig describes the three phases of the creative process in similar terms, as the unfolding of a relationship between artist and work. In the first phase of creativity parts of the ego are projected out and 51 lodged, in a fragmented form, in the work. The second, intermediate phase involves a process Ehrenzweig describes as dedifferentiation. Just as in the merging with the mother, "creative dedifferentiation tends towards a 'manic' oceanic limit where all differentiation ceases. The inside and outside world begin to merge and even the differentiation between ego and superego becomes attenuated."[161] This is "the dynamic process by which the ego scatters and represses surface imagery".[162] In artistic terms, it entails moving beyond the restrictive focus of conscious attention. Thus the artist before the easel does not seek to match marks to the appearance of objects as the result of a rational, analytical viewing process, rather, through "unconscious scanning" the artist seeks to hold the total structure of the work in a single view and in this manner the fragmented structure of the work is integrated.[163] The third and final phase is one of re-introjection, in which part of the work's substructure is taken back into the artist's ego. In this phase there is also a secondary revision, for the more narrowly focused surface perception of analytical vision cannot comprehend the undifferentiated vision of unconscious scanning; as a result of this revision the work of art attains a greater coherence.[164] Thus for Ehrenzweig the creative process has a pronounced rhythm of dedifferentiation and integration, of expansion and containment.

When Ehrenzweig applied his theory to modern art, he was led to the perhaps unsurprising conclusion that "in much modern art the rational superstructure is torn away and the ordinarily hidden substructure exposed".[165] However, whilst in some ways predictable, such an account of modern art was to prove particularly useful to Smithson in his own ongoing campaign against rational categories. This much is clear in the essay on earth projects when Smithson turns to engage with his old adversary Michael Fried. Towards the beginning of the essay, Smithson describes Ehrenzweig's intermediate phase, "the low levels of consciousness" in which "the artist experiences undifferentiated or unbounded methods of procedure that break with the focused limits of rational technique".[166] Following Ehrenzweig, he notes that only the creative artist may accept and explore this level of consciousness and the actualities of perception. "The rational critic of art cannot risk this abandonment into 'oceanic' undifferentiation, he can only deal with the limits that come after this plunge into such a world of non-containment".[167] Fried, of course, is precisely such a critic, his ego threatened by the agents of endlessness.[168] Although artists may plunge into the oceanic, most critics "cannot endure the suspension of *boundaries* between what Ehrenzweig calls the 'self and the non-self'".[169] Yet while artists can and must endure this, Smithson, like Ehrenzweig, recognises that the oceanic phase is just one part of the creative process. He goes on to acknowledge that the evidence of the oceanic is only offered through a limited revision of the original unbounded state. The oceanic must be contained for if "art is art it must have limits".[170]

I suggested much earlier in this essay that for Smithson the limits of a work could not be the canvas and stretchers—the given limits of a format. In rejecting these limits

Smithson's work moved beyond Ehrenzweig's account. Ehrenzweig's description of analytic and unconscious vision was largely conceived in terms of the figure/ground relations of the picture plane and so for all its innovations it remains an account of the correlation of spaces. Ehrenzweig was ultimately concerned with understanding the process which led to the creation of vibrant pictorial spaces, it was this that he saw as the desired result of the rhythm of dedifferentiation and integration.[171] Of course, Smithson was also deeply concerned with this rhythm. Yet he wished to release it from the limits imposed by the art object. With the non-sites he found a way to preserve the creative rhythm whilst disposing of what he considered merely fictional limits. The non-sites do have limits, oceanic sites are contained. Franklin, New Jersey, is held in five bins. Yet the act of containment is incomplete, the contained non-site is subverted by the expansive site. In this manner the non-sites deepened the opposition between the "'subjectivity' of point of view" and larger spatial conditions. Smithson came to describe the non-site as a "three-dimensional perspective that has broken away fro the whole, while containing the lack of its own containment".[172] The subjectivity of point of view which constitutes perspective is made contingent. Yet it is not just contingent because it is athwart the metaoptical grid, broken away from this whole. It is also contingent because the subject is not whole, is not a rational *cogito* but an ego with different working levels, conscious and unconscious.

The contingency of the subject redefines both 'viewer' and 'maker'. For Smithson it was to undo the pathetic fallacy of expression. The expressive interpretation of art is reliant on the following sequence. Within the pictorial imagination of the maker forms are arranged; this arrangement is then set down in a work of art. Through the correlation of spaces, the viewer encounters the work as an arrangement of forms and is able to intuit them as expressive. This suggests a calm and comforting symmetry of mind between maker and viewer. Smithson remained implacably opposed to this model of interpretation and sought to subvert it. Thus the non-sites present not a correlation of spaces but a rhythm of expansion and containment. The viewer is not presented with an image and so cannot intuit a mental image in the mind of the maker. The manner in which materials are combined in the non-sites does not reveal a mind; the materials remain 'raw', 'contained' rather than 'formed'. Within the Western tradition, to form is to shape material to a mental image and in this sense, as Summers notes, form is essentially mental; "unity of material in art corresponds to the unity of mental form or image *as mental*".[173] This much is refused in the non-sites. As Smithson insisted "in terms of my own work you are confronted not only with an abstraction but also with the physicality of here and now, and these two things interact in a dialectical method and it's what I call a dialectic of place... that dialectic can be thought of that way: as a bipolar rhythm between mind and matter".[174]

The non-sites are not mind like, they are not rational, and do not offer a unity of mental form. They stand outside the Western tradition of imaging.

3. BEYOND MODERNISM

I began this essay with a trivial example of everyday viewing, that of an encounter with a photographic reproduction on a page. My initial purpose was to make a point which was conventional, referring at once to the basic condition of imaging and the way in which that condition had been refined in the Western tradition. I may now turn to a further example of such viewing, to make an historical point. This example is a work of 1971, a neat examination of the encounter with the page by Douwe Jan Bakker [Fig. 97]. Whilst *Project for two contexts and a third one* is a work which self-avowedly operates on many levels, here one basic description will have to suffice. At a first level the work is about dissemination—the dissemination of peoples after Babel and the dissemination of images through various media. These include not just the privileged technique of painting but also the print media, here in the form of the catalogue for the exhibition *Sonsbeek '71*. The historical point which may be drawn from this is simple enough: as art after Modernism ceased to be defined by the correlation of spaces many ways of making became available. Or rather became newly available; print was hardly invented in 1971 but, nevertheless, it—and many other media—had remained marginal within traditional art practice. And it is not difficult to see why this should be so whilst art was defined as the unique encounter of work and viewer in real space. Under this definition print and other technologies of reproduction seemed to offer at best substitutes for the experience in real space. However, once the value of the viewer's experience in the gallery was questioned, the artist's range of media was vastly expanded. Smithson's non-sites, of course, offered an experience to the viewer in the gallery, yet qualified this experience by direct reference to the absent site. Other artists would redirect these relations of presence and absence. Some turned to examine the gallery space as a medium, and others, conversely, exploited new media to obviate the need for a gallery altogether. In the final part of this essay I shall briefly survey these two paths away from the non-site, although they are paths which meander and cross each other at several points.

The experience in the gallery was transformed at the *Earth Art* exhibition organized by the Andrew Dickson White Museum of Art at Cornell University in Ithaca, which opened on 11 February 1969. Smithson was invited to participate along with nine other artists, including Dennis Oppenheim.[175] For his contribution, Oppenheim drew out one logic of the non-site through inversion: he produced a gallery transplant in which the dimensions of his allocated space within the museum were marked out on a site at a bird sanctuary a little distance from Ithaca [Fig. 53]. In this manner the 'neutral' space of the gallery was articulated as the condition for the viewer's encounter with the work. If Smithson's non-sites directed the viewer towards an absent site, Oppenheim's transplant made that site the work itself. Oppenheim stated in the symposium held on the occasion of the exhibition: "Most of the art here is implying dialectic, implying a thing other than what takes place in front of your eyes."[176] The gallery transplant simply makes this explicit.

Les Levine, a scourge of avant-garde pretensions, drew a parodic conclusion from this dialectic in *Systems Burn-off X Residual Software*. Levine documented the *Earth Art* show with 33 photographs taken during a trip made by New York critics to the opening. 31 of these photographs were then exhibited in 1,000 copies at the Phyllis Kind Gallery in Chicago. "Most were randomly distributed on the floor and covered with jello; some were stuck to the wall with chewing gum; the rest were for sale."[177] Thus one exhibition became the content of another as part of a series of translations. The Ithaca earthworks as unique configurations at specific locations became mere reproductions, their physicality parodied by the tactility of jelly and chewing gum. Here the organic was rendered artificial. Levine argued:

> The experience of seeing something first hand is no longer of value in a software controlled
> society, as anything seen through the media carries just as much energy as first hand experience.
> We do not question whether the things that happen on radio or television have actually occurred.
> The fact that we can confront them mentally through electronics is sufficient for us to know
> that they exist.... In the same way, most of the art that is produced today ends up as information
> about art.[178]

Levine's emphasis on media systems effectively displaced the dialectic which Smithson had been concerned to explore. Thus the *Earth Art* exhibition was drawn into the context of conceptual art.

No longer considered a neutral space, the gallery was no longer the 'natural' home for works of art. But this did not mean that it was abandoned. Rather, its spatial and social conditions were re-examined. Oppenheim's reversal with the 'transplant' had served to articulate the gallery space, that space which was arguably the lesser term in Smithson's non-sites, and Oppenheim was to extend this examination of the gallery to embrace the processes implicit in the non-sites. In Smithson's works a tension is established between the 'raw' materials of a site and their placement in carefully finished containers; for the artist, this was an attempt at 'recycling', a partial rehabilitation of sites ravaged by industry.[179] Yet recycling by-products such as the slag used in *Non-site, Oberhausen, Germany* is also a process of production, resulting in an artwork. Oppenheim proposed to make this explicit in *Void*, a project of 1969.[180] This was to make congruent the extraction of materials in the creation of art and the processes of extraction operating in industrialised agriculture [Fig. 55]. *Void* was to trace a series of operations constituting at once the artwork and the manufacturing process. This was to begin with a removal of sugar cane from a field, then the removal of a quantity of sugar from a processing factory; from a total of 100,000 boxes of sugar, Oppenheim proposed removing a number of boxes proportionate to the first removal from the field. The next stage was to be a 'plug-in', laid out in the gallery, and also in proportion to the voids which would have been created by the removals from field and factory. Then the plug-in was to be photographed and the image placed in a box, a reduction of a reduction. Then a receipt was to be compiled, listing all the processes; on reading the receipt the viewer of the work would reduce physical removals to mental operations. Whilst this would offer one parallel to Smithson's work, there is a fundamental difference in that the viewer of *Void* was to be made aware that the production of the work is aligned with the operation of capital in generating the abstraction of exchange value. The gallery was to be brought into alignment with the factory and warehouse.

Such alignments were explored by a number of artists at this moment, so that the gallery was repositioned within larger systems. For Douglas Heubler, this was part of an attempt to move beyond the dimensions of physical objects. For example, with *Site Sculpture Project: Duration Piece No. 9: Berkeley, California—Hull, Massachusetts, 1969*, Huebler produced a work the dimensions of which vastly exceeded those of a gallery [Figs. 57–60]. The artist arranged to have a package posted to a series of addresses and returned as "undeliverable"; in this way the package followed a line across America from west to east coast. The package, postal receipts and a map form a system documentation which completes the work. In its final form the documentation may be displayed in a more or less conventional fashion. However, Huebler was soon to reverse the terms of this process in a work which placed an emphasis on the context of display.

For *Location Piece No. 23: Los Angeles—Cape Cod*, the artist arranged to have the dimensions of the Ace Gallery in Los Angeles marked out at locations in Cape Cod [Figs. 61–64]. A different location was used each day for the six-day duration of the exhibition. By fiat, Huebler declared that each east coast location existed for the 'viewer' in the west coast gallery. Here the logic of Oppenheim's gallery transplant is extended and directed more forcefully toward the viewer as a consciousness now aware of several durations, that of viewing the work, that of the work's existence for one day only, and that of the hours changing between the time zones of the two coasts.

A permutation of this practice was developed by Bill Vazan with his *Cross Canada Line* of 1969–1970. For this piece eight museums and galleries across the country were linked by collaborators who placed lines of tape across each exhibition space as directed by the artist. Thus at the Musée d'art contemporain in Montréal the line entered from the direction of Toronto and turned a corner in the centre of the space in order to proceed in the direction of the next destination, Fredericton. At each point the physical line on the floor was accompanied by a map, photographs of installation and a diagram of coordinates. In important respects the line was both notional in the manner of coordinate lines on a map, and real as a physical trace. Yet the photographs of the installation did more than assert physicality, for in making visible the collaboration Vazan also suggested the lines of communication which made the work possible. These could potentially be of any length, as Vazan demonstrated in 1971 with *World Line* [Figs. 18, 88–93].

In these works Huebler and Vazan drew on the largest national networks of post offices, time zones and mapping. Vito Acconci was to address these systems at a more personal level. In 1970 he produced two works in which the gallery space was used for different aspects of the conduct of the artist's everyday life. For *Room Piece (Room Situation: A Situation using a Room)*, each weekend for three weeks, the artist installed the contents of a different room of his apartment at the Gain Ground Gallery in New York [Figs. 77–78]. Thus, for each period, the artist was obliged to go to the gallery should he require an article normally stored in that room. Rather than use the physical dimensions of the gallery space as Oppenheim and Huebler had done, Acconci presents it as a functional space containing useful objects. And these objects are, of course, distinct from the nonutilitarian artworks which customarily occupied that space. This is a further variant on the gallery transplant but one in which the artist is more directly implicated than the viewer. The personal life of the artist is now exposed to the public yet the work is not 'expressive'; Acconci does not transplant a studio to expose the processes whereby

18

the work of art comes into being. Only mundane aspects of his life become visible
(although this might in itself be taken as a comment on the biographical impulse). In
a related piece for the *Information* exhibition at the Museum of Modern Art, the artist
arranged to have his post redirected to the museum for the duration of the show. Once
again he was inconvenienced in the name of art. And, here, once again, a relatively
neutral process adopted by Huebler has more personal consequences for Acconci.
Huebler, Vazan and Acconci retained one feature of the non-sites insofar as the
experience they offered viewers in the gallery was displaced, literally dislocated.

18
Bill Vazan, *World Line* (detail), 1971.
Documentation book. Courtesy of the
artist. Copyright the artist 2008.

19
Marshall McLuhan and Quentin Fiore,
The Book, from *The Medium is the Massage:
An Inventory of Effects*, coordinated by
Jerome Agel, Allen Lane, London: The
Penguin Press, 1967. Copyright the
artist 2008.

In this respect their works fulfil the function of Burnham's modern didactic art in revealing the "relations between people and between people and the components of their environment".[181] Yet of course this environment could no longer be restricted to a narrow definition of physical space, let alone the space of the gallery. As McLuhan had argued, the environment had been transformed by electronic media. Levine had drawn one set of conclusions from this at the Phyllis Kind Gallery when he translated *Earth Art* into 'information'. The public relations manager Seth Siegelaub was to arrive at a different conclusion, reasoning that if the viewer's experience was displaced, if 'information' was the primary content of a work, then the gallery was redundant and could be replaced by the catalogue. Thus a second path away from the non-site could lead from the gallery to the catalogue page. Taking this path, however, leads one quickly beyond the page to other forms of communication, the photocopy, the Telex, and finally to television.

Yet the first step is to the page. Here the most relevant illustration is to be found in *The Medium is the Massage*, a work produced by McLuhan and Quentin Fiore. In this volume one double page spread is left blank except for the words 'the book' and photographs of thumbs grasping the white pages in a prefiguration of the reader's own hands [Fig. 19]. With this graphic device the book as a material fact is made to appear anew before the reader.[182] Once again, this was the result of new technologies; the very status of the page was to be transformed by new modes of reproduction. In the first instance, this happened through the exploitation of the photocopier. Already in 1966, Iain and Ingrid Baxter had discerned the new conditions the copier created. Working as NE Thing Co. Ltd., they produced *Expansion No. 1*, a multiple featuring the text: "I CONTINUED THIS EXPANSION BY MAKING A PHOTOCOPY AND SENDING IT ON AS DIRECTED BY IT" [Fig. 20]. Accordingly, a tension was created between the individual sheet before the viewer and its status as one link in a lengthening chain. This tension between the individual piece and its counterparts elsewhere offered a different framing of the relation of site and non-site. Here, the status of the reproduction inflects the status of the 'work'. And this much was immediately evident in the 'work' produced under Siegelaub's aegis.

In November 1968, Siegelaub organised an exhibition for Huebler which existed solely as a catalogue. This volume contains two distinct kinds of work which are nevertheless related. One group Huebler described as site sculpture projects, a series involving various operations at various specific sites, operations documented with maps and photographs in the catalogue. Yet as the operations produced effects which were invisible or nearly so, the information offered by the catalogue was of an order distinct from that documenting traditional sculpture. The viewer has to rely on the accompanying texts to 'see' the work. Alongside the series of site sculptures, the other series of works treats the catalogue page as a site. These works are identified as drawings, and indeed show arrangements of points and lines. Yet these arrangements are strictly planar; the lines do not intersect to create illusions of space. However, virtual space is suggested in the accompanying texts. The viewer is invited to see the lines as positioned at different angles to the picture plane, and thus the planar relations of lines of different length are converted into virtual relations between lines of identical length. Huebler uses the correlation of spaces to demonstrate how language interacts with visual forms.[183] This is what he drew out on the catalogue page. Thus in the exhibition of November 1968 Huebler carried site investigation in two quite different directions.

the

book

I CONTINU
ED THIS EXP
ANSION BY
MAKING A PH
OTO COPY A
ND SENDING
IT ON AS DIF
ECTED BY IT

20
NE Thing Co. Ltd., *Expansion No. 1*,
1966. Xerox, Archives Collection,
Morris and Helen Belkin Art Gallery,
University of British Columbia,
Vancouver Photograph: Pete Huggins,
Camera Techniques. Copyright Iain
Baxter& 2008.

21
Land Art, 1969. Poster announcing the
Land Art exhibition on television. From
Groos, Ulrike, Barbara Hess and Ursula
Wevers eds., *Ready to Shoot Fernsehgalerie
Gerry Schum, videogalerie schum*, Cologne:
Snoek 2004. Copyright The Gerry Schum
and Ursula Wevers Archives, Cologne.

20

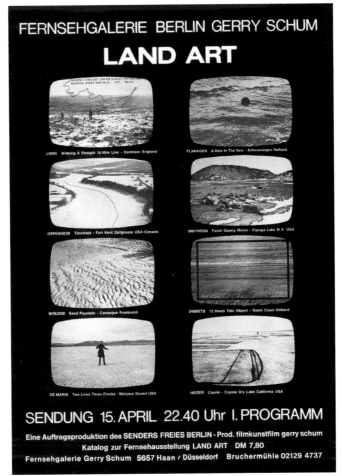

Once Siegelaub had developed his new exhibition strategy, a logical consequence was to examine the catalogue itself and its production. If work was to be produced for publication, should not the means by which the work is produced be absorbed by the process of publication? In December 1968 Siegelaub's response to this question was to establish as the conditions for his next exhibition the use of 25 pages from a Xerox machine. The *Xerox Book*, as it came to be known, was in principle to unite the artistic process and the process of dissemination [Figs. 33–34].[184] In fact, dissemination could become the work itself. Adrian Piper demonstrated this in a series of 'relocation' pieces which exploited the periodical press as a system [Fig. 69]. In these works the agency of the press in connecting sites is made explicit. The page, or at least the periphery of an advertisement in *The Village Voice*, becomes a site, but one mobile in a system linking publisher and purchaser.[185] This offered one more inflection of the relationship between site and non-site, one which was to be developed through the electronic media.

In 1969 the NE Thing Co. Ltd began to experiment with the possibilities offered by the Telex machine. A first Telex exhibition was held at the Paula Cooper Gallery in April but a larger and more ambitious project was executed in September, when the NE Thing Co. Ltd organised an exhibition in Halifax from their base in Vancouver. This latter exhibition consisted of works made on the east coast by following instructions Telexed from the west.[186] One of the initial tasks given to the collaborators, on 18 September, was to locate typical postcard scenes in Halifax, rephotograph them and then chart these locations first on a map of the city and then on a larger map of Canada. This larger map was then marked with the line of communication to Vancouver. In this manner, specific locations gradually receded from view. The process may be understood as a charting of some of the distances Graham had listed in *March 31, 1966*, however, the process was now given a radical extension. On 26 September the command was given for an individual in Halifax to stand outside and look towards the North Pole whilst members of the NE Thing Co. Ltd did the same thing in the Arctic Circle, east of Fairbanks at Inuvik, "resulting in two sight lines converging on [the] North Pole".[187] The actions were documented with photographs and the tracing of the sight lines on a map. So, once again as in Graham's work, the act of viewing is extended notionally. Nevertheless, for the NE Thing Co. Ltd work, the act is also made visible by the lines drawn on the map. To develop this relationship between drawn and projected lines, an attempt was made to create a triangle between Halifax, Inuvik and Burnaby through Telex transmissions. Lines drawn to scale on a map were then to be redrawn at their full length; the transmission was to create a triangle which existed as a flow of information. However, judging from the documentation, the attempt seems to have failed for technical reasons. Nevertheless, despite the failure, this use of information is a means of positioning conceptual art. To the extent that the drawing across Canada could be said to exist, the work was a mapping of metaoptical space. The NE Thing Co. Ltd project was perhaps the first to exploit the modern conditions of telecommunication to validate Burnham's account of a post-visual age.

In a piece such as the Telex triangle, and to a lesser extent with Vazan's cross-country line, the gallery space is reduced to a small point within the work. Yet these pieces still retained the gallery as one coordinate. This was true of a number of explorations of the relations of presence and absence, proximity and distance. For example, in November 1969, the new Museum of Contemporary Art in Chicago held the exhibition *Art by Telephone*, in which participants were invited to contribute works through telephoned instructions; whilst the artists remained at a distance, the focus of the exhibition remained in large part the institution in Chicago.[188] Yet increasing attempts were made to overturn these relations altogether. Here Gerry Schum's exhibition *Land Art* was pivotal, for this project was conceived for a television gallery, and existed for the period of broadcast only [Fig. 21].[189] Thus the exhibition space was any room with a television tuned to the right channel for the broadcast. In this sense the tension within the non-sites between presence and absence was extended to the gallery space itself; the physical institution now lost its privilege.

Yet even with the *Land Art* exhibition, whilst the viewer was made aware that they were receiving a form of primary information, they also remained in relative passivity. Finally, it was this passivity which Douglas Davis sought to address. In his work the exploration of electronic media reached one limit. With the introduction of the Sony Portapak to the consumer market in 1968, a number of artists had begun to investigate the possibilities of closed-circuit relays and Davis wished to extend these investigations by creating dialogues through simultaneous broadcasts. Thus, in 1971, he produced *Electronic Hokkadim*, "the world's first two-way live television programme".[190] As the impact of this experiment was reduced by the participating television station, WTOPTV of Washington DC, Davis developed a further project, *Talk Out!* This refined "the two-way possibility, by bringing the artist into mind-to-mind live dialogue with his public on camera".[191] Interaction was achieved as the viewer could see events unfold at a distance through the live broadcast and intervene in them by telephone. In this manner the gallery space was displaced for both the artist and the viewer. And so the conditions of viewing which Smithson had inherited and reformulated with the non-sites were transformed.

EPILOGUE

My account cannot conclude with the work of Schum and Davis, as if art practice were reducible to technological intervention, or as if dematerialisation had been fully achieved; a television set certainly remains a material object. The use of electronic media did permit the re-organisation of the physical spaces in which artworks existed, and the spaces in which they were viewed, yet as these media came to be exploited so they were also resisted. This resistance took various forms, including willful blindness. Smithson had insisted on a heavy, ponderous art; the physicality of sites remained important for him and it also remained vital for figures such as Nikolaus Lang and Anne and Patrick Poirier [Figs. 98–100]. Whilst these artists could present their work in the same contexts as celebrated practitioners of video art such as Nam June Paik and Valie Export, their work did not directly exploit the same technology.[192] Instead, Lang and the Poiriers sought to reassert the particularity and materiality of sites, allowing these features to saturate the work they produced. Thus, by the early 1970s, it was indeed the case that different artists assumed different roles, to address "a span of problems more natural to architects, urban planners, civil engineers, electronic technicians, and cultural anthropologists".[193] In this situation, the arts of painting and sculpture were increasingly marginalised, as was the traditional relationship of work, viewer and context of viewing which these arts supported. The correlation of spaces, the basic condition of imaging, had ceased to be central to art practice. This marked more than just the end of the Modernist tradition. It was also the end of that longer tradition in which the correlation of spaces served expressive ends, and in which a symmetry could be imagined between the minds of maker and viewer.

ENDNOTES

1 Sources for opening quotations: Smithson, Robert and Mel Bochner, "The Domain of the Great Bear", *The Collected Writings*, Jack Flam ed., Berkeley, Los Angeles and London: University of California Press, 1996, p. 27; Burgy, Donald, *Art Ideas for the Year 4,000*, Andover: Addison Gallery of American Art, 1970, unpaginated. Lippard, Lucy and John Chandler gave a new currency to the term 'dematerialisation' in "The Dematerialization of Art", *Art International*, Vol. 12, No. 2, February 1968.

2 See, for example, Fried, Michael, "Art and Objecthood", *Art and Objecthood: Essays and Reviews*, Chicago and London: The University of Chicago Press, 1998. The essay was first published in *Artforum*, June 1967.

3 At an earlier moment, 'modern art' was defined as a response to 'modernity'. Here a foundational text is Charles Baudelaire's "Le Peintre de la vie moderne", first published in 1863. See Baudelaire, Charles, "The Painter of Modern Life", *The Painter of Modern Life and Other Essays*, Jonathan Mayne trans., London: Phaidon Press, 1964. The case for Modern art as a reaction against modernity was developed in the early writings of Clement Greenberg. See Greenberg, Clement, "Avant-Garde and Kitsch" and "Towards a Newer Laocoon", The Collected Essays and Criticism: Vol. 1. Perceptions and Judgments 1939–1944, John O'Brian ed., Chicago and London: University of Chicago Press, 1986.

4 This is a necessarily condensed summary of a large set of issues. The accounts of imaging and of spatial context given here are drawn from Summers, David, *Real Spaces: World Art History and the Rise of Western Modernism*, London: Phaidon, 2003. For the conditions of imaging see pp. 257–260 but also pp. 251–342 more generally. For the importance of spatial contexts see pp. 43–53.

5 Again, this is merely a summary. The definition of the 'fine arts', the emergence of 'criticism' and the securing of institutional space were related yet not coordinated. For example, French criticism did not simply spring from the regular Salon exhibitions. On this issue see Wrigley, Richard, *The Origins of French Art Criticism: From the Ancien Régime to the Restoration*, Oxford: Clarendon Press, 1993. For a sense of the complexity of the relationship between criticism and the aesthetic see Becq, Annie, *Genèse de l'esthétique française moderne: De la Raison classique à l'imagination créatrice 1680–1814*, Vols. 1–2, Pisa: Pacini, 1984.

6 Smithson, "Earth", *The Collected Writings*, p. 187. This text consists of excerpts from a symposium held on the occasion of the *Earth Art* exhibition; a transcript of the symposium was published in *Earth Art*, Ithaca: Andrew Dickson White Museum of Art, 1969.

7 See, for example, Greenberg, Clement, "Abstract and Representational", *The Collected Essays and Criticism:* Vol. 3. *Affirmations and Refusals 1950–1956*, John O'Brian ed., Chicago and London: University of Chicago Press, 1993, and "The Case for Abstract Art", *The Collected Essays and Criticism: Vol. 4 Modernism with a Vengeance 1957–1969*, John O'Brian ed., Chicago and London: University of Chicago Press, 1993.

8 Greenberg, Clement, "Modernist Painting", *The Collected Essays and Criticism: Vol. 4*, 1993, p. 86. The text was first a radio broadcast and was subsequently published as a pamphlet in the series *Forum Lectures*.

9 Greenberg, "Modernist Painting", p. 86.

10 Greenberg, "Modernist Painting", p. 86.

11 The reception of the essay led Greenberg to append a postscript to its reprinting. This brief text has a tone grumpy even by the standards of the irascible defender of the artists dubbed the Irascibles: see Greenberg, "Modernist Painting", p. 93–94. It should be noted that "Modernist Painting" has received uneven commentary. Greenberg's political context has been carefully excavated: see, for example, Jachec, Nancy, "Modernism, Enlightenment Values, and Clement Greenberg", *Oxford Art Journal*, Vol. 21, No. 2, 1998, and Frascina, Francis, "Institutions, Culture, and America's 'Cold War Years': the Making of Greenberg's "Modernist Painting"", *Oxford Art Journal*, Vol. 26, No. 1, 2003. I do not wish to challenge these arguments here but I do want to reassert the conditions which permitted Greenberg to argue for Modernism as continuity. For one—albeit brief—account of the relationship between Greenberg's criticism and the older tradition of easel painting see Puttfarken, Thomas, *The Discovery of Pictorial Composition: Theories of Visual Order in Painting 1400–1800*, New Haven and London: Yale University Press, 2000, pp. 6–8.

12 Greenberg, "Modernist Painting", p. 87.

13 Greenberg, "Modernist Painting", p. 87.

14 Greenberg, "Modernist Painting", p. 92.

15 Greenberg, "Modernist Painting", p. 90.

16 Greenberg, "Modernist Painting", p. 88.

17 Greenberg, "Modernist Painting", p. 90.

18 Greenberg, "Modernist Painting", p. 90.

19 Greenberg, "Modernist Painting", p. 90.

20 As Summers notes, whilst "we may only touch things at the size they are…we may, however, see the same thing as the same thing over a wide range of actual sizes….To put the matter in the most general terms, all images are sight-like in being abstracted from actual size." Summers, *Real Spaces: World Art History and the Rise of Western Modernism*, pp. 256–257.

21 Greenberg, "Modernist Painting", p. 93.

22 Summers, *Real Spaces: World Art History and the Rise of Western Modernism*, p. 30.

23 Summers, *Real Spaces: World Art History and the Rise of Western Modernism*, p. 30.

24 Summers, *Real Spaces: World Art History and the Rise of Western Modernism*, p. 30.

25 Summers, *Real Spaces: World Art History and the Rise of Western Modernism*, p. 32.

26 Summers, *Real Spaces: World Art History and the Rise of Western Modernism*, p. 34.

27 Vasarely, Victor, *Notes brutes*, Paris: Editions Denoël, 1972, pp. 19–20.

28 Vasarely would pursue the logic of this by producing kits for viewers to assemble as they pleased.

29 Cage, John, "On Robert Rauschenberg, Artist, and his Work", *Silence: Lectures and Writings*, Cambridge, Massachusetts and London: MIT Press, 1966, p. 99. The essay was first published in *Metro*.

30 Cage, "On Robert Rauschenberg, Artist, and his Work", p. 108.

31 There had been a number of more or less private displays of these works, the first possibly being as early as 1949. See the biography in Centre Georges Pompidou, *Yves Klein: Corps, couleur, immatériel*, Paris, 2006, pp. 282–305.

32 Restany, Pierre, "La Minute de verité", from the invitation card to the exhibition *Yves, Propositions Monochromes*, Galerie Colette Allendy, 21 February–7 March 1956. Reproduced in Centre Georges Pompidou, *Yves Klein*, p. 288.

33 Cage, "On Robert Rauschenberg, Artist, and his Work", p. 103.

34 On the filiation of the Groupe to Vasarely see Bann, Stephen, "Unity and Diversity in Kinetic Art", Bann, Stephen, Reg Gadney, Frank Popper and Philip Steadman, *Kinetic Art: Four Essays*, St Albans: Motion Books, 1966.

35 Leo Steinberg repeats the comment made by Jasper Johns that "Rauschenberg was the man who in this century had invented the most since Picasso". Steinberg adds: "What he invented above all was, I think, a pictorial surface that let the world in again." Steinberg, Leo, "Other Criteria", *Other Criteria: Confrontations with Twentieth Century Art*, Oxford and New York: Oxford University Press, 1972, p. 90.

36 Piene, Otto, "The Development of the Group Zero", *Times Literary Supplement*, 3 September 1964, reprinted in Piene, Otto and Heinz Mack eds., *Zero*, Cambridge, Massachusetts and London: MIT Press, 1973.

37 The interaction between these various groups was complex and not always harmonious. For a clear account of this period see Hillings, Valerie L, "Concrete Territory: Geometric Art, Group Formation, and Self-Definition", *Beyond Geometry: Experiments in Form, 1940s–70s*, Lynn Zelevansky ed., Los Angeles County Museum of Art, Cambridge, Massachusetts and London: MIT Press, 2004.

38 Restany, Pierre, "A quarante degrés au-dessus de Dada (2e manifeste)", *Le nouveau réalisme*, Paris: Union Générale d'Editions, 1978, p. 285.

39 Restany, Pierre, "Le nouveau réalisme: que faut-il en penser? (3e manifeste)", *Le nouveau réalisme*, p. 287.

40 Haags Gemeentemuseum, *Journey to the Surface of the Earth: Mark Boyle's Atlas and Manual*, Cologne, London and Reykjavik: Edition Hansjörg Meyer, 1970, unpaginated [Appendix 16]. For an account of this work as a readymade see Thompson, David, "Object, experience, drama", *Studio International*, Vol. 177, No. 912, June 1969. See also Ohff, Heinz, *Anti-Kunst*, Düsseldorf: Droste Verlag, 1973, pp. 139–141.

41 Haags Gemeentemuseum, 1970, unpaginated [Appendix 1]. Boyle described these works as 'presentations', thus using a term which Restany also employed for new realist work. For Boyle's description see Reichardt, Jasia, "On Chance and Mark Boyle", *Studio International*, Vol. 172, No. 882, October 1966. For one example of Restany's usage see Restany, Pierre, "Un nouveau sens de la nature", *Le nouveau réalisme*, pp. 294–298.

42 In fact, Boyle and Hills first experimented with resin as an adhesive for a series made at Hammersmith Reach in 1965. The first resin casts were made at Camber Sands in 1966. For the development of their practice see Elliott, Patrick, "Presenting Reality: An Introduction to Boyle Family", *Boyle Family*, Edinburgh: National Galleries of Scotland, 2003.

43 Smithson, "The Spiral Jetty", *The Collected Writings*, 1996, p. 147.

44 Smithson and Bochner, "The Domain of the Great Bear", p. 27.

45 Smithson and Bochner, "The Domain of the Great Bear", p. 27.

46 Smithson and Bochner, "The Domain of the Great Bear", p. 27.

47 Smithson and Bochner, "The Domain of the Great Bear", p. 27.

48 Smithson, Robert, "Four Conversations between Dennis Wheeler and Robert Smithson", *The Collected Writings*, p. 207.

49 Pascal's dictum is an explicit point of reference in Smithson, Robert, "A Museum of Language in the Vicinity of Art", *The Collected Writings*. And it is clearly relevant in other contexts, when it is not referred to directly: see, for example, the discussion of a "scale of centres" and a "scale of edges", Smithson, "The Spiral Jetty", p. 150.

50 Smithson, Robert, "Fragments of a Conversation", *The Collected Writings*, p. 188.

51 Smithson, Robert, "A Sedimentation of the Mind: Earth Projects", *The Collected Writings*, p. 111.

52 Smithson, Robert, "Smithson's Non-Site Sights: An Interview with Anthony Robbins", *The Collected Writings*, p. 175.

53 Smithson, "The Spiral Jetty", p. 147.

54 Smithson, "The Spiral Jetty", p. 147.

55 These artists included Donald Judd, Robert Morris and Sol LeWitt. Judd and Morris were associated with the Green Gallery, which opened in 1960 and closed in 1965. After its closure both artists moved to Leo Castelli. The John Daniels Gallery was run by Dan Graham, who gave LeWitt his first one man show and helped him gain the support of Virginia Dwan after his gallery closed. See Graham, Dan, "Interview with Eugenie Tsai", *Robert Smithson: Zeichnungen aus dem Nachlass/Drawings from the Estate*, Münster: Westfälisches Landesmuseum für Kunst und Kulturgeschichte, 1989.

56 Graham, "Interview with Eugenie Tsai", p. 12.

57 Graham is enlightening on Smithson's context: "Interview with Eugenie Tsai". For a set of personal responses to Smithson see the comments of individuals associated with *Artforum* as assembled in Newman, Amy, *Challenging Art: Artforum 1962–1974*, New York: Soho Press, 2000, pp. 248–256. There are a series of problems here. Whilst a number of detailed studies of Smithson's work exist, most are monographic and retain a perspective which sometime takes for granted a unified *oeuvre*. If one reviews the skein of quotations

in the paragraphs above, I will certainly appear guilty of this charge. Moreover Smithson's writings, their range and density of reference, have often encouraged exegeses which render other contexts trivial and this has not always served Smithson's work. The text which does the most to acknowledge rather than repress these issues is Crow, Thomas, "Cosmic Exile: Prophetic Turns in the Life and Art of Robert Smithson", *Robert Smithson*, Eugenie Tsai with Cornelia Butler eds., The Museum of Contemporary Art, Berkeley, Los Angeles and London: University of California Press, 2004.

58 Burnham, Jack, "Systems Esthetics", *Artforum*, Vol. 7, No. 1, September 1968. Burnham's writings have not featured prominently in histories of the 1960s, however his work was reassessed in De Salvo, Donna ed., *Open Systems: Rethinking Art circa 1970*, London: Tate Publishing, 2005. One indication of the original currency of Burnham arguments may be found in the frequency and ease with which they are discussed in the interviews Patricia Norvell conducted in the spring and summer of 1969. See Alberro, Alexander and Patricia Norvell eds., *Recording Conceptual Art: Early Interviews with Barry, Huebler, Kaltenbach, LeWitt, Morris,Oppenheim, Siegelaub, Smithson, Weiner*, Berkeley, Los Angeles and London: University of California Press, 2001.

59 Burnham, "Systems Esthetics", p. 31.

60 Burnham, "Systems Esthetics", p. 31.

61 Schjeldahl, Peter, "Systems '66", *The Village Voice*, 15 September 1966, p. 4.

62 Burnham, "Systems Esthetics", p. 34.

63 Burnham, "Systems Esthetics", p. 34.

64 Greenberg was to acknowledge as much when he wrote in 1967: "Today Pollock is still seen for the most part as essentially arbitrary, "accidental", but a new generation of artists has arisen that considers this an asset rather than a liability". "Recentness of Sculpture", *The Collected Essays and Criticism: Vol. 4*. p. 252. The essay was first published by Maurice Tuchman in *American Sculpture of the Sixties*, 1967.

65 Kaprow, Allan, "The Legacy of Jackson Pollock", *Essays on the Blurring of Art and Life*, Jeff Kelley ed., Berkeley, Los Angeles and London: University of California Press, 1996, p. 5. The essay was first published in *Art News* in 1958.

66 Kaprow, "The Legacy of Jackson Pollock", p. 5.

67 Kaprow, "The Legacy of Jackson Pollock", p. 7. Of course, this account was also a response to the work of John Cage, with whom Kaprow had studied at the New School for Social Research.

68 For Oldenburg's account of this period see the interview in Kostelanetz, Richard, *The Theatre of Mixed Means: An Introduction to Happenings, Kinetic Environments and Other Mixed-Means Performances*, London: Pitman Publishing, 1970, p. 133–162.

69 On this development see Rose, Barbara, "Claes Oldenburg's Soft Machines", *Artforum*, Vol. 5, No. 10, Summer 1967.

70 Oldenburg, Claes, "Extracts from the Studio Notes (1962–1964)", *Artforum*, Vol. 4, No. 5, January 1966, p. 33.

71 Oldenburg, "Extracts from the Studio Notes (1962–64)", p. 33.

72 Certainly, it was possible to respond to Oldenburg's work with a framework drawn from Kaprow. Writing of Oldenburg, Ellen H Johnson commented: "It has frequently been pointed out that the older generation's projection of the picture's space out into our world, engulfing the spectator and demolishing the barrier between him and the work of art, find its natural outcome in the spatial *Environments* and *Happenings* of the younger artists." Johnson, Ellen H, "The Living Object", *Art International*, Vol. 7, No. 1, January 1963, p. 44.

73 Rose, "Claes Oldenburg's Soft Machines", p. 31.

74 A number of critics understood Oldenburg's early work as a powerful evocation of New York. See, for example, Johnson, "The Living Object". The *Bedroom Ensemble* was the result of a six-month stay in Venice, California. For Oldenburg's response to this environment see Rose, Barbara, *Claes Oldenburg*, New York: Museum of Modern Art, 1970, pp. 92–94.

75 This assessment is based on the close reading of Morris' development in Meyer, James, *Minimalism: Art and Polemics in the 1960s*, New Haven and London: Yale University Press, 2001. See especially pp. 162–166.

76 Robert Morris, "Notes on Sculpture, Part 2", *Continuous Project Altered Daily: The Writings of Robert Morris*, Cambridge, Massachusetts and London: MIT Press, 1995, p. 1. This essay first appeared in *Artforum* in 1966.

77 Judd, Donald, "Specific Objects", *Complete Writings: 1959–1975: Gallery Reviews, Book Reviews, Articles, Letters to the Editor, Reports, Statements, Complaints*, Halifax and New York: The Press of the Nova Scotia College of Art and Design and New York University Press, 1975, p. 181. The essay first appeared in *Contemporary Sculpture: Arts Yearbook* in 1965.

78 Judd, "Specific Objects", p. 181.

79 Judd, "Specific Objects", p. 187.

80 Oldenburg receives more attention than any other artist: see Judd, "Specific Objects", pp. 188–189. On its first publication the essay was introduced with a large reproduction of Oldenburg's *Switches Sketch* of 1964. Morris and George Brecht are also given attention at the conclusion of the essay. Yet the positions of these individuals should not be collapsed. The differences between Morris and Judd are a major theme of Meyer, *Minimalism*. Yet see also Rose, "Claes Oldenburg's Soft Machines", p. 31. In this essay the author goes out of her way to reject what she sees as artificial distinctions between certain works of Pop art and certain Minimalist pieces.

81 Greenberg, "Recentness of Sculpture", p. 252.

82 Greenberg, "Recentness of Sculpture", p. 252.

83 Greenberg, "Recentness of Sculpture", p. 254.

84 Fried, Michael, "New York Letter: Oldenburg, Chamberlain", *Art and Objecthood*, p. 279. The review was first published in *Art International* in 1962.

85 Fried, "Art and Objecthood", p. 155 and p. 148. In "Art and Objecthood" Fried distinguishes Minimalism from Pop because the former is an articulation of a position and is more than an episode in the history of taste. Nevertheless, the objection to Oldenburg's work in 1962 was also an objection to the work as merely the articulation of a position, even though Fried confesses that he cannot identify the principles involved.

86 Fried, "Art and Objecthood", p. 153.

87 Fried, "Art and Objecthood", p. 163.

88 Fried, "Art and Objecthood", p. 163.

89 Fried, "Art and Objecthood", p. 166.

90 This is not to collapse the positions of Fried and Greenberg, which differed in important respects, as is made clear in their responses to the work of Frank Stella, which Fried was able to appreciate in ways that Greenberg could not. Fried himself sets out some of the distinctions in a long footnote: Fried, "Art and Objecthood", pp. 168–169.

91 Smithson, Robert, "Letter to the Editor", *The Collected Writings*, pp. 66–67. This letter was first published in *Artforum* in October 1967 as a response to "Art and Objecthood".

92 Smithson, Robert, "Quasi-Infinities and the Waning of Space", *The Collected Writings*, p. 35.

93 Smithson, "Quasi-Infinities and the Waning of Space", p. 35.

94 Smithson, "Quasi-Infinities and the Waning of Space" p. 35. The quotations are drawn from Greenberg's essay of 1954 "Abstract and Representational". The passage cited is to found in Greenberg, *The Collected Essays and Criticism: Vol. 3. Affirmations and Refusals 1950–1956*, p. 191.

95 "Only with Smithson's work does a truly nonanthropomorphic art appear—an art that refuses to make man's visual apparatus as well as his sense of time and space a raison d'être." Hobbs, Robert, *Robert Smithson: Sculpture*, Ithaca and London: Cornell University Press, 1981, p. 108. This may also be taken to be the conclusion reached by Crow.

96 Smithson, Robert, "Interpolation of the Enantiomorphic Chambers", *The Collected Writings*, p. 39.

97 In an interesting discussion of the *Chambers*, Ann Reynolds notes that Smithson considered the works a point of departure for "all the different breakdowns within perception": see "Enantiomorphic Chambers", *Robert Smithson*, p. 140.

98 In fact, Smithson compared the *Enantiomorphic Chambers* to Graham's poetry. See Reynolds "Enantiomorphic Chambers", p. 139.

99 The work was shown in *Art in Series*, November 1967, one of a sequence of exhibitions organised by Elayne Varian at Finch College Museum of Art. The *Enantiomorphic Chambers* were shown an earlier exhibition of Varian's: *Art in Process II: The Visual Development of a Structure*, May 1966.

100 At the same time as Graham produced *March 31, 1966* he also completed *Schema*, which directly addressed the materiality of the page through a text which was a description of its physical properties. Graham discusses the opposition between physicality and scheme in an interview with Ludger Gerdes. See Graham, Dan, *Two-Way Mirror Power: Selected Writings by Dan Graham on His Art*, Alexander Alberro ed., Cambridge, Massachusetts and London: MIT Press, 1999, especially pp. 63–64.

101 *Primary Structures* opened on 26 April. Meyer argues that the exhibition served to inaugurate a season of the minimal. Smithson had one work in the exhibition, *The Cryosphere*.

102 This feature of the installation is noted in Hobbs, *Robert Smithson*, p. 74.

103 That Smithson was prepared to manipulate the sculpture during the exhibition, reorganising the relation of parts, only underlines the contingency of the work.

104 The dialogue is reprinted under the title "What is a Museum?" in Smithson, *The Collected Writings*.

105 Smithson, Robert, "Some Void Thoughts on Museums", *The Collected Writings*, pp 41–42.

106 Such accounts were heavily troped. The foundational texts for the transformation of art through the mass media remain Benjamin, Walter, "The Work of Art in the Age of Its Technological Reproducibility", *Selected Writings: Vol. 3, 1935–1938*, Edmund Jephcott et al., trans., Cambridge, Massachusetts and London: The Belknap Press of Harvard University Press, 2002, and Malraux, André, "The Imaginary Museum", *The Voices of Silence*, Stuart Gilbert trans., London: Secker and Warburg, 1956. For one series of reflections on the impact of the media on the art world of the 1960s see Rosenberg, Harold, *The Anxious Object*, Chicago and London: The University of Chicago Press, 1966, especially pp. 89–96 and pp. 197–202. The articles and essays gathered in this volume were written during the years of Pop's ascendancy.

107 Ellin, Everett "Museums as Media", *ICA Bulletin*, May 1967, p. 14.

108 Ellin, "Museums as Media", p. 14.

109 Ellin, "Museums as Media", p. 14.

110 For Kaprow's comments see Smithson, "What is a Museum?", pp. 44–45. For Ellin's see McLuhan, Marshall, Harley Parker, Jacques Barzun, *Exploration of the Ways, Means and Values of Museum Communication with the Viewing Public: A Seminar held on October 9 and 10, 1967*, sponsored by the Museum of the City of New York and the New York State Council on the Arts, New York, 1967, p. 65. This seminar was a further occasion for debates about the crisis of the museum.

111 McLuhan, Marshall, *The Gutenberg Galaxy: The Making of Typographic Man*, London: Routledge and Kegan Paul, 1962, p. 275.

112 McLuhan, Marshall, *Understanding Media: The Extensions of Man*, London: Sphere Books Limited, 1967, p. 367.

113 McLuhan, *Understanding Media: The Extensions of Man*, p. 369.

114 McLuhan, *Understanding Media: The Extensions of Man*, p. 373.

115 McLuhan, *Understanding Media: The Extensions of Man*, p. 272. For an account of the impact of McLuhan, and also an assessment of the problems with his work, see Alberro, Alexander, *Conceptual Art and the Politics of Publicity*, Cambridge, Massachusetts and London: MIT Press, 2003.

116 Parker, Harley, "The Waning of the Visual", *Art International*, May 1968, Vol. 12, No. 5, p. 28. In 1968 Parker and McLuhan published *Through the Vanishing Point: Space in Poetry and Painting*, World Perspectives, Vol. 37, New York: Harper and Row Publishers, Evanston and London, 1968.

117 Burnham, Jack, *Beyond Modern Sculpture: The Effects of Science and Technology on the Sculpture of this Century*, London: The Penguin Press, 1968, p. 172. For another discussion of the example of the electronic circuit see Meyer, Ursula, "The De-Objectification of the Object", *Arts Magazine*, Summer 1969, Vol. 43, No. 8. Such

circuits could indeed provide direct inspiration for works: see, for example, William Soya's *Kommunal Sommernat*, 1962.

[118] Burnham, *Beyond Modern Sculpture*, p. 248.

[119] Burnham, *Beyond Modern Sculpture*, p. 256.

[120] Burnham, *Beyond Modern Sculpture*, p. 256.

[121] Burnham, *Beyond Modern Sculpture*, p. 12.

[122] Burnham, *Beyond Modern Sculpture*, pp. 369–370.

[123] Burnham, "System Esthetics", p. 34. The source for this quotation is probably a passage in McLuhan, Marshall, and Quentin Fiore, *The Medium is the Massage: An Inventory of Effects*, San Francisco: Hardwired, 1967, p. 68. I have to write "probably" not only because Burnham does not provide a reference but also because McLuhan's various works contain a number of repetitions. A related statement may be found in McLuhan and Parker, *Through The Vanishing Point*, p. 7. Yet Burnham may well have been extrapolating from several points made in McLuhan, Marshall, "The Relation of Environment to Anti-Environment", *University of Windsor Review*, Vol. 1, No. 11, Fall 1966.

[124] Smithson, Robert, "Towards the Development of an Air Terminal Site", *The Collected Writings*, p. 52.

[125] Smithson, "Towards the Development of an Air Terminal Site", p. 53. Part of the stimulus for this would have come from Smithson's direct experience of other visual materials, such as maps and diagrams, when working with the architects Tippetts-Abbett-McCarthy & Stratton.

[126] Smithson, "Towards the Development of an Air Terminal Site", p. 54.

[127] McLuhan, *Understanding Media: The Extensions of Man*, p. 366.

[128] McLuhan, Parker, Barzun, *Exploration of the Ways, Means and Values of Museum Communication*, p. 9. Smithson was certainly aware of McLuhan's arguments, he refers to them in both writings and interviews. Unsurprisingly, Smithson rejected the "humanistic projection" of viewing the media as the extension of man and explicitly countered McLuhan's position with reference to Pascal. See Smithson, "Four Conversations between Dennis Wheeler and Robert Smithson", p. 210.

[129] Smithson, "Towards the Development of an Air Terminal Site", p. 55.

[130] Smithson, "Towards the Development of an Air Terminal Site", p. 55.

[131] Smithson, "Towards the Development of an Air Terminal Site", p. 55.

[132] Smithson, "Towards the Development of an Air Terminal Site", p. 55.

[133] Smithson, "Towards the Development of an Air Terminal Site", p. 55.

[134] Smithson, Robert, "Aerial Art", *The Collected Writings*, p. 116.

[135] Smithson, Robet, "Language to be Looked at and/or Things to be Read", *The Collected Writings*, p. 61. The equivocations of Smithson's title and text have a precedent in Bochner's installation *Working Drawings and Other Visible Things on Paper Not Necessarily Meant to be Viewed as Art*, December 1966.

[136] Smithson, "Language to be Looked at and/or Things to be Read", p. 61.

[137] Smithson, "Towards the Development of an Air Terminal Site", pp. 55–56.

[138] Smithson, "Towards the Development of an Air Terminal Site", p. 56.

[139] Smithson, "Aerial Art", p. 116.

[140] Nevertheless, Smithson's account of landscape and language is foreshadowed by Dan Graham's "Homes for America", *Arts Magazine*, No. 3, December 1 1966–January 1967. This work is acknowledged in Smithson, "A Museum of Language in the Vicinity of Art", p. 82.

[141] Smithson comments on this in "Interview with Moira Roth", *Robert Smithson*, p. 91.

[142] Fried, Michael, "Art and Objecthood", *Artforum*, Vol. 5, No. 10, Summer 1967, and LeWitt, Sol, "Paragraphs on Conceptual Art". On the role of Fried's essay in defining Minimalism see Meyer, *Minimalism*, pp. 242–243.

[143] Smithson would make this explicit in Smithson, "Cultural Confinement", *The Collected Writings*. See also Kurtz, Bruce "Conversation with Robert Smithson on 22 April 1972", *The Fox*, No. 2, 1975. The version of this conversation in Smithson, *The Collected Writings*, has been edited.

[144] For Smithson's views on materialism and dematerialisation see Smithson, "A Museum of Language in the Vicinity of Art", especially p. 80 and p. 84. For Andre's history see Bourdon, David, "The Razed Sites of Carl Andre", *Artforum*, Vol. 5. No. 2. October 1966, p. 15.

[145] Smithson, "A Sedimentation of the Mind: Earth Projects", p. 102. There is once again a complex history here. Smithson was in many ways an admirer of Andre and his use of the term "serenification" is perhaps relatively neutral. Yet in a later interview he would register important distinctions between his practice and that of Andre. See, Smithson, Robert, "Interview with Robert Smithson", *The Collected Writings*, p. 240.

[146] Smithson, "A Sedimentation of the Mind: Earth Projects", p. 100.

[147] Other contexts may be adduced here. For example, Dennis Oppenheim's *Sitemarkers* were doubtless important to Smithson. For Smithson's comments on the growth of interest in Earth Art at this moment, see Smithson, "Interview with Moira Roth", pp. 91–92.

[148] Smithson, "Aerial Art", p. 117.

[149] Smithson, "The Spiral Getty", p. 153.

[150] Smithson, Robert, "A Provisional Theory of Non-Sites", *The Collected Writings*, 1996, p. 364.

[151] Smithson, Robert, "A Provisional Theory of Non-Sites", p. 364.

[152] Hobbs, *Robert Smithson*, pp. 104–127. Hobbs notes that a further non-site was made by staff at the Walker Art Center in Minneapolis and then destroyed.

[153] The relationship between *Pointless Vanishing Point* and the non-sites is discussed in Hobbs, *Robert Smithson*, pp. 105–106.

[154] The nature of these materials is discussed in Hobbs, *Robert Smithson*, pp. 106–108. Hobbs cites unpublished notes by Smithson concerning one site used for the non-site, the Buckwheat Mineral Dump,

which provided ultraviolet light to allow collectors to view colours in minerals not visible in daylight. Hobbs connects this level of visibility to the range of scientific discoveries referred to above in the writings of Parker and Burnham.

155 Alberro and Norvell, *Recording Conceptual Art: Early Interviews with Barry, Huebler, Kaltenbach, LeWitt, Morris, Oppenheim, Siegelaub, Smithson, Weiner*, p. 126.

156 Alberro and Norvell, *Recording Conceptual Art: Early Interviews with Barry, Huebler, Kaltenbach, LeWitt, Morris, Oppenheim, Siegelaub, Smithson, Weiner*, p. 131.

157 Alberro and Norvell, *Recording Conceptual Art: Early Interviews with Barry, Huebler, Kaltenbach, LeWitt, Morris, Oppenheim, Siegelaub, Smithson, Weiner*, p. 130.

158 Summers, *Real Spaces: World Art History and the Rise of Western Modernism*, p. 555.

159 Summers, *Real Spaces: World Art History and the Rise of Western Modernism*, p. 556.

160 Ehrenzweig, Anton, *The Hidden Order of Art: A Study in the Psychology of Artistic Imagination*, London: Weidenfeld and Nicolson, 1967, p. 249. In the preface to this work, Ehrenzweig is cheerfully unrepentant about the somewhat haphazard organisation of his text, as it fits his subject: hidden order. Such an order resists easy summary and in what follows I have had to sacrifice much of the subtlety of his arguments.

161 Ehrenzweig, *The Hidden Order of Art: A Study in the Psychology of Artistic Imagination*, p. 103.

162 Ehrenzweig, *The Hidden Order of Art: A Study in the Psychology of Artistic Imagination*, p. 19.

163 Ehrenzweig, *The Hidden Order of Art: A Study in the Psychology of Artistic Imagination*, p. 102.

164 Ehrenzweig, *The Hidden Order of Art: A Study in the Psychology of Artistic Imagination*, pp. 102–103 and pp. 192–193.

165 Ehrenzweig, *The Hidden Order of Art: A Study in the Psychology of Artistic Imagination*, p. 171.

166 Smithson, "A Sedimentation of the Mind: Earth Projects", p. 102.

167 Smithson, "A Sedimentation of the Mind: Earth Projects", p. 102.

168 For an account of threats to the rigidity of the ego see Ehrenzweig, *The Hidden Order of Art: A Study in the Psychology of Artistic Imagination*, p. 102 and p. 190.

169 Smithson, "A Sedimentation of the Mind: Earth Projects", p. 103.

170 Smithson, "A Sedimentation of the Mind: Earth Projects", p. 111.

171 Ehrenzweig, *The Hidden Order of Art: A Study in the Psychology of Artistic Imagination*, p. 146.

172 Smithson, "A Sedimentation of the Mind: Earth Projects", p. 111.

173 Summers, *Real Spaces: World Art History and the Rise of Western Modernism*, pp. 634–635.

174 Smithson, "Earth", p. 187.

175 The full list of participants is: Jan Dibbets, Hans Haacke, Michael Heizer, Neil Jenney, Richard Long, Walter de Maria, Robert Morris, Dennis Oppenheim, Robert Smithson and Günther Uecker. De Maria and Heizer withdrew their work and so are not mentioned in the catalogue for the exhibition. On this point, and for an account of the exhibition in general, see Boettger, Suzaan, *Earthworks: Art and the Landscape of the Sixties*, Berkeley, Los Angeles and London: University of California Press, 2002, pp. 158–170.

176 Andrew Dickson White Museum of Art, *Earth Art*.

177 Levine, Les, "Systems Burn-off X Residual Software", *Software: Information Technology: Its New Meaning for Art*, New York: Jewish Museum, 1970, p. 60.

178 Levine, "Systems Burn-off X Residual Software", p. 61.

179 See, for example, his comments in Kurtz, "Conversation with Robert Smithson", and in "Conversation in Salt Lake City", *The Collected Writings*, pp. 297–300.

180 *Void* was not executed but the project was at least given a material form through a gallery installation. My account of the work is drawn from that in Celant, Germano ed., *Conceptual art arte povera land art*, Turin: Galleria civica d'arte moderna, 1970.

181 Burnham, "System Esthetics", p. 31.

182 There were of course precedents for this. The page had already been presented as an object by Yves Klein when in 1961 he had arranged to have the final sheet of an essay burnt in each issue of *Zero*. See Klein, Yves, "Truth Becomes Reality", Piene and Mack eds., *Zero*.

183 See Huebler's interview with Patricia Norvell in Alberro and Norvell, *Recording Conceptual Art: Early Interviews with Barry, Huebler, Kaltenbach, LeWitt, Morris, Oppenheim, Siegelaub, Smithson, Weiner*, especially p. 139 and p. 144.

184 Although this was not to happen: see Alberro, *Conceptual Art*, p. 133. A precursor of Siegelaub's use of the Xerox is Bochner's *Working Drawings*, which presented its materials in four binders of photocopies.

185 This was anticipated in the advertisement in *Artforum* for Huebler's November 1968 exhibition, which announced itself as one form of documentation, and as such as part of the work. The issues surrounding the advertisement are cogently presented in Alberro, *Conceptual Art*, pp. 130–133.

186 NE Thing Co. Ltd, *Trans VSI Connection NSCAD-NETCO 15 September–5 October 1969*, Halifax: Nova Scotia College of Art and Design, 1970, correspondence in chronological order.

187 NE Thing Co. Ltd, *Trans VSI Connection NSCAD-NETCO 15 September–5 October 1969*.

188 See Museum of Contemporary Art, *Art by Telephone*, Chicago, 1969. The catalogue was a gatefold album, labelled "This is a Recording" on the cover and "This is a Catalogue" when opened. It should be noted that Joseph Kosuth attempted to surpass the limits of the gallery space by making his contribution one part of an exhibition embracing 15 cities.

189 For a full account of Schum's work see Groos, Ulrike, Barbara Hess and Ursula Wevers eds., *Ready to Shoot Fernsehgalerie Gerry Schum, videogalerie schum*, Cologne: Snoeck, 2004.

190 Everson Museum of Art, *Douglas Davis: Events Drawings Objects Videotapes 1967–1972*, Syracuse, 1972, unpaginated.

191 Everson Museum of Art, *Douglas Davis*.

192 For example, all the artists referred to here exhibited in *Kunst bleibt Kunst: Aspekte internationaler Kunst am Anfang der 70er Jahre: Projekt '74* at the Cologne Kunsthalle in 1974.

193 Burnham, "Systems Esthetics", p. 34.

1964-1967

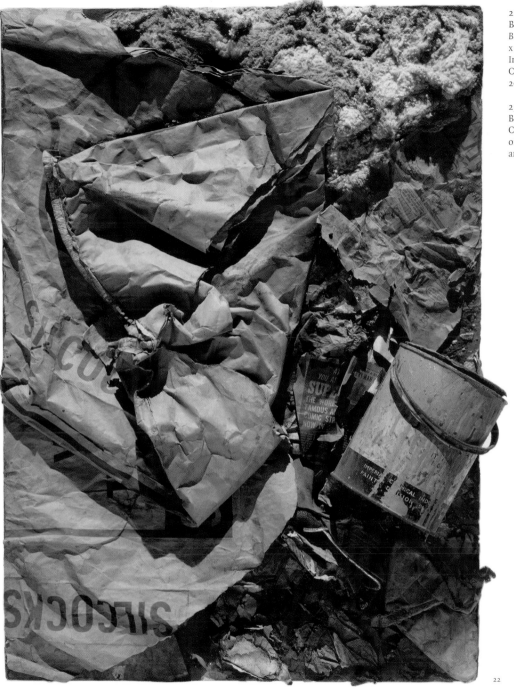

22

22
Boyle Family, *Norland Road Study (Blue Bag)*, 1964. Mixed media on board, 81.5 x 59.5 cm. Collection Boyle Family. Image courtesy of Boyle Family. Copyright Boyle Family and DACS 2008. All rights reserved.

23
Boyle Family, *Street* (event), 1964. Collection Boyle Family. Image courtesy of Boyle Family. Copyright Boyle Family and DACS 2008. All rights reserved.

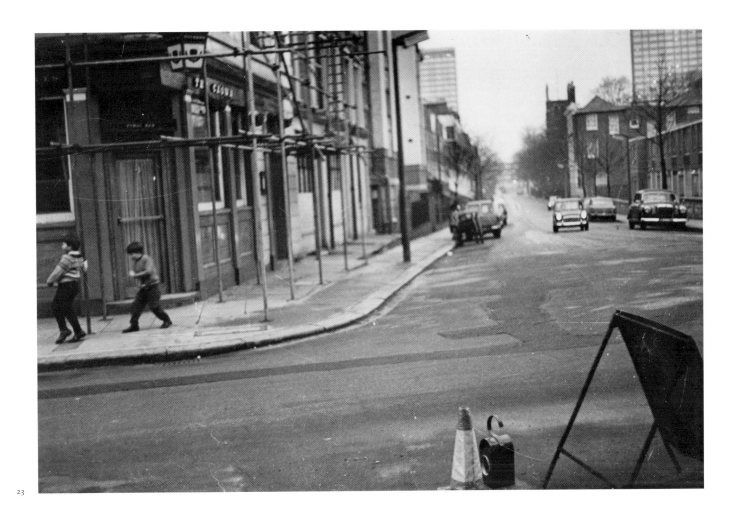

23

24
Boyle installation at Indica Gallery, London, July 1966. Image courtesy of Boyle Family. Copyright Boyle Family and DACS 2008. All rights reserved.

25
Boyle Family, *Holland Park Avenue Study, London Series*, 1967. Mixed media, resin and fibreglass, 238.8 x 238.8 x 11.4 cm. Tate. Purchased 1969. Copyright Tate 2008. Copyright Boyle Family and DACS 2008. All rights reserved.

25

SITE No.

SIX

TITLE

UNTITLED

DESCRIPTION

AN 8' x 16' ROOF SECTION WITH TWO 18"-
SQUARE OPENINGS POSITIONED IN THE CENTER
AREA. CONSTRUCTION IS WOODEN TWO-BY-
FOUR's COVERED WITH A TAR PAPER EXTERIOR.
THIS UNIT IS AT GROUND-LEVEL AND IS
BORDERED BY HIGH GRASS. THE AREA UNDER-
NEATH IS DEPRESSED EARTH, WHICH ALLOWS
FOR A SUBSTANTIAL ENCLOSED POCKET WHEREBY
ONE COULD ENTER.

LOCATION

NEAR NORTHPORT, LONG ISLAND,
SIX BLOCKS EAST OF CITY CENTER
ON ROUTE 25A ON RIGHT-HAND
SIDE OF ROAD JUST BEFORE THE
CITY LIMITS.

ARTIST — July 1968
DATE OF LOCATION HOLDER DATE OF TRANSFER

26

26
Dennis Oppenheim, *Site No. 6*, from
Sitemarkers No. 1–10, 1967. Photograph
and text. Copyright the artist 2008.

27
Dennis Oppenheim, milled aluminium
marker, from *Sitemarkers No. 1–10*, 1967.
Photograph and text. Copyright the
artist 2008.

27

28
Richard Long, installation in Frankfurt
for the exhibition 19:45–21:55,
September 1967, Frankfurt, Germany.
Reproduced in the exhibition catalogue
19:45–21:55, Galerie Dorothea Loehr,
Frankfurt, 1967. Courtesy Tate Archive.
Copyright the artist 2008.

29
Richard Long, installation near
Bristol for the exhibition 19:45–21:55,
September 1967, Frankfurt, Germany.
Reproduced in the exhibition catalogue
19:45–21:55, Galerie Dorothea Loehr,
Frankfurt, 1967. Courtesy Tate Archive.
Copyright the artist 2008.

28

29

On Location

SITES

MIRRORS AND MONUMENTS, ENTROPY IN THE EBB TIDE

WILLIAM WOOD

In an exchange published during the 1994–1995 tour of Robert Morris' retrospective, *The Mind/Body Problem*, Pepe Karmel inquired about Morris' use of mirrors in his 1968 work *Threadwaste* [Fig. 30]. Karmel suggested that, while the mirrors are "interpreted in the catalogue as citing Robert Smithson's 1968–1969 mirror pieces... there is a significant difference in that your mirrors are positioned in a simulacral rather than a real landscape".[1] But he does not really receive an adequate response. "Yes," Morris replied, following a detailed memoir concerning his encountering threadwaste as a lubricant for freight-trains in his Midwestern youth, "maybe it cited Smithson. One of the great artists of our time."[2] Further, Morris recalled of Smithson:

> He said to me once that he was citing my 1965 *Mirrored Cubes* with his *Mirror Displacements*. I thought of mirrors as a kind of 'degraded' material when I first used them. I was sick of gray surfaces. I made a pact with myself: get into the bathtub and don't come out until coming up with a new surface.... In memory that bath lasted for hours. Fingers very wrinkled upon emerging. Anyway, eureka, mirrors. Then the *Mirrored Cubes*, etc.[3]

This anecdote, a consequence of Karmel's attempt to counter the supposed "impersonality" of Morris' art through eliciting "autobiographical intimations," helps us to see some of the complexity in relations between Smithson and Morris.[4] On the one hand, the "citing" attributed to Morris' *Threadwaste* is revised and reversed with Smithson "citing" Morris' 1965 *Mirrored Cubes* instead [Fig. 31]. In addition, there is the notion of Morris, then best-known for his grey-painted plywood polyhedrons, being "sick" of that "surface" in 1965, combined with his parody of Archimedes in the bath and his interest in exploiting "a kind of 'degraded' material" by using mirrors. Finally, there is a self-deprecating remark from Morris to the effect that, since he had previously used mirrors in his 1962 work, *Pharmacy*, he could have saved himself a bath if he had thought about it, suggesting, perhaps, another series of associations with lapses of memory, wastes of time and the overall inability of anyone to answer sufficiently as to origin or influence.

Dysfunctional relations of inquiry to response occur across the exchange between Karmel and Morris, with Morris providing digressions and anecdotes, self-appraisals and moments of comic relief, but there is rarely anything quite so striking as his appreciation of Smithson as one of "the great artists of our time". We could, in turn, ask if the back-and-forth movement of the entangled citations—hinting at intimacy and mutual admiration between the two artists—is not entirely appropriate to the subject of mirrors, just as Morris' sense of them as "a kind of 'degraded' material" chimes with Smithson's extensive pursuit of entropy, that systematic degradation he seemed able to spy in all processes and institutions. In this essay, I want to explore some aspects of this entanglement of Smithson and Morris.

30
Robert Morris, *Untitled (Threadwaste)*, 1968. Threadwaste, asphalt, mirrors, copper tubing and felt, overall dimensions variable. Gift of Philip Johnson, New York: Museum of Modern Art. Copyright DACS 2008.

31

For my purposes, I want to note several things about Morris' recollection. First is the revision of citation, from Smithson's *Mirror Displacements* to Morris' *Threadwaste* to his earlier *Mirrored Cubes*, which also revises and reverses what Karmel referred to as the "significant difference" between a simulacral and a real landscape. Instead of a simulated landscape such as that called up by the low-lying multi-coloured threads spread across the gallery floor in *Threadwaste*, with the 1965 initial presentation of the *Mirrored Cubes* at the Green Gallery we are faced with what Morris referred to a year later as "literal space", a space which permitted reflection and mirroring to enhance, or perhaps degrade, "one's awareness of oneself existing in the same space as the object".[5] When Smithson began to deploy mirrors at specific sites for his *Mirror Displacements*, in the Cayuga Salt Mines and the Andrew Dickson White Museum of Art in Ithaca, New York, for the *Earth Art* exhibition, or in the photographs accompanying one of his texts to form the delirious travelogue, *Incidents of Mirror-Travel in the Yucatan* (all of early 1969) he was, in effect, dismantling Morris' cubes and putting the constituent mirrors in situations where they were either placed horizontally and partially occluded by surrounding materials or oriented vertically and shored up by soil, rocks or vegetation. Unlike the *Mirrored Cubes*, which reflected the gallery enclosure and fragmented its patrons' bodies in order to draw out "awareness" of phenomenological wholeness potentially shattered, the *Mirror Displacements* continued to point to the relation of site to gallery that Smithson had been working through with his 1968 "non-sites".[6] Through the hard-edged squares and rectangles of the mirrors and the rough, uncontained surfaces and volumes of geologic material piled on, around and under them, here "the site/non-site becomes encompassed by mirror as a concept—mirroring, the mirror becoming a dialectic" in some sort of "dialectical" relation to Morris' *Mirrored Cubes* with their simultaneous mirroring and displacing of viewers in the gallery.[7] Similarly, with Morris' *Threadwaste*, the tangled spread of an unravelled fabric of single threads was interrupted by vertically placed square mirrors (along with pieces of copper tubing, scraps of felt and lumps of tar), providing again a hard-edged reflection of an intricate and uncontained material—an unwanted residue of the garment industry—but this time placed within a gallery.[8]

I see this back-and-forth movement between mirror and material, "real" and "simulacral," site and non-site, wanted and unwanted as a way to recall something of the period that is often forgotten. When, in 1969 or so, work such as Smithson's *Mirror Displacements* began to be classified as Earth Art, Earthworks or Land Art (all terms with specific connotations), the distinction now enforced between works installed in galleries and works produced on-site was important but not decisive. Rather, art which encouraged "awareness of oneself within the same space as the object" was a matter of intensifying "awareness" of processes employed in making the work—the self-styled "Search for the Motivated" which formed the subtitle for Morris' 1970 essay "Some Notes on the Phenomenology of Making".[9] The locale itself, gallery or site, was not (yet) the determining factor. Instead, concentration on materials and the actions and placements they were subject to—especially those categorized as exemplifying "[random] piling, loose stacking, hanging, giving passing form to the material" by Morris in 1969— constituted the greater part of what counted when considering "the work's refusal to continue estheticising the form by dealing with it as a prescribed end".[10] To a large extent, this attempt to refuse "estheticising" and to refuse the art work as "a prescribed end" was what mattered and the means were variable, and up for debate.

Second, it seems that "citing" as a device is also eminently appropriate for Morris and Smithson, since both applied themselves consistently to writing and publishing as well as making art. Indeed, although artists who also publish were not all that uncommon among the Minimal artists Morris and Smithson are often associated with—Carl Andre, Mel Bochner, Dan Flavin, Donald Judd, Sol LeWitt—only Judd had as regular a publishing record; yet that record was sharply curtailed in 1965, after "Specific Objects", just at the time when Smithson and Morris began their most productive and insightful period of publication. With writing added to art work, then, there is a second type of back-and-forth movement to follow, and, as we shall see, artistic "citing" was in operation between Morris and Smithson in their work, writings and in the ways they can be seen to be dealing strategically with (and in) the art world. Smithson recorded that the two first met through Ad Reinhardt, who brought them together to organize the 10 exhibition for the Dwan Gallery early in 1966.[11] Then, in July 1966, Smithson began regular meetings with the architectural firm Tippetts-Abbett-McCarthy & Stratton acting as "artist consultant" on their plans for the air terminal of the Dallas-Fort Worth Airport in Texas.[12] Along with Andre and LeWitt, Morris and Smithson prepared models for works to be installed surrounding the terminal. With the prospect of working at a scale great enough to be visible both from the terminal building and "from arriving and departing aircraft", Morris planned an "'earth mound' circular in shape and trapezoidal in cross section... extended as much as a thousand feet", while Smithson proposed a "progression of triangular concrete pavements that would result in a spiral effect... built as large as the site would allow".[13] Both wanted to produce, at monumental scale, work whose abstract character and prepared surfaces related to their gallery based sculptural practices.[14] Though the proposed works were neither commissioned nor executed, they remain among the earliest examples of what would come to be referred to by both Morris and Smithson as *Earth Projects*. This designation for such work indicated for Smithson deliverance "from the confines of the studio... the snares of craft and the bondage of creativity", and marked the possibility of a deviation from conventional sites and conventional modes of presentation.[15]

In contrast to baleful incarceration, Smithson proposed an engagement with "geologic time" in which the "strata of the earth is a jumbled museum. Embedded in the sediment is a text that contains limits and boundaries which evade the rational order and social structure which confine art." [16] His intended target was art criticism with its "art historical limits".[17] He continued: "Critics, by focusing on the 'art object', deprive the artist of any existence in the world of both mind and matter."[18] To attempt to restore the sense of "mind and matter", he concentrated on "the consciousness of temporality" which he found both in the ruined sites of pre-history and in the "existence of the artist in time".[19] While describing a visit to Pennsylvanian quarries in service of such goals, Smithson took the opportunity to point to a sense of displacement, provoking the recognition that: "All boundaries and distinctions lost their meaning in this ocean of slate and collapsed all notions of *gestalt* unity."[20] He went on to counter this collapse of boundaries with the insistence that "if art is art it must have limits".[21] The non-site "in a physical way contains the disruption of the site".[22] Referring to the fabricated metal bins in which rocks and minerals were deposited, to be displayed with maps and texts documenting the site where Smithson had collected the materials, he spoke of the containers as representing "a three-dimensional map" and again stressing

displacement, noted: "Without appeal to *gestalts* or 'anti-form', it actually exists as a fragment of a greater fragmentation." [23] These references to *gestalts* are obvious criticisms of Morris' "Notes on Sculpture", much as the direct mention of "anti-form" cannot but refer to Morris' 1968 essay of that title.

The opposition here is straightforward. Morris had written in 1966 of how "the concerns of sculpture have been for some time not only distinct but hostile to that of painting", since "the sculptural facts of space, light, and materials have always functioned concretely and literally", whereas painting was involved with illusion and opticality, most explicitly in Clement Greenberg's theory of art. [24] In this skirmish over media, Morris wanted to endorse a type of sculpture which produced awareness of shape in contrast to interest in other aspects of the work such as parts, colour, composition, texture. He wrote of how "simpler forms... create strong gestalt situations. Their parts are bound together in such a way that they offer maximum resistance to perceptual separation. In terms of solids, or forms applicable to sculpture, these gestalts are the simpler polyhedrons". [25]

Further, by listing "beams, inclined planes, truncated pyramids" as forms which "are relatively more easy to visualise and sense as wholes", Morris was reinterpreting the work he had been displaying in recent years, the grey plywood works such as *Untitled (Two L Beams)*, 1965, *Untitled (Battered Cubes)*, 1965, and his much spoken-of Green Gallery installation of 1964–1965. [26]

Smithson's objection to the talk of *gestalt* and "wholeness" was part of his rejection of "the question of form" altogether. Early in 1969, he stated:

> My things don't offer any kind of freedom in terms of endless vistas or infinite possibilities. There's no exit, no road to utopia, no great beyond in terms of exhibition space. I see it as an inevitability: of going to the fringes, towards the broken, the entropic.... It isn't a question of form or anti-form. I'm not all that interested in the questions of form and anti-form but in limits and how these limits destroy themselves and disappear. [27]

When Morris extolled "wholeness" or tried to base the issue of "anti-form" on the notion that the "process of 'making itself' has hardly been examined" and that form is "perpetuated by preservation of separable idealised ends" my argument would be that Smithson thought Morris was not going far enough towards the broken, the entropic, even through Morris "cited" Smithson by calling the perpetual idealism he deplored "an anti-entropic and conservative enterprise." [28] In a context in which "examining" and "wholeness" were stressed, a road ahead appeared to be already laid out, made inevitable, and, indeed, the first of Morris' "Notes on Sculpture" published in 1966 concluded by stating that "shape" and "greater unification" establish "a new limit and a new freedom for sculpture". [29] Similarly, the penultimate sentence of "Anti Form" reads: "Disengagement with preconceived enduring forms and orders for things is a positive assertion." [30] With this, Morris appeared to attempt to ameliorate his otherwise radical claims by pointing to an inevitable "freedom" and making a progressive, "positive assertion" while, quite clearly, Smithson wanted to stress the negative confines of artistic practice and to luxuriate in the desire to see these limits "destroy themselves and disappear", collapsing into that greater fragmentation.

Besides simple disagreement between two artists acutely aware of position-taking in the contested New York art world, there may be something more here that diverges from the usual tale of Minimal art's "broad rationality" and admiration for the "reasonableness of the well built" gradually ceding place to the utopian claims offered by talk of the post-studio condition of Earth Projects or Land Art.[31] Instead of that tale of "new freedom" and "positive assertion," the back-and-forth between Smithson and Morris involved a partial recognition of a repetitive, unceasing critical drive. That drive, which Smithson first "cited" after seeing Morris' early work and which then came to be adopted later by Morris in his writing and working, was a way of going not just "beyond objects" but towards a recognition of an ending.[32] As Morris had it in 1973, over the 1960s and early 1970s, a "phase of art ends".[33] He continued:

> It foundered partly on the contradictions of a negating, critical enterprise transforming itself into one of bland production. Its success was its undoing, the notion of 'professional artist' is a contradiction in terms for any avant-garde position. Other corners of the edifice crumbled because the underlying epistemology of the accompanying discourse was so rotten with historicism.[34]

We should be familiar enough with the waning of Modernist criticism to grasp Morris' meaning. Yet his rejection of "historicism" is not merely a repudiation of Modernist criticism and its foundations but also an acceptance and an assertion on his part that the art of the 1960s was, by and large, "open and had an impulse for public scale, was informed by a logic in its structure, sustained by a faith in the significance of abstract art and a belief in an historical unfolding of formal modes that was very close to a belief in progress".[35] Yet this situation was to collapse. Midway into the 1970s and, incidentally, following Smithson's death in June 1973, Morris found that, for contemporary art, "the private replaces the public impulse", redefining space in close-held, "private" terms.[36] "Deeply skeptical about experiences beyond the body" and equally "skeptical of participating in any public art enterprise", such art was far removed from the faith in "progress" which Smithson admonished and Morris had now surely abandoned.[37]

Such an account may be said to situate Morris' grey polyhedrons and the "Notes on Sculpture" in the contingencies of their mid-1960s production between what he would call formalism and phenomenology, but Morris may have misrecognised or unwittingly misrepresented what his grey surfaces could have meant in the mid-1960s. From the above, he seemed in the 1970s to have considered the polyhedrons, with their "gestalt" shapes and their engagement with "actual space", to have participated in the "impulse for public scale" and so to have shared the "faith in the significance of abstract art" which that impulse suggested. Smithson, however, had experience of a different character. In "Entropy and the New Monuments", his 1966 survey of an expanded *cadre* of "minimal" artists including Morris, the entire group was enlisted in a programme distinctly antipathetic to any public impulse or belief in progress. "Instead of causing us to remember the past like old monuments, the new ones cause us to forget the future.... They are not built for the ages but against the ages."[38] Within this contrary framework, Smithson wrote of Morris in two registers: first as an ironically "gifted artist" inspired by "the dullness and vapidity" of contemporary interior design given over to "consumerist oblivion"; second as an artist some of whose work—the "wall structures" in particular—were cited as "direct homages to Duchamp".[39] Smithson was referring to

the reliefs which Kimberly Paice in *Robert Morris: The Mind/Body Problem* classifies as *Leads* and dates as appearing first in 1963.[40] These works were made of lead sheet over particle board and sculpt metal over plaster casts, as well as incorporating various forms of "found object". Inset lead batteries, remnants of electrical wire, and a truck's side mirror with the mirror facing the relief's major plane, all would fit within the generous category of assemblage, with noticeable references to Jasper Johns in the use of casts and found objects.[41] Ever clever and perversely historicist, Smithson picked up on such allusions—as well as the alchemical associations of lead and Marcel Duchamp's ascribed fondness for that pseudo-science—in order to link Morris to Duchamp by way of viewing the *Leads* in terms of "many types of stillness: delayed action, inadequate energy, general slowness, an all over sluggishness" that related broadly to the notes for the *Large Glass* in Duchamp's *Green Box*.[42] All in all, the *Leads* came with the proper aesthetic pedigree to be considered neither Minimal art nor as "specific objects" but had a distinctive Neo-Dadaist or even camp aspect to which Smithson—certainly in his drawings and collages—was also partial. As if to further establish a distance from the "gestalts" of the plywood polyhedrons, Morris initially presented a series of *Leads* in New York at the Green Gallery in 1965; in the middle of the gallery stood the four *Mirrored Cubes* reflecting the grey surfaces of the *Leads* as well as the discomposed bodies of spectators. This juxtaposition of *Leads* and *Mirrored Cubes* was predicated, if we accept Morris' retrospective comment in 1995, on his being "sick of gray surfaces" in 1965, a disease which spoke to a less than "positive assertion" regarding *gestalts* and the limits of sculpture.

In a similar vein, when Morris is mentioned in Smithson's "A Museum of Language in the Vicinity of Art" in 1968, after the three instalments of the "Notes on Sculpture" had been published, it is not Morris' essays that are "cited" but his *Card File* of 1962, a work in which was recorded on index cards all of the actions and events that went into the production of *Card File*. Smithson revelled in the absurdist quality of this extreme example of self-reference and reflexivity:

> Robert Morris enjoys putting sham 'mistakes' into his language systems. His dummy
> [*Card*] File for example contains a special category called 'mistakes'. At times, the artists
> admits it is difficult to tell a real mistake from a false mistake. Nevertheless, Morris likes
> to track down the irrelevant and then forget it as quickly as possible. Actually he can barely
> remember doing the File.[43]

These remarks remind us that, already in 1968, someone as attentive as Smithson did not value the Morris refracted through the apparently earnestly hopeful and potentially freeing (as well as limiting) statements of "Notes on Sculpture". Rather, an "anarchic" Morris, the one who produced *Leads* and *Mirrored Cubes* while making plywood *gestalts*, the one who made not just *Card File* but the equally absurdly reflexive *Box With the Sound of its Own Making* in 1962, the Morris who continued to produce grey surfaces in artisanal workshops and fabricated of fibreglass and painted steel after supposedly becoming sick of them, this was the Morris Smithson thought worth highlighting.[44] One could surmise that to Smithson's sure and disenchanted eye even the plywood works could be assimilated to the broader category of "hyper-prosaism" which he saw as "inspired by the vapid and the dull".[45] These pieces also puzzled Donald Judd, who noted: "Morris'

works are minimal visually, but they're powerful spatially. It's an unusual asymmetry."[46] It might well have been the displacement inherent in such "asymmetry" that Smithson sensed in *Mirrored Cubes*, to the extent that he emulated and disassembled that work to make his series of *Mirror Displacements*.

David Antin has described the type of irregularity sensed by Judd and Smithson as recurring across Morris' career and refers to two specific reactions. One is that Morris is what Roberta Smith of *The New York Times* notoriously called "an artistic kleptomaniac" or, as Philip Leider, *Artforum*'s founding editor, held: "What little kids call a 'copycat'".[47] The accusation was that Morris visited other artists' studios, saw their work and subsequently made work close to that which he had seen. This was most obvious with "delayed action" when he spent some months in Düsseldorf in 1963 making *Leads* to show at Galerie Schlema, and, after some contact with Joseph Beuys, came out with *Felts* of his own in 1967. (Here, certainly, the logic of the "kleptomaniac" is tempered by the four-year time lag and the distinctly different use of felt, by Beuys as therapeutic symbol and by Morris as process-material.) The second, less pathological version, according to Antin, is that the overall shape of Morris' career does not share the "persistence" of his contemporaries—Judd and Flavin, for example, who began working with almost all of the materials, forms and structures of their entire *oeuvres* by 1966—and this has encouraged an innate distrust of Morris. The "persona that emerges from Morris' body of work is fairly consistent—that of a restless, ironic and intellectual artist who engages with whatever surrounding discourses happen to interest him and leaves them as soon as they cease to interest him".[48] I would like to propose that the tag of "restless, ironic and intellectual" would apply equally to Smithson as an artist and that, partly due to his early death and consequently relatively small corpus of work, he tends to be regarded as developing coherently while, in the six or seven years of his mature production, fault lines can be spotted readily enough.

Indeed the "restless" character shared by Morris and Smithson is notable in their respective activities centring on the years between 1968 and 1970. Just as with his *Felts* Morris ostensibly repudiated the rigid and "well built" for the ductile and gravitationally responsive, so it was he who eliminated the confining container when he displayed pieces such as *Threadwaste* and the even more diverse and eccentric *Dirt*. This later work was first produced for the Dwan Gallery *Earth Show* in October 1968; Morris brought together, on a large plastic sheet laid out on the floor, a ton of soil mixed with peat moss and a flow of grease, along with randomly scattered bits and pieces of felt, assorted metal wires, rods and piping.[49] It was like introducing a building site into the gallery, admitting a stain or a smear on the white-walled interior. In the same exhibition, Smithson exhibited his contained *Non-site (Franklin, New Jersey)* and Walter de Maria a version of his similarly contained *Pure Earth*. In terms of "citing", then, it might also be pertinent to note that it was following this presentation that Smithson began his more nomadic and uncontained works such as the *Mirror Displacements* and his broken glass works, as well as his exploration of material flows in works like *Asphalt Rundown* and *Glue Pour* and his various proposals for pouring concrete, mud and paint.[50] All of these attest not merely to Smithson's ingenuity, his seeking out "limits" to "disappear" and his move to exceed the confines of the "site to non-site" relation, but were, moreover, in productive and critical dialogue with Morris' gallery-sited example.

Morris, meanwhile, enacted works that, like *Threadwaste* and *Dirt*, remain spatially bound to gallery-like conditions whilst defying strict boundaries. Whereas Smithson moved from the artisanal commissions of "minimal" fabrication to the deployment of industrial materials and the technology of dump trucks and earthmovers, Morris returned to his performing past in works such as *Continuous Project Altered Daily*, his March 1969 three-week residency in the Leo Castelli Warehouse in northern Manhattan.[51] Here Morris effectively re-staged the sort of materials and processes used in *Dirt* in terms compatible with his *Untitled (Stadium)*, a modular sculpture that had been presented through a series of permutations over the month of March 1967 in Castelli's uptown gallery.[52] Whereas that work had been accompanied by a poster giving the schedule of permutations, Morris' improvisation with his non-rigid materials in *Continuous Project Altered Daily* meant that the stages of the work were documented through photographs, 12 in all were ultimately pinned to the wall. Viewers who traveled up to the West 108th Street storage depot could see the current state and the past states Morris had realised, while the material was removed at the end of the period and no final piece resulted.[53] As with the later, ephemeral *Asphalt Rundown* or *Glue Pour*, that Smithson presented and had documented, the impermanence of *Continuous Project Altered Daily* was a function of extending process not merely to materials but to the "consciousness of temporality" which Smithson advanced as being "worth as much as a finished product".[54]

★

The final pairing between Morris and Smithson in 1969 and 1970 that I want to look at directly involves their respective *Earth Projects*. As is well known but often misrepresented, Smithson planned *Island of Broken Glass* for a site in Georgia Strait near Nanaimo, British Columbia, Canada.[55] Miami Islet was selected, a small outcrop set among lightly populated islands on a passage regularly traversed by commercial boats and pleasure craft; government permission for the work was secured in December 1969. With delivery of "100 tons of green-tinted industrial glass" from Stockton, California, expected for 2 February 1970, the intent was to cover the islet with glass dumped from a crane and further smashed by the artist.[56] While Smithson had executed a smaller *Map of Broken Clear Glass (Atlantis)* in Loveladies, New Jersey, during the summer of 1969 as a temporary work, *Island of Broken Glass* was intended to be his first *Earth Project* that would have a more sustained existence [Fig. 32]. Sustained but not permanent, since one aim of the work was to have the glass slowly be washed and eroded by the action of the sea, so that the fused silica would inevitably return to its primary locale having traveled the long route through human manipulation, commoditsation and containerisation towards dispersion and "de-differentiated" consciousness via Smithson's administration.

6 tons
of clear
glass

TOP VIEW

MAP OF BROKEN GLASS
(ATLANTIS)

after Scott Elliot

SIDE VIEW

32
Robert Smithson, *Map of Broken Glass
(Atlantis)*, 1970. Graphite and collage
on card, 41.4 x 35.2 cm. Collection of
the Vancouver Art Gallery, Permanent
Collection Fund, VAG. Photograph: Trevor
Mills, VAG. Copyright Estate of Robert
Smithson, DACS and VAGA, 2008.

32

In conversations with critic and filmmaker Dennis Wheeler, recorded in December
1969 and early January 1970 in Vancouver, Smithson also spoke of plans to complete
a number of projects at the Anaconda Copper Mine at Britannia Beach, just north of
Vancouver, in addition to executing *Island of Broken Glass*. Those proposals included
paint flowing out of mine shafts and a probably unrealisable plan to build a cinema in
a cavern deep within the mine. In evident reverie over these works, Smithson describes
how his thoughts,

> … are like an avalanche in the mind, in the sense that they are breaking apart, there's no
> information that can't be collapsed or broken down, so that it's not a matter of establishing
> a perfect system. There is no perfection in this situation. There is no perfection in my
> range, because my thoughts as well as the material I'm dealing with are always coming
> loose, breaking apart and bleeding at the edges. There's no attempt to finalise into a static
> concept—rather if I am interested in concepts, the concepts are so much sludge collapsing
> down the side of my mind.[57]

Such identification of the human mind with inanimate materials—especially with
Smithson's bizarre imagery of bleeding "thoughts" and of "sludge" emanating from his

mind—highlights a important aspect of his work and writing which is often neglected but which may, ironically, have been instrumental in the project of *Island of Broken Glass* being indefinitely postponed by the Province of British Columbia.

I mean to point to Smithson's jagged anti-humanism and the gangly fatalism espoused through his thorough immersion in the metaphors of rundown, dispersion, entropy and exhaustion. This dystopian vision was contradicted by a lofty and exaggerated exaltation of the artistic calling. When the *Island of Broken Glass* project was publicised in the regional media, local and provincial environmental groups began campaigning against the work and successfully encouraged citizens to write to, telegraph and telephone the Ministry of Lands, Forest and Water Resources to protest. Although British Columbians have long had (and continue to have) a deeply ambivalent relation to nature and to natural resources—the province's economy has consistently been tied as tightly as possible to the competing and contradictory aims of resource extraction and tourist attraction—the late 1960s and early 1970s were a particularly acute period of both ecological and anti-American sentiment. Many of the objections to Smithson's project combined these two factors. One letter of protest admonished officials, "don't let yourself be conned into permitting the dumping of US garbage in BC"; another suggested that the artist was using "broken bottles" so that the result would "be just like any average Yanky [sic] public park".[58] In an undated, bristling retort (sensibly not published until after his death), Smithson compared the environmentalists to National Socialists, suggested that some of them were "suffering from a Nationalist castration complex", and claimed that his art was being made the "scapegoat" for a society of "hypocrites", ultimately claiming that: "The sick smell of dead religion hangs over the ecological mania."[59] While all this is debatable, what is striking is Smithson's staunch defence of his art: "Out of the self-awareness gained by putting dreadful questions to the world, art achieves its dignity.... Art is not an escape, a party, or distraction, but a painful awakening into a terrible arraignment".[60]

He concluded with the sobering line: "The island is not meant to save anything or anybody but to reveal things as they are."[61] The controversy went on until, on 27 January, 1970, Minister Ray Williston telegraphed Douglas Christmas, Smithson's Vancouver dealer, saying that Christmas and Smithson: "GAVE ASSURANCE PROJECT WAS FOR THE BETTERMENT OF THE PUBLIC STOP SINCE THIS IS NOW EVIDENTLY MOST QUESTIONABLE YOU ARE DIRECTED TO HOLD THE MATTER ABEYANCE."[62]

⋆

Of course, the type of project Smithson wanted to realise probably had to sail under the flag of convenience offered by claims to serve "THE BETTERMENT OF THE PUBLIC". Yet, in line with Morris' later mordant recognition that the "public art enterprise" of the 1960s had passed so that the "private replaces the public impulse", *Island of Broken Glass* was now "EVIDENTLY MOST QUESTIONABLE" due to the critical drive which entailed a "terrible arraignment" perplexingly indicting, in the name of art's "self-awareness" and "dignity", the very public whose "BETTERMENT" would not have been furthered by Smithson's project.

Perhaps one could also spy an alertness to the vagaries of the public in the suite of ten lithographs Morris produced late in 1969 under the title *Earth Projects*. Each print features a portion of the United States Geographical Survey quadrangle maps of the state of Missouri—Morris was born in Kansas City, Missouri—with technical drawings locating the site and sectional details of the planned project. More forthrightly than Smithson, whose *Island of Broken Glass, Asphalt Rundown* and *Glue Pour* attempted some accommodation for the meeting of the industrial and natural within peripheral areas, Morris' *Earth Projects* sought to bring disorienting, technically spectacular effects to the countryside. Among the projects are relatively tame proposals to create a regular series of alternating mounds and trenches over a mile area and another to make a series of regularly gridded, alternating piles and pits of stones, but there are also proposals that four jet engines be installed just above level height in order to produce an ongoing circular dust storm (*Dust*), and that a 400 by 600 foot square area be dug up and concrete pads be placed six inches beneath the surface. In this piece, titled *Vibration*, the proposition is that beneath the concrete pads a series of vibrating engines be placed so that the ground itself would continually move. In perhaps the most outrageous project, *Burning Petroleum*, Morris proposed to provide the means to turn the surface of a stream near Liberal, Missouri, into a perpetual firestorm.

Morris' *Earth Projects* lend a sardonic, if not apocalyptic, tenor to the generally ameliorative atmosphere surrounding Earthworks and Land Art. For, as Morris noted in 1973's "Some Splashes in the Ebb Tide": "Much recent work appropriates both natural and cultural processes. What is judged as a lack of nerve, as flaccidity and weakness in such work, is precisely its deliberate abandonment of heroic refusals."[63] Many such proposals were indeed flaccid and weak, whereas, to the contrary, Morris and Smithson were anti-heroic while also appearing overly hubristic in their plans. For the "restless" Morris, messing about between heroics and ironies seems to have been seriously in play in the late 1960s, with the "anarchic" element of his character overwhelming the seemingly "well built" artistic persona all too often associated with his "minimal art". Meanwhile, despite Smithson's investment in the shadow of the tradition of American truth-telling—evident in his appeal to art's "self-awareness gained by putting dreadful questions to the world"—he saw such questioning as corrosive and in league with the forces of scattering and crumbling he ascribed to a totalised vision of all structured formations coming to ruin, something not hard to discern in the New York of the early 1970s. From this point of view, *Island of Broken Glass* would indeed "reveal things as they are" inasmuch as the shards of glinting glass in the water might act as a kind of "ruin in reverse" for the crystalline towers of the urban skyline returned to their constituent parts, leaving entropic waste as remainder.

Underpinning this joint move to exceed confines and containers, confound heroics and dismantle structures is what Smithson referred to as "a dialectics that seeks a world outside of cultural confinement", in order for the artist, according to Morris, "to engage more directly with the world".[64] This sounds as if they were in agreement yet, once again, the two were in back-and-forth motion. By 1972, when he published "Cultural Confinement" as his contribution to both the catalogue and exhibition *Documenta 5*, Smithson was now absolutely against gallery display. Besides describing how cultural confinement "takes place when a curator imposes his own limits on an art exhibition, rather than asking an artist to set his limits", he indicted the type of work Morris had

been pursuing: "I am not interested in art works that suggest 'process' within the metaphysical limits of the neutral room.... Confined process is no process at all. It would be better to disclose the confinement than make illusions of freedom".[65]

Whether Morris truly had promulgated such "illusions" in his early writing is arguable, but his published writing and his work after 1967 is a deliberate—for some, as Antin observed, too deliberate—attempt to signal aspects of solidarity with the positions Smithson articulated. In 1967, Morris was comfortable with the relative "flaccidity" of this sort of affirmation. He could write: "Such work that has the feel and look of openness, expendability, accessibility, publicness, repeatability, equanimity, directness, and immediacy, and has been formed by clear decision rather than groping craft would seem to have a few social implications, none of which are negative".[66]

After toing-and-froing with Smithson, however, and with some tempering, Morris suggested in 1973 that perhaps "no social value can now be assigned to art in any of its forms" because any expectation of "hope for coherent art that would be broadly based in the culture is completely deluded".[67] This is surely a bleak conclusion, but it is consistent with Morris' conviction that what had occurred in art over the previous decade was the result of "a negating, critical enterprise transforming itself into one of bland production". Note the importance of the word "negating" here. In a similar fashion, the "social implications" of his polyhedrons are described in "Notes and Non Sequiturs" not as having some immediate "positive" aspect; rather they are described as having qualities "none of which are negative", perhaps implying some not quite workable programme arising from the activity.

Such a desire for release from "confinement" or the recognition that hope for "an art broadly based in the culture" was delusional may be seen to have been produced out of the immediate context of the fragmented political and social milieu of late 1960s America or as a precognition of the arrival of Postmodernism.[68] It might also, equally, show up a situation, mirror-like and reversed, whereby what appears to be a "real" landscape—that is, the stuff of materials, processes and technological manipulation in Earth Projects—is physically present but, we might say, psychically simulated to form a screen for a set of projections. Those projections, always at play in the oscillations between Morris and Smithson, may have arisen from wishes for "a new limit and a new freedom" for art or may reject the very notion of there being "limits", seeing the acceptance of limitations as a trap leading to the "road to utopia". Yet such projections are also present in embraces of the energies of negation and stand behind art as a "painful awakening". Awakening to what? Recognising a relentless, impossible and contradictory drive behind Morris and Smithson, we need to understand that drive as an attempt to remake art as well as a way to "disappear" art's "confines" in order to disavow its recent past. Emphasising the tension inherent in such projections, it might be possible to understand why it was necessary for the Mirrored Cubes to be set up in the gallery. Their dispersal into pieces like Threadwaste and their recurrence in the ephemeral sitings of the Mirror Displacements could at once situate a space in which towork and constitute a reflected elsewhere where the quiet dissolution of the "public art enterprise" could occur.

ENDNOTES

Research for this essay was funded through the HSS Hampton Fund of The University of British Columbia and aided by the assistance of Rebecca Lane.

[1] Karmel, Pepe, "Robert Morris: Formal Disclosures", *Art in America*, Vol. 83, No. 6, June 1995, p. 95.

[2] Karmel, "Robert Morris: Formal Disclosures", p. 117.

[3] Karmel, "Robert Morris: Formal Disclosures", p. 117.

[4] Karmel, "Robert Morris: Formal Disclosures", p. 88.

[5] Morris, Robert, "Notes on Sculpture, Part 2", *Continuous Project Altered Daily: The Writings of Robert Morris*, Cambridge, Massachusetts and London: MIT Press, 1995. This essay first appeared in *Artforum* in 1966.

[6] Smithson, Robert, "Smithson's Non-Site Sights: An Interview with Anthony Robbins", *The Collected Writings*, Jack Flam ed., Berkeley, Los Angeles and London: University of California Press, 1996, p. 175. This interview first appeared in *Art News*, 1969.

[7] Smithson, Robert, "Fragments of a Conversation", *The Collected Writings*, p. 190.

[8] For an account of the uncontained see Ehrenzweig, Anton, *The Hidden Order of Art: A Study in the Psychology of Artistic Imagination*, London: Weidenfeld and Nicolson, London, 1967.

[9] Morris, Robert, "Some Notes on the Phenomenology of Making: The Search for the Motivated", *Continuous Project Altered Daily*, p. 71. This essay first appeared in *Artforum* in 1970.

[10] Morris, Robert, "Anti Form", *Continuous Project Altered Daily*, p. 46.

[11] Smithson, Robert, "Interview with Robert Smithson for the Archives of American Art/Smithsonian Institution", *The Collected Writings*, p. 290. Besides those three and the four artists listed above, painters Jo Baer and Agnes Martin and Michael Steiner made up the roster. See Meyer, James, *Minimalism: Art and Polemic in the Sixties*, New Haven and London: Yale University Press, 2002, p. 202.

[12] Smithson, Robert, "Towards Development of an Air Terminal Site", *The Collected Writings*. This essay was first published in *Artforum* in 1967.

[13] Smithson, Robert, "Aerial Art", *The Collected Writings*, p. 117–118.

[14] Morris' model for the mound was executed in polished plaster and later cast in gleaming acrylic. See Paice, Kimberly, "Dirt 1968", Thomas Krens ed., *Robert Morris: The Mind/Body Problem*, New York: Solomon R Guggenheim Foundation, 1994.

[15] Smithson, Robert, "A Sedimentation of the Mind: Earth Projects", *The Collected Writings*, p. 107. This essay was first published in *Artforum* in 1968.

[16] Smithson, "A Sedimentation of the Mind: Earth Projects", p. 110.

[17] Smithson, "A Sedimentation of the Mind: Earth Projects", p. 110.

[18] Smithson, "A Sedimentation of the Mind: Earth Projects", p. 112.

[19] Smithson, "A Sedimentation of the Mind: Earth Projects", p. 112.

[20] Smithson, "A Sedimentation of the Mind: Earth Projects", p. 110.

[21] Smithson, "A Sedimentation of the Mind: Earth Projects", p. 111.

[22] Smithson, "A Sedimentation of the Mind: Earth Projects", p. 111.

[23] Smithson, "A Sedimentation of the Mind: Earth Projects", p. 110.

[24] Morris, Robert, "Notes on Sculpture", *Continuous Project Altered Daily*, p. 3.

[25] Morris, "Notes on Sculpture", p. 6.

[26] See Paice, Kimberly, "Early Minimalism" and "Green Gallery Show, 1964–1965", *Robert Morris: The Mind/Body Problem*.

[27] Smithson, "A Sedimentation of the Mind: Earth Projects", p. 191.

[28] Morris, "Anti-Form", p. 43–45.

[29] Morris, "Notes on Sculpture", p. 8.

[30] Morris, "Anti-Form", p. 46.

[31] On rationality and the well built see Morris, "Anti-Form", p. 41.

[32] Morris, Robert, "Notes on Sculpture, Part 4: Beyond Objects", *Continuous Project Altered Daily*. This essay first appeared in *Artforum* in 1969.

[33] Morris, Robert, "Some Splashes in the Ebb Tide", *Continuous Project Altered Daily*, p. 141.

[34] Morris, "Some Splashes in the Ebb Tide", p. 141.

[35] Morris, Robert, "Aligned with Nazca", *Continuous Project Altered Daily*, p. 172. This essay first appeared in *Artforum* in 1974.

[36] Morris, "Aligned with Nazca", p. 173.

[37] Morris, "Aligned with Nazca", p. 173.

[38] Smithson, Robert, "Entropy and the New Monuments", *The Collected Writings*, p. 11.

[39] Smithson, "Entropy and the New Monuments", p. 13 and p. 19.

[40] Paice, Kimberly, "Leads", *Robert Morris: The Mind/Body Problem*. Although there is also a section dedicated to "The Duchamp Connection" (pp. 112–121), the works here are not easily understood as "wall structures".

[41] The Museum of Modern Art held the exhibition consolidating such work in 1961. See Seitz, William C ed., *The Art of Assemblage*, New York: Museum of Modern Art, 1961.

[42] Smithson, Robert, "Entropy and the New Monuments", p. 19. See also Hamilton, George Heard, and Richard Hamilton, *The Bride Stripped Bare by Her Bachelors, Even... A Typographical Version By Richard Hamilton of Marcel Duchamp's Green Box*, New York: Wittenborn, 1960.

[43] Smithson, Robert, "A Museum of Language in the Vicinity of Art", *The Collected Writings*, p. 80.

[44] Rosalind Krauss notes: "When I got to know Bob [Morris] he used to talk of the ethos of Minimalism in terms of a kind of joy in destruction and the pleasure of completely anarchic gestures." Newman, Amy: *Challenging Art, Artforum 1962–1974*, New York: Soho Books, 2000, p. 238.

45 Smithson, "Entropy and the New Monuments", p. 16.

46 Judd, Donald, "In the Galleries: Robert Morris", *Complete Writings: 1959–1975: Gallery Reviews, Book Reviews, Articles, Letters to the Editor, Reports, Statements, Complaints*, Halifax and New York: The Press of the Nova Scotia College of Art and Design and New York University Press, 1975, p. 165.

47 Smith, Roberta, "A Hypersensitive Nose for the Next Big Thing", *The New York Times*, 20 January 1991, Section H, Leider, Philip, in Newman, *Challenging Art*, p. 236.

48 Antin, David, "Have Mind, Will Travel", *Robert Morris: The Mind/Body Problem*, p. 48.

49 See Paice, Kimberly, "Dirt", p. 230. One might also speculate that Morris reacted with great speed to Smithson's query in "A Sedimentation of the Mind: Earth Projects": "What then is one to do with the container?" in as much as Smithson was citing Morris' claim in "Anti-form" that the paint brush devolves into Pollock's stick and further into Morris Louis's pouring of paint from a can. See Smithson, p. 102, and Morris, "Anti-Form", pp. 43–44.

50 For a detailed examination of Smithson's flows and glass works, see Arnold, Grant, ed., *Robert Smithson in Vancouver: Fragmentation of a Greater Fragmentation*, Vancouver: Vancouver Art Gallery, 2004.

51 Paice offers examples of Morris' 1960s performances: *Arizona*, 1963, *Site*, 1964, and *Waterman Switch*, 1965, *Robert Morris: The Mind/Body Problem*.

52 Paice, "Permutations" and "Continuous Project Altered Daily". For a psychoanalytic reading of *Dirt* and *Continuous Project Altered Daily* see Taylor, Brandon, "Revulsion/Matter's Limits", *Sculpture and Psychoanalysis*, Aldershot: Ashgate, 2006.

53 *Continuous Project Altered Daily*, a fold-out series of the photographs Morris took of the piece, was published as an artist's multiple by *Multiples, Inc.* in 1970 as part of a portfolio titled *Artists and Photographs*.

54 Smithson, "A Museum of Language in the Vicinity of Art", p. 112.

55 Once again, the most complete source is Arnold, *Robert Smithson in Vancouver*. See also, Stimson, Blake, "An Art and Its Public—A Public and Its Art: Robert Smithson versus the Environmentalists", *Collapse*, No. 2, 1996.

56 Arnold, *Robert Smithson in Vancouver*, p. 17.

57 Smithson, Robert, "Four Conversations Between Dennis Wheeler and Robert Smithson", *The Collected Writings*, p. 202.

58 Arnold, *Robert Smithson in Vancouver*, p. 24.

59 Smithson, Robert, "A Rejoinder to Environmental Critics", *Collapse*, No. 2, 1996, p. 124.

60 Smithson, "A Rejoinder", p. 124.

61 Smithson, "A Rejoinder", p. 124.

62 Arnold, *Robert Smithson in Vancouver*, p. 24.

63 Morris, "Some Splashes in the Ebb Tide", p. 140.

64 Smithson, Robert, "Cultural Confinement", *The Collected Writings*, p. 155 and Morris, "Some Notes on the Phenomenology of Making: The Search for the Motivated", p. 92.

65 Smithson, "Cultural Confinement", p. 155.

66 Morris, Robert, "Notes on Sculpture, Part 3: Notes and Non Sequiturs", *Continuous Project Altered Daily*, p. 33.

67 Morris, "Aligned with Nazca", pp. 137–138.

68 The later option is discussed in Foster, Hal, "The Crux of Minimalism", *The Return of the Real*, Cambridge, Massachusetts and London: MIT Press, 1996.

1968–1969

33–34
Carl Andre, *Untitled*, 1968. From *Carl Andre, Robert Barry, Douglas Huebler, Joseph Kosuth, Sol LeWitt, Robert Morris, Lawrence Weiner* (the *Xerox Book*), New York: Seth Siegelaub, 1968. Courtesy of Tate Archive. Photograph: Pete Huggins, Camera Techniques. Copyright DACS and VAGA 2008.

33

34

35–44
NE Thing Co. Ltd., *Portfolio of Piles*
(details), 1968. Offset lithographs
on paper, 16.5 x 24 cm. Archives
Collection, Morris and Helen Belkin Art
Gallery, University of British Columbia,
Vancouver. Photograph: Pete Huggins,
Camera Techniques. Copyright Iain
Baxter& 2008. The map indicates the
locations of the photographed piles..

35

36

37

38

39

40

41

42

43

44

5681C 2500X

Title: Rock #5

Date: September 4, 1968

Work: Documentation of selected
 physical aspects of a
 rock; its location in,
 and its conditions of,
 time and space.

Contents

Daily weather map and chart
Electron beam x-ray photographs
Electron microscopy
Location photographs and maps
Mass spectrographic analysis
Petrographic analysis and photographs
Weight and density data

45
Donald Burgy, Rock 5, 1968. From
Wedewer, Rolf and Konrad Fischer eds.,
*Konzeption: Dokumentation einer heutiger
Kunstrichtung (Conception: Documentation
of Today's Art Tendency)*, Städtisches
Museum Leverkusen, Cologne and
Opladen: Westdeutscher Verlag, 1969.
Image courtesy of Tate Archive.
Copyright DACS 2008.

46
NE Thing Co. Ltd., *Trans VSI. (Network
70) (details)*, 1970. Telex and xerox
paper. Dimensions variable. Archives
Collection, Morris and Helen Belkin Art
Gallery, University of British Columbia,
Vancouver. Photograph: Pete Huggins,
Camera Techniques. Copyright Iain
Baxter& 2008.

46

TWO DOTS

N. E. THING CO. TRANSV. S.I. INFORM
TITLE SEND LIE RECEIVE TRUTH
1968-70 NETWORK-70
PRODUCER N. E. THING CO. LTD 10/16/70
TRANSMISSION RECEIVING
PLACE N. Vanc. PLACE UBC FINE ARTS
TIME 12.58 pm PST. TIME
BY NETCO BY
BY Telecopier BY
COMMENTS

1419 RIVERSIDE DRIVE, N. VANCOUVER, B.C.
Canada Cable: "ANYTHING" (604) 929-3662

47–48
NE Thing Co. Ltd. *Trans VSI. (Network 70)* (details), 1970. Telex and xerox paper, dimensions variable, Archives Collection, Morris and Helen Belkin Art Gallery, University of British Columbia, Vancouver. Photograph: Pete Huggins, Camera Techniques. Copyright Iain Baxter& 2008.

47

TWO DOTS.

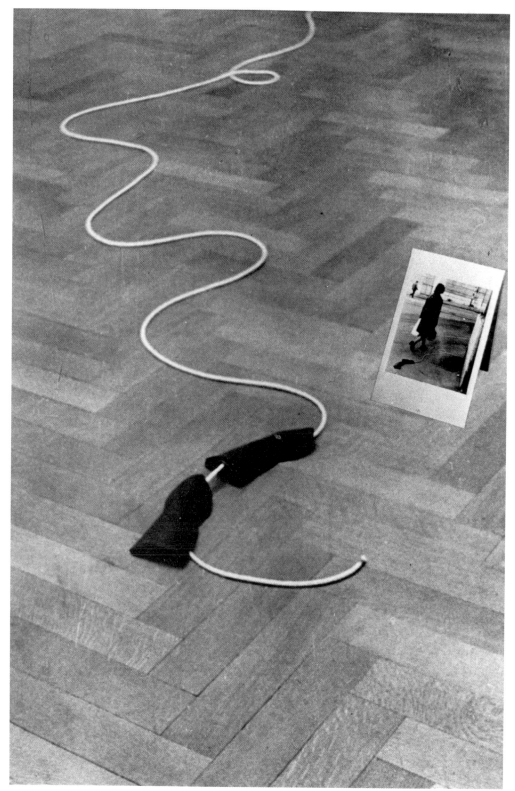

49–50
Jochen Gerz, *Alternatives to Memory*, 1969. 300 m length of rope, two pairs of gloves, two black and white photographs, two wooden stands. Gerz Studio, Ireland. Copyright Gerz Studio and the artist 2008. For an installation at the Kunsthalle, Basel, a piece of rope was run from the gallery out into the street; at each end of the rope was a pair of gloves and a photograph of the other end.

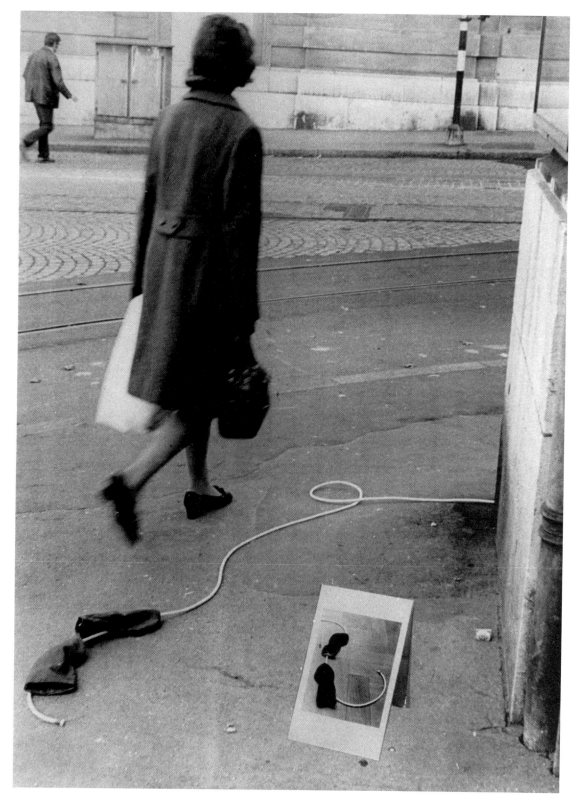

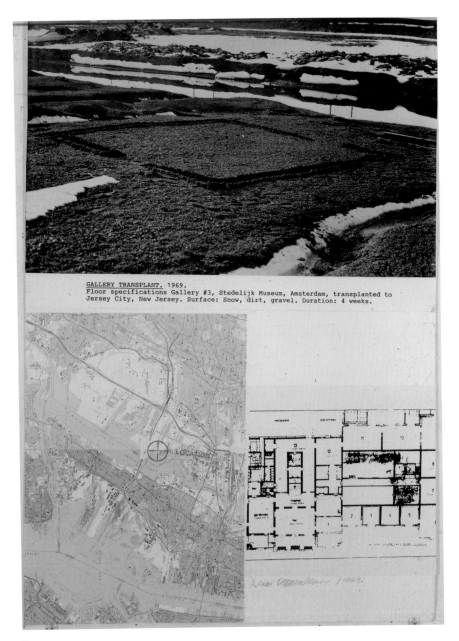

GALLERY TRANSPLANT. 1969.
Floor specifications Gallery #3, Stedelijk Museum, Amsterdam, transplanted to
Jersey City, New Jersey. Surface: Snow, dirt, gravel. Duration: 4 weeks.

LOCATION

51

51
Dennis Oppenheim, *Gallery Transplant,
Floor specification, Gallery 3, Stedelijk
Museum, Amsterdam, transplanted to Jersey
City, New Jersey. Surface: Snow, dirt, gravel.
Duration: four weeks,* 1969. Photographs,
hand stamped topographic map, marked
photographic floor plan mounted
on museum board, 152.4 x 101.6
cm. Courtesy of Dennis Oppenheim.
Photograph: David Sundberg, New
York. Copyright the artist 2008.

52
Dennis Oppenheim, *Gallery Transplant,
Floor specification, Gallery 3, Stedelijk Museum,
Amsterdam, transplanted to Jersey City, New
Jersey. Surface: Snow, dirt, gravel. Duration:
four weeks,* 1969, (detail).

This work was made for the exhibition
Op Losse Schroeven: situaties en cryptostructuren,
at the Stedelijk Museum, 15 March–27
April 1969. Copyright the artist 2008.

53
Dennis Oppenheim, *Gallery Transplant:
Floor Specification, Gallery 4, AD White
Museum transplanted to bird sanctuary near
Ithaca, New York. Activated surface: dirt and
snow,* 1969. Annotated black and white
photography, colour photography,
topographic map, text, 150 x 300 cm.
MAK-Austrian Museum of Applied
Arts/Contemporary Art, Vienna.
Photograph: Copyright MAK/Georg
Mayer. Copyright the artist 2008.

LOCATION

52

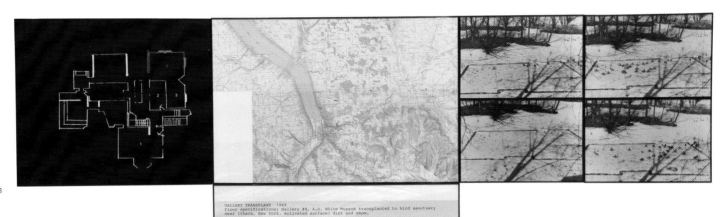

53

GALLERY TRANSPLANT 1969
Floor specifications: Gallery #4, A.D. White Museum transplanted to bird sanctuary
near Ithaca, New York. Activated surface: dirt and snow.

SALT FLAT, 1969. 1000 pounds of baker's salt placed on asphalt surface and spread into a rectangle, 50' X 100'. Sixth Ave., New York, New York. Identical dimensions to be transferred in 1' X 1' X 2' salt-lick blocks to ocean floor off the Bahama Coast. Identical dimensions to be excavated to a depth of 1' in Salt Lake Desert, Utah.

54
Dennis Oppenheim, *Salt Flat*, 1,000 *pounds of baker's salt placed on asphalt surface and spread into a rectangle 50' x 100'. Sixth Avenue, New York, New York. Identical dimensions to be transferred in 1' x 1' x 2' salt-lick blocks to ocean floor off the Bahama coast. Identical dimensions to be excavated to a depth of 1' in Salt Lake Desert, Utah*, 1969. Collection of the artist. Copyright the artist 2008.

55
Dennis Oppenheim, *Void. Proposal for Flinsterwolde, Holland. One square 20 meters by 20 meters of ripe sugar beet will be removed from the centre of a field 150 by 250 meters. This material will be destroyed. The effect if this action upon the yield in proportion to the field size will be enforced throughout trucking processing, and the end product. 50,000 cubes of sugar will be left out of the centre of 25,000 boxes of sugar. Void will be sold in retail markets surrounding Flinsterwolde, Holland. On floor: Scale model using boxed sugar cubes. On wall: Photodocument, annotated colour photography, map, text*, 1969. Collection of the artist. Copyright the artist 2008. A partially executed project, as published in Celant, Germano ed., *Conceptual Art, Arte Povera, Land Art*, Turin: Galleria civica d'arte moderna, 1970.

54

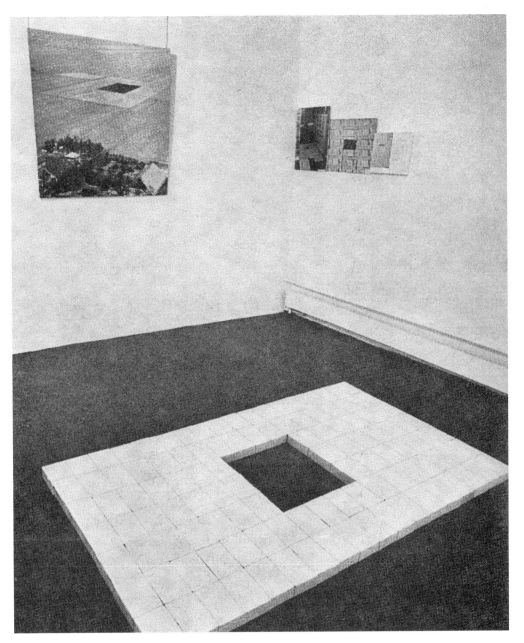

55

Site Sculpture Project

Windham College Pentagon

Putney, Vermont

On October 23, 1968 a small quantity of dirt was removed from
each of five sites (each being located approximately 1.33 miles
from a central point on the Windham College campus) and then
mixed with an epoxy composition that was cured to finally form a
wedge shape. In turn the five wedges so formed were placed
together in such a manner as to describe a small pentagonal shape
that was exactly similar to the "shape" created by sites A B C D E.

That "object", two maps locating A B C D E and five Polaroid
photographs of the sites formed a presentation of this piece that
was located at the central point (Windham College).

Approximately one month later the "wedges" were returned to the
earth and the maps, photographs and this statement constitute the
completed work.

November, 1968 Douglas Huebler

THE
PUTNEY
COUNTRYSIDE

A map for walkers, riders on horseback, campers, hunters, fishermen, skiers, naturalists and historians of a section of southeastern Vermont between the Connecticut River and Grassy Brook—West River, comprising the whole township of Putney, the southern half of Westminster and the northern half of Dummerston with small sections of Brookline and Newfane and a minute corner of Athens.

Topographical contours enlarged from U. S. Geological Survey material in Putney as of 1800 as recorded by Clifford G. Carpenter. Other old roads, houses and cemeteries from Big Windham County. Compiled by E. Dodd and for sale by the Society for the benefit of the historical societies of the vario[...]

SCALE

100 rods to the inch

Grid lines are drawn at one mile intervals
from intersections of the four USGS maps

LEGEND

Dirt roads, old and new,
suitable for horseback

Walkable trails, suitable
for exploration

Blacktop roads, suitable
for the mechanized

■ Old houses still standing

□ Cellar holes or old sites

● Cemeteries or monuments

These and other listed items of historic interest
are keyed to the vertical columns of square miles
A, B, C, etc. and to the horizontal squares q, r, s, etc.

WARNING

Roads are shifted, houses built,
abandoned or rebuilt; a round
distorts a flat map; man's memory is
fallible; expect not exactness

19

56

56
Douglas Huebler, *Site Sculpture Project, Windham College Pentagon, Putney, Vermont 1968*, 1968. Maps, photographs, typescript and printed text on board, approx. 62.2 x 127.6 cm. Tate Collection. Presented by Mr and Mrs Joshua A Gollin through the American Federation of Arts 1973. Copyright Tate 2008. Copyright ARS and DACS 2008.

For this work Huebler drew a pentagon around Windham College, with the campus at the centre. He then collected samples from the five locations and displayed them in an exhibition at the college before returning them to their original sites at the close of the exhibition.

57

58

57–60
Douglas Huebler, *Duration Piece No. 9, Berkeley, California–Hull, Massachusetts, January–October 1969,* 1969. Statement, map, nine framed mail receipts and box, statement 27.9 x 21.6 cm; map 25.4 x 36.8 cm; framed receipts 56.8 x 48.9 cm; box 7.3 x 13 x 8.9 cm. Solomon R Guggenheim Museum, New York. Panza Collection, Gift, 1992. Image courtesy of Guggenheim Museum Image Archive. Copyright Solomon R Guggenheim Foundation. Copyright ARS and DACS 2008.

59

60

Location Piece #23
Los Angeles - Cape Cod

For each day of the week beginning Monday August 11, 1969 and ending Saturday August 16, 1969 the exact dimensions of the gallery floor at ACE, Los Angeles, California will be "marked" onto a different physical location existing on Cape Cod, Massachusetts. Having been transposed in that manner the virtual physical substance of the area so marked will exist, for one day, within the actual space contained by the walls at ACE.

The photographs of the general area of each location on Cape Cod may be seen at ACE during the week of August 11. The actual marking of each location will be done in the morning on the date set by the following schedule.

Date	Location	Marker Material
1. August 11	Longnook Beach, Truro	Pebbles
2. August 12	Provincetown	3/4" Paper Stickers
3. August 13	Ballston Beach, Truro	6" Wood Stakes
4. August 14	Truro	6" Wood Stakes
5. August 15	Provincetown	3/4" Paper Stickers
6. August 16	Pamet River, Truro	6" Wood Stakes

As there is a 3 hour time differential between Cape Cod and Los Angeles a visitor at ACE in the late afternoon will be experiencing a location that is in near darkness.

A map of Cape Cod, this statement and 6 photographs constitute the form of this piece.

August, 1969

[signature: Douglas Huebler]

Douglas Huebler, *Location Piece 23, Los Angeles-Cape Cod, August 1969* (details), 1969. Statement, map and six photographs. Statement: 27.9 x 21.5 cm; Map: 21.2 x 27.8 cm. Six photographs, each: 18.6 x 23.5 cm. Solomon R Guggenheim Museum, New York. Panza Collection, Gift, 1992. Image courtesy of Guggenheim Museum Image Archive. Copyright Solomon R Guggenheim Foundation. Copyright ARS and DACS 2008.

Cape Cod

5 4 3 2 1 0 5

1" Equals Approx. 4.7 Miles

Location Piece # 23
Los Angeles-Cape Cod

General Areas of Cape Cod Locations

Douglas Huebler

August 1969

65
Cildo Meireles, *Mutações Geográficas: Frontiera Rio/São Paulo (Geographical Mutations: Rio/São Paulo Border)*, 1969. Leather case, soil, plants, 60 x 60 x 60 cm. Fundação de Serralves, Porto: Museu de Arte Contemporâneo. Copyright the artist 2008. The work entailed making a hole at each side of this border and exchanging the soil and plants between the holes. The line of the border is reproduced in the case with material from the excavations.

66–67
Cildo Meireles, *Arte Física: Cordões/30 km de Linha Estendidos (Physical Art: Cords/30 km extended line)*, circa 1969. Industrial cord, map, wooden case, cord length 30 km; case 60 x 40 x 8 cm. Private Collection. Copyright the artist 2008. This length of cord transported in the case corresponds to a length of coastline indicated on the map on the inside of the case lid.

65

66

67

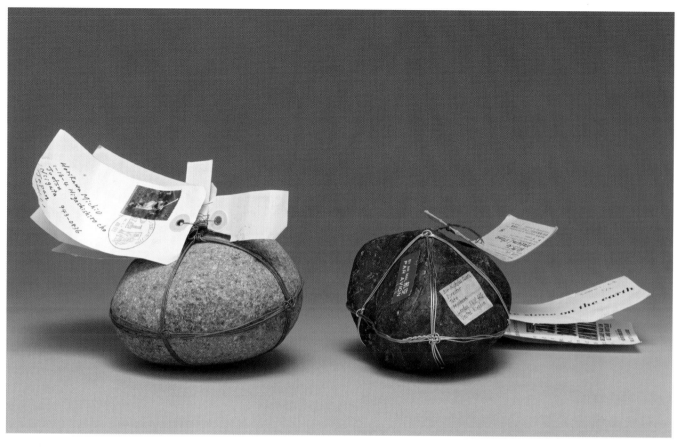

68
Michio Horikawa, *The Shinano River Plan* 2000 12.8 (black stone) and *The Shinano River Plan*, 2001 1.1 (grey stone), 2000 and 2001. Two stones with travel tickets attached. Courtesy Tate Archive. Copyright the artist 2008. These works are part of a recreation of a series of 1969, for which the artist collected stones from rivers in Niigata prefecture and sent them to politicians and figures from around the world.

69
Adrian Piper, *Area Relocation Series*. As published in *The Village Voice*, 29 May 1969. Copyright the artist 2008.

art

Continued from preceding page

autobiographical. If one reports one's reactions to a work of art—or to life—rather than describing or analyzing, it is one's sensitivity and one's truthfulness that determines the worth of this confession.

But back to the panel discussion. First of all the panelists did not arrive at the appointed time. Charlotte Moorman filled in the gap by sitting on the stage all wrapped up in pink cloth, as was her cello. By 9 o'clock I began to think that the bastards had really done it and that the rascals were not going to arrive at all. I toyed around with the idea and felt comfortable with it and felt it appropriate given the announced topic, so at 9.05, when they began filing in, I was a little disappointed. It was an incestuous panel, just as this is, I suppose, an incestuous column. The panel, was David Bourdon (Life magazine), was the moderator and was joined by Ultra Violet, Brigid Polk (of Cock-book fame), Walter Gutman, John de Menil, Gregory Battcock, Lil Picard, and Andy Warhol, who was introduced by Bourdon as a young man impersonating a rather well-known artist. Throughout Andy did not say a word, but occasionally used his Polaroid. To make a long story short, thanks to Bourdon's cool and sometimes cruel wit, everything was light-hearted and fairly entertaining. At one point Brigid took off her blouse. Gregory exposed his cock to Warhol's camera, forgetting that those in the balcony could see what was going on and began shouting "How big is it?"

This was the third in a series of panels organized or disorganized by Jill and, yes, the topic "The

Galleries

THE GILL PROPOSAL WRITTEN TO THE EDITOR OF THE CHICAGO TRIBUNE,
OCTOBER FIFTH, NINETEEN HUNDRED AND SIXTY-NINE.
THAT A STONE FROM AN ANONYMOUS SITE BE PLACED IN THE WALLS OF THE
TRIBUNE TOWER ; CHICAGO, ILLINOIS.
TO SYMBOLISE THE VARIOUS ROCKS AND LOCATIONS WHICH WERE NOT CHOSEN.

A Rock from Westminster Abbey, London, was placed in Notre Dame
Cathedral, Paris.
Executed - October Twenty-ninth, Nineteen hundred and sixty-nine.
by Jeremy Fox.

A PLAQUE WITH THE GILL PROPOSAL AND A ROCK FROM EDINBURGH CASTLE,
SCOTLAND WERE EPOXIED TO A WALL IN TRAFALGAR SQUARE, LONDON.
EXECUTED - NOVEMBER ELEVENTH, NINETEEN HUNDRED AND SIXTY - NINE.
REMOVED - NOVEMBER SIXTEENTH, NINETEEN HUNDRED AND SIXTY - NINE.

On November Twenty-fifth, Nineteen hundred and sixty-nine Peter
Braithwaite deposited a hundred and thirty rocks on the Great
Barrier Reef off the coast of Australia.

ON NOVEMBER TWENTY-FIFTH, NINETEEN HUNDRED AND SIXTY-NINE,
KEITH PRITCHARD DEPOSITED A HUNDRED AND THIRTY ROCKS TAKEN FROM
CHICAGO, ILLINOIS, ON FLODDEN FIELD, NORTHUMBERLAND. THIS WAS
THE SITE OF THE BATTLE WHERE THE ENGLISH ARMY DEFEATED THE SCOTS
IN 1513

Birthplace of Colonal Robert McCormick, 150 East Ontario Street,
Chicago, Illinois, July 30th.1880.
A brick was taken from the doorway of the house and embedded in the
walls of the Tribune Tower. On December seventh, nineteen hundred
and sixty nine, a brick was placed on the site of a hundred and fifty
East Ontario Street.

COLLECT A HUNDRED AND THIRTY ROCKS. STANDING IN ONE PLACE THROW
THEM AWAY ONE AT A TIME.

PETER P. DAVIES.

70
Peter P Davies, Untitled, 1969. Proposal
as published in Spear, Athena T ed.,
Art in the Mind, Oberlin: Allen Art
Museum, Oberlin College, 1970.
Copyright the artist 2008.

71
Brecht and MacDiarmid Research
Associates, Land Mass Translocation:
Information Sheet No. 1 (8 Sept. 1969),
1969. As published in Spear, Athena
T ed., Art in the Mind, Oberlin: Allen
Art Museum, Oberlin College, 1970.
Copyright the artist 2008.

70

Brecht & MacDiarmid
Research Associates

83 Ladbroke Grove London W11

<u>LAND MASS TRANSLOCATION: INFORMATION SHEET No. 1 (8 Sept. 1969)</u>

<u>Introduction.</u>
One of us (G.B.) proposed in 1966 that the Arctic ice pack be
interchanged with the Antarctic, and in the winter of 1967-68, in
London, the idea of moving England closer to the equator presented
itself. This intuition was reinforced by recent scientific studies
which have shown that England is being tilted, through movements in
the earth's mantle, upward in the northwest and downward in the south-
east, about a line running from Devon to northern Yorkshire, at a
rate such that areas of London 15 meters above sea level or less will
be submerged in 1500 years time. Considering that London has been an
inhabited place for at least 2000 years, this is not as remote an
event as it may seem. In this light, Brecht & MacDiarmid are under-
taking research into the feasibility of moving land masses over the
surface of the earth, such translocation, they feel, being techno-
logically realizable within ten years. More speculatively, they will
consider the translocation of land masses between the earth and other
bodies in our solar system or beyond. Movement of the Isle of Wight
would be a pilot project for the larger translocation of England.

<u>Some Technical Aspects of Translocation.</u>
Translocation of a land mass can be thought of in three stages:
<u>separation</u> (freeing the land mass from its sub-strata);
<u>translocation</u> (movement); <u>securing</u> (making fast on a new base).

<u>Separation</u> could be accomplished either by mechanical methods (mining
techniques; remote-controlled "diggers"; high-pressure water streams
with abrasive additives; long-term direction of underwater currents),or
thermally (suggested by W. De Maria) by use of a laser.

<u>Translocation</u> might be accomplished by undercutting the land mass to
form a hollow beneath into which air is injected. Alternatively a
rigid foam might be injected such as polystyrene (W. De Maria) or
an inorganic cement foam. C. Price has suggested insulating the mass
with polyurethane or polystyrene foam and freezing it, for increased
rigidity and buoyancy. Magma from a natural crevice or borehole could
be artificially directed beneath the body to be transported. The mass
could be transported by liaison to or floating it upon an iceberg,
for example an antarctic iceberg which may be "tens of miles across
and more than 2000 ft. thick", with flat top and bottom surfaces
and steep sides 250-300 ft. above the water surface (A.N. Strahler).
"Walking"-piers might be utilized, or some land masses might simply
be cut free and slid along the sea bottom (for example, the Isle of
Wight cut free at 20 fathoms, westward to the Bill of Portland).

<u>Securing</u> a translocated land mass could be accomplished by utilizing
an as yet unused portion of the earth's crust such as a seamount
coming sufficiently close to the sea's surface, by supporting it on
a continental shelf, or by placing it on the base left behind by
another land mass taking advantage of one of the first two
alternatives (or simply taking up the position abandoned by the first).

Our research on this project covers geological, oceanographical,
sociological, economic, and other aspects found to be relevant.
Results will be communicated through a series of publications,
exhibits, and lectures. Your ideas, opinions, and inquiries are
invited.

George Brecht
George Brecht, B.Sc.

INSTITUTIONS

ARTS OF ISOLATION, ARTS OF COALITION

Alistair Rider

As the debates on the legacy of Robert Smithson have shifted from wide-eyed celebration to more measured and historical perspectives, there has been a renewed interest in gaining a clearer sense of the artist's often surprising and unorthodox views on matters pertaining to the social and public sphere.[1] Of course, it is always possible to select individual statements which, once isolated, help pin him to recognizable political positions. Those who have wished to align Smithson with a suitably sceptical, left-wing perspective, for instance, have often turned to his interview with Bruce Kurtz, first published in *The Fox*, in which he voices his contempt for the machinations of the art world: "I think it will be the growing issue, of the 1970s", he concluded "the investigation of the apparatus the artist is threaded through".[2] Yet in isolation that statement hardly captures the complexity or the slipperiness of his position. After all, in 1970, when widening opposition to the Vietnam War had compelled the New York art world to take a stand both morally and politically, Smithson famously refused to collaborate. And when the journal *Artforum* inquired of his position "regarding the kinds of political action that should be taken by artists", he could only respond with acidic cynicism. "My 'position'", he explained, "is one of sinking into an awareness of global squalor and futility.... Direct political action becomes a matter of trying to pick poison out of boiling stew."[3] It's hard to make such fatalism sound enlightened, and comments like these have often provided grist to the mill of those who have felt Smithson's politics veer towards the right-wing and downright reactionary.

Perhaps the most helpful adjectives used to define Smithson's response to politics have come from the artist, Dan Graham, who once called his position "amphibious" and "amoral".[4] But Graham never meant to imply that Smithson was either fickle or even insensitive; in fact, far from it: "Bob was a politician", Graham insisted. "He had an instinct for the political.... If he was combining disparate movements together for his own advantages, he was also doing it because politically it was important, even for the art-cultural world at that moment, to make those connections."[5] The artist Carl Andre concurred with this view, and even chose to subtitle his 1978 interview on Smithson: "He always reminded us of the questions we ought to have asked ourselves."[6] This, in a nutshell, is part of the reason why Smithson continues to remain such a provocative and seminal figure for histories of late Modernist art: he is felt to have stayed alert to the implications of what it was to operate as an artist in an era in which the isolation of art from larger social pressures was understood to be no longer a viable option.

The version of modern art to which Smithson remained so opposed had, of course, always insisted that art, in essence, should remain quarantined from the remainder of the social realm. Here, the early writings of Clement Greenberg are often held up as exemplary. Without the "moral aid" of radical political attitudes, Greenberg explains in "Avant-Garde and Kitsch", artists would never have had "the courage to assert themselves as aggressively as they did against the prevailing standards of

THE PRESIDENT AND TRUSTEES OF

THE MUSEUM OF MODERN ART

REQUEST THE PLEASURE OF YOUR COMPANY

AT A SPECIAL PREVIEW OF

THE EXHIBITION

TWENTIETH-CENTURY ART FROM THE

NELSON ALDRICH ROCKEFELLER

COLLECTION

ON MONDAY EVENING, MAY 26

FROM 9:30 TO 11:30

BLACK TIE

RSVP

TICKETS ARE REQUIRED FOR ADMISSION

M.o.M.A.

WE INVITE YOU TO THE END OF A POLITICAL CAMPAIGN AT THE MUSEUM OF MODERN ART.
— *Art Workers' Coalition*

72

society".[7] But once these political positions have served their role in helping artists to establish their distance from the larger culture, then they become for him expendable. For Greenberg, the advance of avant-garde art is not driven by politics alone, but is fuelled by the impulse to entrench art more firmly. And because society offers only false promises and easy escapes, artists can only sustain the high level of their work by leaving the larger culture behind. Assured values are no longer to be located in the "subject matter of common experience", but in the medium of the artist's own craft.[8] Thus, non-representational art becomes a kind of medal of dissent; in the absence of true social values, the avant-garde abstract artist has had to forge their own standards. Greenberg had espoused this position in the late 1930s. Yet it was clear to Smithson by the late 1960s that it was simply naive to presume that a work of art could preserve even a modicum of separation from the world, on these or any other grounds.[9] In an unpublished text from 1969, he wrote that, today, "the artist can uphold the failure of Modernism with its pretence of closed, immobile hierarchical values by being a slave to all its compromises or he can choose to be a terrorist. Savage forces make isolation doubtful".[10]

It is important to appreciate, however, just how dramatically Smithson's outright repudiation of the artist's capacity to maintain a necessary autonomy for his or her art distinguishes him from many of his contemporaries. Consider Carl Andre's position, for instance. Andre had come to prominence at roughly the same moment as Smithson, and yet he has always to define his eminently abstract sculptural practice as an "art of isolation".[11] Furthermore, Andre's reason for insisting on this separation of his work from the rest of the society was precisely because of the 'savage forces' that appeared to pervade the public sphere. Invoking the ongoing American military aggression in south east Asia in 1967, he asserted that "the same fat surplus which burns in Vietnam feeds us. Art is what we do. Culture is what is done to us."[12] By the late 1960s, Andre's statement had become something of a mantra for many artists, and it was he, not Smithson, who was felt to be much more attuned to the anti-establishment ethos of the later 1960s. Yet such a clear division between art and all other aspects of socio-political life was something Smithson was never prepared to accede, and in this essay I want to draw attention to the degree to which his position differs from those of his peers. I shall go about this by attempting to reconstruct the larger critical debates within the New York art world at this moment, focusing in particular on the various claims that were made in defence of art's preservation from what was felt to be its institutional corruption. Doing so provides, I hope, a larger context for thinking further about the implications of Smithson's exacting perspective.

*

I want to begin with a very specific image, one that throws us directly into the midst of the art-world polemics of New York in 1969. It concerns an action illustrated in Michael Meier's famous 1618 volume on alchemy, the slicing open by the alchemist of the hermetic vase [Fig. 72]. An unlikely and obscure subject, one might think, for the New York-based Art Workers' Coalition to have appropriated for agitational purposes, yet it is also one that is curiously revealing of a number of widely-held suppositions regarding art's relation to institutional power at that time. The picture was incorporated into a flyer and used to advertise the picket that Art Workers' Coalition members staged

at the opening of the exhibition *Twentieth Century Art from the Nelson Aldrich Rockefeller Collection* at the Museum of Modern Art. The show ran throughout the summer of 1969. Above the mimeographed reproduction of the tunic-clad alchemist is the official invitation to the preview: black-tie and tickets mandatory. Below, the raised sword has been labelled with the acronym: AWC, whilst the vase, aligned so as to receive the full impact of the blow, is designated with the letters MoMA. In this *détournement*, then, a decidedly mystical disposition is ascribed to art. It becomes the philosopher's stone; art's extraordinary, alchemical potential will burst forth only once it has been liberated from its restrictive, institutional shell.

The idea that art deserved to be extracted from its establishment confines casts a long shadow over the later 1960s. In particular it played a considerable role in shading the reception in America of the large, dispersed field of artworks which emerged during this period, most notably process-based art, land art and post-object art. We might think it somewhat late in the century to have been insisting, as Oscar Wilde once had, that art is "that intense form of individualism" which provokes the public to exercise over it "an authority that is as immoral as it is ridiculous, and as corrupting as it is contemptible". But amongst artists and critics in the final years of the 1960s such antinomian rhetoric was rife. It comes as quite a surprise to learn it that was the conceptual artist Joseph Kosuth who, in 1969, quoted Wilde's words to an assembled audience of New York artists and critics, and there is little to suggest his selection of citation was intended as ironic.[13] Likewise the artist, Robert Barry, also claimed the "spirit of the museum and the spirit of art" to be "two totally different conceptions".[14] The former he described as "a huge, artistically impotent superstructure", which was utterly opposed in both essence and character to that of the latter.[15]

Kosuth and Barry were not alone. By this date it had almost become received wisdom to regard museums as little more than establishment prisons for works of art. Most museums, grumbled the art critic Gregory Battcock, "resemble nothing more than banks, complete with their armed guards".[16] They help "protect the people from the art" and the art "from the people".[17] But in New York this was hardly a recent development. The command the moneyed elite enjoyed over the city's major public art institutions had always assumed an overtly imperial nature. That art was a precious commodity—a nest egg—was clearly not lost on the likes of the Rockefellers. Their involvement with The Museum of Modern Art dated back to its foundation—a fact Nelson, son of Abby Aldrich, was keen to remind readers of in the well illustrated catalogue accompanying the 1969 exhibition of his private collection.[18] He himself had been appointed the second president of the museum in 1939; his brother, David, assumed the post in 1962. Yet, by the late 1960s, the rhetoric of continuity, public service and philanthropy that emanated from New York's trustee classes was beginning to sound increasingly disingenuous. The student-led opposition to the war in Vietnam had turned individuals such as Nelson Aldrich Rockefeller into easy targets. In fact, Rockefeller especially so, because he also happened to be the city's Republican Governor, and was standing for re-election in 1969. Rockefeller endorsed the Nixon regime in Washington, and also supported the military campaign in Vietnam. Under such circumstances the timing of an exhibition of his private art collection seemed particularly suspicious. To an art world already profoundly hostile to the establishment politics that Rockefeller personified,

his venture looked much less like an act of public largess than a rather crass attempt to acculturate his public image in the interests of decidedly party-political ambitions. For the Art Workers' Coalition, the paintings and sculptures by the likes of Braque, Brancusi, Matisse, Picasso, Léger, Johns and Smith were being paraded as little more than Republican Party trophies.

This, then, was the moment at which dozens of New York art journalists turned their attention to exposing the extent to which the directors of transnational corporations and major media concerns were shaping the nature of art's public reception. "The Corporate Structure of the American Art World" was the title of one much-read article of 1968.[19] "The Manhattan Arrangement of Art and Money" was another from 1969.[20] "Who were the Guggenheims? The Fricks? The Whitneys?", asked the painter Rudolf Baranik in mock ignorance. "Why should artists mouth these names daily? And why should museums hang separate 'collections' not based on the history of aesthetics but on the will of the 'collector' who donated it?"[21] The focus on corporate benefactors led in turn to no-nonsense assertions of the museums' general cultural conservatism. This, for example, is the art journalist, Alex Gross, writing in March 1969:

> Basically the art museum was (and remains) a place one visits to commune with what are supposed to be the truly meaningful values of life and society, as distinguished from the imperfect poverty-stricken, money-grubbing world outside its walls. The museum was (and is) a place to avoid life rather than to encounter it, a place to congratulate oneself on one's values rather than to doubt them and move on to something new.[22]

Andre was especially clear about exactly what this meant. Museums might want to pretend that they are apolitical organisations, he told his interviewer in 1970. "And yet the people who run them... are exactly the same people who devised American foreign policy over the last 25 years. Man for man they are the same."[23] In his mind the boards of trustees were not only supporting the war, they actually wanted to see it continued. "And they wish to run these quiet apolitical organisations like museums and universities suppressing politics among artists, among students, among professors. They don't want people to have broader and more general considerations."[24] Athletes are supposed to do nothing but practice their sport, he continues, musicians are meant to stick to their music, whilst artists ought simply to remain artists.[25]

Artists might well have been turning their attention to main-stream politics to a degree that had hardly been witnessed in America since the 1930s, yet what 'politicisation' meant in practice requires some qualification. After all, there was no real widespread flourishing of a collaboratively-produced political art at this moment. In New York, it was largely one organisation which was responsible for codifying the terms under which artists' activism took place, and this was the Art Workers' Coalition. The Coalition had emerged as an entity in early 1969, and over the course of the following year it was highly successful, gathering several hundred members. However, the very terms by which it accomplished this were premised—ironically—on a strictly-enforced division between politics and art. This might sound highly surprising, bearing in mind the role the coalition played in exposing the vested political interests of the major public museums of New York. Yet at the same time, the Coalition wanted to assemble as many

members as possible, and this meant that it established no criteria for the kind of art its affiliates were making. All who were involved with art in some way were invited to participate in its activities. In fact, the flyer distributed to advertise an open public hearing to debate artists' relations with the Museum of Modern Art in April 1969 reads as a parody of their efforts not to appear elitist: invited are architects, choreographers, filmmakers, museum workers, painters, photographers, printers, sculptors, critics, and even taxidermists.[26] Almost immediately the Coalition became a crucial forum for artists who previously had been marginalised by the art world establishment. Amongst its membership were a significant group of African American artists, many of whom were associated with the Black Emergency Cultural Coalition which picketed the opening of the Metropolitan Museum's exhibition *Harlem on My Mind* in January 1969.[27] There was also an influential Ad Hoc Women's Committee, which emerged as one of the major catalysts for the women's art movement in the early 1970s. A number of artists' groups such as Minority A and the Guerrilla Art Action Group were associates, yet would also operate independently from the Coalition. Later, the Coalition worked alongside the New York Art Strike Against Racism, Sexism and Oppression, following its formation in May 1970. It also established close ties with Women Students and Artists for Black Liberation.

The Coalition may well have served as an important impetus for artists to engage in political activism, yet it also led to the notion that their art was extraneous to their political activities.[28] In a way, art practice never seems to have been a major component of these debates. It was museums that were the root of the problem, not art. If institutional powers had proven themselves to be irresponsible and corrupt guardians of art, then the works simply deserved to be returned to their rightful parents. In fact, the act that is most often cited as inaugurating the AWC occurred on an afternoon early in January 1969, when the Greek sculptor Takis, accompanied by friends, marched into the exhibition *The Machine as seen at the End of the Mechanical Age* at the Museum of Modern Art, freed his work *Telesculpture* from its plinth and retreated with it into the sculpture garden. There he sat, surrounded by a crowd of onlookers, until museum officials agreed to speak. John Perreault, art critic for *The Village Voice*, could not decide whether Takis' deftness reminded him of a bank robber or an anarchist positioning a bomb.[29] His hesitancy nicely captures the equivocal nature of Takis' motives, which were both profoundly self-interested and impressively idealistic. Takis was desperately concerned that the institution was misrepresenting his current interests by exhibiting this particular sculpture, which he had created ten years earlier and which happened to be significantly smaller than his current large-scale installations. He wanted to insist on his moral right as the maker of the work to determine how his art was displayed. A typewritten flyer his friends distributed to startled guards and gallery-goers articulated his aspirations clearly. "Let's hope that our unanimous decision" he wrote, "to remove my work from the *Machine* exhibition... will be just the first in a series of acts against the stagnant policies of art museums all over the world".[30] "Let us unite", he continued, "artists, with scientists, students with workers, to change these anachronistic situations into information centers for all artistic activities, and in this way create a time when art can be enjoyed freely by each individual".[31]

In Takis' statement a vision of a more perfect institution is propounded, not one where the art would be discussed in hushed and reverential tones as though a sacred, religious object, but where knowledge and information would be disseminated with spontaneous and willful abandon.[32] As it happened, such an 'ideal' exhibiting environment was soon to be initiated. In fact, during the next decade there would be dozens inaugurated across lower Manhattan, but the space that came to be established at 729 Broadway assumed particular symbolic importance. Museum: A Project for Living Artists, as it was called, had been established by eight artists the previous year, but thanks to the AWC, it expanded its activities exponentially.[33] An early advert described Museum: A Project for Living Artists as providing facilities designed to present the artist's work "simply, strongly, and directly".[34] It was also intended to serve as "a social centre for artists... stimulating a greater sense of community".[35] "At this hour", announced another piece of promotional literature, "starts the testing of every 'museum'.... Will they be vapid death-chambers of a sectarian, crustacean, bourgeois establishment? Or will they become the illuminated harbours of the throbbing, flowering masses of a just society?"[36] The contrast could not be more explicit. Institutional power is envisaged as prescriptive, illegitimate and corrupt, whilst the artist-led space is understood to promote an ideal of an ethical community of individuals working towards shared interests for the betterment of humanity.

How could artists, you might ask, believe that they were accomplishing such ends merely by grouping together in this fashion? After all, no mention is made here of the nature of these artists' work, and there is certainly no indication that their art would necessarily possess or even need to assume a recognisably political content. The Art Workers' Coalition may well have been responsible for the politicisation of the terms of curatorship, but there the conversation ceased. One year later, in 1970, the Museum on Broadway was selected to stage a New York protest Biennale in response to the official contribution to the United States Pavilion in Venice. Yet the underlying principles behind the show's selection became so highly charged that the works themselves soon seemed more like an afterthought. At the time, the absence of a recognisable political content in many of the works did not go entirely unnoticed, with one critic observing that most of the art was abstract and vaguely "Minimalist". It was "hardly something to advance the revolution", she felt.[37]

Lacking a clear sense of how art itself might be politicised, a blind faith often came to reign: that art, in itself, was ultimately a humanising moral force in society. There was little new about this conviction; it is, after all, a staple of art discourse that dates back at least to the German Idealists. But art historians have often implied that the critique of institutions which commenced at this moment was responsible for ushering in a cynical attitude towards a notion of 'art for art's sake'. This, it is often insisted, paved the way for an increasing awareness that all art was inseparable from ideology, and that there was no such thing as an art that was distinct from the institutional conditions of its display. But in New York in 1969 the spectre of the idealist aesthetic was still hauntingly present. Moreover, it was busy acquiring a new lease of life within the context of these early, fledgling critiques of institutional power.

The perspective of the critic Gene Swenson might be taken as a case in point. His very public haranguing of New York's major art institutions, conducted at least a year before the Art Workers' Coalition took up a similar cause, was motivated primarily by his conviction that art deserved a better fate than to be affiliated with these slick, corporate entities. His famous speech at the AWC open public hearing at the New York School of Visual Arts in April 1969 was said to have "brought down the house".[38] In it, he boldly announced that "the training of sensual appetites, which is the traditional concern of artists seems a frivolity to most citizens… because politics seeks to subdue those conflicting appetites which are the very meat of art".[39] In these terms, political and institutional authorities are presented as diametrically opposed to art. He goes on to depict this authority as a kind of malicious power that operates covertly, infiltrating even the terms of established culture, shaping itself in conversations and in aesthetic theories, until it "begins to creep through the studio doors as the artist sits alone".[40] Swenson paints a picture of the artist barricaded on all sides by this malignant institutional force: "those senses essential to guide the artist's voyage of discovery" are paralysed.[41] That said, he never meant to imply that artists should blockade themselves from the world. Far from it; in fact the art community had "a stake in peace in Vietnam", in the "fairer distribution of national resources", in the ending "of racist domination in the Senate", and ultimately even "in the establishment of a world community… if only because these things would help restore that privacy which is the prerequisite of art".[42] Whatever art was, it deserved nothing less than global peace. In these sentences, Swenson offers a latter-day eschatology for the contemporary art world: he looks to a time when all tensions and conflicts across the globe will be resolved so that a perfect state of seclusion, isolation and independence can be established which, in turn, will allow art to come properly into its own and flourish. Art, understood in this sense, is a delicate entity indeed; it can tolerate no prevarication.

The conviction that art might well be profoundly out of tune with the current state of world politics was one that was given additional authority at this time by the New Left philosopher Herbert Marcuse. As the 1960s progressed, Marcuse was devoting increasing energy to advancing a politicised aesthetics, and his discussions frequently included references to modern and contemporary art. But, in spite of the coverage he received, the New York art world made little substantial headway with his ideas. Perhaps it was because his points of reference were not Greenbergian formalism or abstract expressionism, but Hegel, Kant, Schiller and Marx. Unlike Swenson, for instance, who envisaged art as an entity that deserved to be sequestered from social and cultural influence, Marcuse really did entertain the ideal that art should become part and parcel of life. But—and this is a point he insisted on when he spoke at the Guggenheim Museum in 1969—not "the established way of life".[43] Nor did he feel that art should ever aspire to look like life, or even assume life-like qualities. (Here, he seems to have had the experimental theatre company, the Living Theater, uppermost in his mind.[44]) For Marcuse, when art assumes non-art-like qualities it merely offers an ambience of convivial familiarity with everyday reality.[45] Instead, the crucial issue for him was that reality itself needed to aspire towards art "as reality's own form".[46] His point was one derived from German idealist philosophy. The classic aesthetic, as he explains in

An Essay on Liberation, had always insisted on the objective character of the beautiful because this was the form in which both man and nature could be seen to come into their own and realise their full potential. In these terms, the aesthetic dimension might well be regarded as "a gauge for a free society". It could serve as a bench-mark for an alternative reality. Only in an environment, Marcuse insisted, in which human affairs were no longer dominated by terror and market-driven exploitation, would the forms of beauty currently manifested merely in the aesthetic imagination become the norm of an everyday reality.[47] Marcuse was often elliptical on these matters, but he does imply that certain elements of Modernist art and also a particular sensibility amongst the counterculture did give evidence of a straining towards "a stage where society's capacity to produce may be akin to the creative capacity of art".[48]

The question was, what elements of current art did Marcuse mean exactly? After all, his knowledge of recent developments in contemporary art was hardly extensive.[49] In one of the few direct engagements with Marcuse's writings from within the New York art world, Gregory Battcock took it upon himself to resolve just these sorts of questions.[50] His essay for the summer 1969 issue of *Arts Magazine* sets out promisingly enough, but by the second page his sense of Marcuse's argument is starting to drift. Lacking Marcuse's vision of "the aesthetic ethos of socialism", he settled back into debates closer to home and turned his attention instead to the question of how art might evade institutional capture.[51] "What this boils down to", Battcock writes, "is that the artist... should not be concerned with any type of work that can be accommodated to commercial or technological institutions".[52] Artists should structure their art "in such a way that it cannot be exploited by the system nor lend itself to its repressive mechanisations".[53] For this he had a new name: "outlaw art".[54] It was a category that had little to do with Marcuse's thinking, but it proved much more practical for endorsing the kind of work that Battcock preferred to write about. It is almost as though, for Battcock, art in New York could only be imagined as on the defensive. Whilst Swenson had insisted on an ideal of perfect autonomy for art, and Marcuse an avant-garde vision of a life reunited with art, Battcock championed work that made running away from institutional arrest seem like an act of profound political defiance.

★

Where did Smithson stand in relation to these various debates? Certainly, he can hardly be said to have played an active role as a participant in the Art Workers' Coalition. In fact, in 1970, the art critic Lucy Lippard even accused him of helping to bring down the group by publicly scorning their collective efforts.[55] But it is perhaps too easy to paint Smithson as a sneering, disinterested bystander and he was, in many ways, just as committed as his contemporaries to reforming the conditions determining the display of art. Admittedly, his position was largely guided by the needs of his own practice, yet his own stance on museums forms a provocative counter-point to the debates about these institutions initiated by the Art Workers' Coalition. He argued that museums all too often assume "that artists are working in some garret and turning out objects", which, for him, as for many of his contemporaries, was simply no longer true.[56] Museums, in Smithson's mind, were designed for an earlier type of Modernist art, one that could be placed on a pedestal or merely hung discretely on the wall;

artists, he felt, were simply not supposed to take these neutral viewing environments into consideration.[57] Smithson, however, was much more committed to drawing the physical limitations of the museum into view. In itself, this might not sound like a particularly striking or unusual position, since many artists during this period were engaged in similar interrogations of the particular, physical parameters of gallery interiors.[58] After all, much of the work associated with Minimalism had attended to just such spatial concerns.[59] But what distinguishes Smithson is his resolute insistence on bringing these considerations with the viewing location back to the question of the institutional status of the museum. Whereas the Art Workers' Coalition, along with so many of his contemporaries, had often wanted to dissociate 'the spirit of art' from the confining and limiting identity of museums, Smithson, on the other hand, was sceptical as to whether such liberation was ever at all viable.

In fact, in his now famous dialogue with the artist Allan Kaprow from 1967, Smithson provocatively celebrates all those attributes of museums that tended to be regarded as their most undesirable and arcane features.[60] Kaprow's opinions, on the other hand, were similar to those articulated in the advert for the artists' space on Broadway: he too felt museums were "vapid death-chambers". Not only were they deathly edifices, he proclaimed, but they were increasingly becoming superfluous to the kind of contemporary art practice that he was keen to champion.[61] In that sense, he and Smithson were singing from the same hymn sheet. But where they differed fundamentally was that Kaprow believed that art was about plenitude and life, and artists therefore should avoid these mausolea at all costs.[62] Smithson, in contrast, thought "the nullity", the dull emptiness and the inertia of the airless museum interior, was one of its finest assets.[63] "I like the uselessness of the museum", he proclaimed.[64] Moreover, for him, museums were never entities that simply could be transcended or left behind. Instead he preferred to depict them as utterly unavoidable. "Museums are tombs, and it looks like everything is turning into a museum", he wrote in a short article later that same year.[65] "The museum spreads its surfaces everywhere."[66] Smithson does not appear to have had any particular institution in mind—his is a generic image that perhaps most closely resembles a nineteenth-century natural history museum. But what he implied was that for him there was no Eden-like place where art could exist in a form free from the limitations and compromises that were so closely identified with the museum.

As the 1960s progressed, Smithson's refusal to entertain the assumption that there might be an outside to institutional spaces distinguished him ever more dramatically from the popular belief in what Battcock had termed a "fugitive" art. In fact, by 1969 and 1970 the ideal that art should actively evade institutions had become a recurring leitmotif in the debates surrounding advanced art practice. Nowadays, we might view such notions with some scepticism, but perhaps they were so popular at this moment because they enabled works that might otherwise be deemed intransigently selfreferential to be ascribed a vague air of political radicalism. Admittedly, the reasoning was often extremely loose. It could make, for instance, an exhibition curated by Seth Siegelaub that consisted merely of a catalogue of artists' references to objects and places located elsewhere seem to answer to the demands of the AWC.[67] After all, had not the dissident artists associated with the Coalition been clamouring for the Museum of Modern Art to display works beyond the Museum's walls?[68] In the absence

of that establishment conceding any works to the outside, Siegelaub's exhibition could seem positively munificent. Even artists who organised displays of their work in their own lofts could now appear equally anti-institutional. Location, in other words, was becoming increasingly politicised. Even Dennis Oppenheim's eclectic and frequently gargantuan initiatives in far-flung outdoor environments could seem mildly radical, if only because they appeared to refuse the demand for an object to be displaced from its original context and deposited in an exhibition space. Clearly such readings were superficial, but they were extraordinarily persistent.

In fact, there was one artist in particular—a new arrival to America—whose work quickly became a magnet for those who were especially drawn to the ideals of a furtive, fugitive art. This was the British artist, Richard Long, whose first solo exhibition in New York was at the Gibson Gallery in February 1969 and the warmth with which he was received was closely associated with the anti-institutional ethos that his art helped nurture. Long was highly accomplished in summoning a sense of authenticity from natural or rural locations that always seemed especially far removed from the gallery. The black and white photographs on display in New York consisted of discrete interventions that Long had made in outdoor locations. One was a depiction of a small X formed in a field; another consisted of the impression of a line in the grass [Fig. 73]. In themselves, these forms might not seem that rich in connotations. But it was the notion of how these indexical traces had been made that so stimulated the reviewers' imaginations. "What would you do if you were a farmer", wrote John Perreault, "and one morning when you went out to check out the north pasture you discovered someone had removed the heads of just enough flowers to inscribe a large 'X'? How would you feel if in the south pasture there was a narrow 90 foot path worn into the grass, leading from nowhere to nowhere?"[69] The cumulative effect, in other words, of Long's work yielded an image of the artist working busily yet unseen, utterly immersed in his rural environment. "Long bicycles around the English country", added Lil Pickard, "and when he finds a good spot he likes, he starts to do his 'Imprint on Nature.'"[70] Clearly, there was little that was overtly political about such work, yet it, nonetheless, spoke very directly to those who wanted to envisage art as something that existed far, far away from New York's increasingly contested institutional spaces. "Who needs the museums?" asks Perreault in the paragraph immediately following his review of Long's show, and which wearily returns to the subject of the ongoing negotiations between New York's irate artists and the Museum of Modern Art.[71] With artists like Long, it must have seemed for a moment as though institutions really were expendable.

Of course, Long's early work does not necessarily need to be understood in terms of plenitude and authenticity. Some of his first exhibitions were just as much about fragmentation and dispersal. In 1967, for instance, Long was invited to participate in a group show at the Galerie Loehr in Frankfurt. The theme of the exhibition was 'ephemeral situations', which was enforced quite literally by the length of time the galleries were to remain open, namely two hours and ten minutes. A number of the participating artists carried out some kind of time-based performance, but Long chose to perform in the gallery a spatial dispersal of his work. On display were some thin sticks that had been cut down to short equal lengths, and which were placed on the floor end to end around the perimeters of the room [Fig. 28]. Ephemera from nature

73
Richard Long, *A Line Made by Walking*, England, 1967, dimensions unrecorded. Copyright the artist 2008.

73

(or what, at least, was supposed to register as nature) had been scaled to fit the dimensions of art, accomplished here by cutting the sticks into regular manageable segments. But this was not all. In the exhibition catalogue there was a letter, written by Long, explaining that the work was divided into two identical parts. One half was here, whilst the other part, complementary to the first, was to be made in England, near Bristol, at an outdoor location. Over the page, was the photographic confirmation: a black-and-white image of some sticks arranged into a rectangle on the grass of a gently rising slope [Fig. 29]. This part of the piece, perhaps known in actuality only to the artist, was a sketch on a field of a space that was situated in another country. A rectilinear form derived from an architectural setting is inserted in an environment that signals 'nature', whilst a 'natural' material is brought into the context of a gallery. In other words, descriptors such as 'indoors', 'outdoors' are kept in dialectical play, and Long maintains a careful reciprocity between the two locations. But the outcome is also slightly unsettling, in that the piece is not substantially present in either of its two locations.

However, within a short period of time, Long did begin to prioritise the outdoor sites he selected, and a certain stability of reference begins to entrench itself in his work. The photographs, texts, or metonymic traces that he displayed in the gallery soon became props to enable the viewer's imagination to transcend what was often felt to be the dull actuality of the Modernist viewing space. For instance, at the Galerie Konrad Fischer in Düsseldorf in September 1968, Long installed 1,318 thin sticks, laid out in parallel lines down the length of the floor. They acted as orthogonals, visually accentuating and stretching the narrow space. But the gaze his work elicited was not specifically intended to terminate at the glass wall at the rear of the gallery. It was meant to continue in the mind's eye all the way back to the artist's Bristol home. This place was evoked with the aid of the exhibition's announcement card—a standard picture postcard, marked prominently with the artist's name, and featuring the Clifton Suspension Bridge crossing the Avon Gorge. It was an image that provided a consoling sense of origin for the sticks, for they had been collected from Leigh Woods, which featured on the card. The authenticity of Long's art and his cultural identity could now be sensed to derive from this distinct place.

Yet arguably it was Smithson who picked up on the idea of dispersing the focus of the artwork across multiple locations. For him, however, it became a means of exploring the ambiguities of location. It resulted in what he termed his "site/nonsite dialectic", which he described at length in his famous *Artforum* essay of 1968, "A Sedimentation of the Mind: Earth Projects".[72] Smithson's gallery non-sites often consisted of a combination of maps, photographs, surveys and other forms of text, and were complemented by samples of actual materials, such as shale, rock or sand. They may well have referred to topographical sites, but they also playfully undermined any of the securities that place and location are often intended to invoke.

Smithson's *Eight-Part Piece (Cayuga Salt Mine Project)*, built for the *Earth Art* exhibition at Cornell University in January 1969, illustrates this complexity extremely well [Fig 74]. Along one wall of a gallery in the Andrew Dixon White Museum of Art on the university campus, Smithson installed at regular intervals nine small heaps of rock salt, which he had gathered in person from sites inside a local salt mine. Resting between

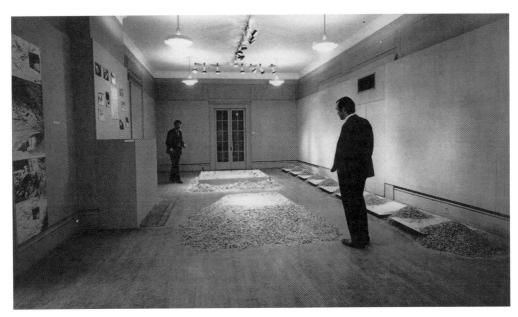

74

these whitish-coloured piles were eight square mirrors, positioned horizontally to the ground, with their reflecting surfaces facing upwards. There is a palpable tension in the work between the geometric precision of the mirror forms and the more amorphous pilings of rock salt, which spill casually over the edges of the glassy surfaces. As the art historian Ann Reynolds observes, the salt hardly provides a clear containing form for the mirrors, and this makes the physical dimensions of the piece somewhat nebulous and unclear.[73] The use of mirrors also complicates the visual coherence of the work, for invariably they refract the viewer's attention to the peripheries of the room. Smithson also liked the fact that mirrors were not only literal objects, but were also powerful metaphors, which contributed, he felt, an additional layering of complexity to the work. But, if the salt and the mirrors could be said to confuse the status of the object, then neither could the work be said to be entirely contained by the gallery space. Complementing the mirrors and salt was a series of photographs, which showed identical mirrors to those used in the installation. Smithson had carried them with him into the mine and then propped them in the dark cavernous space, before photographing them. Consequently, both the site in the mine and the gallery installation—or "the non-site" as he called it—were brought into a complicated and intricate relation. The parts referred to one another, yet neither alone afforded viewers an experience of a coherent entity.[74] At the time, Smithson seems to have been willing to provide tours to the Cayuga Salt Mine to view the site referred to in the work. Yet he also made it clear that the destination of these visits would simply be places from which the rock salt had been removed. Since he had taken the mirrors away, there was nothing to see at these nondescript locations except "displacement".[75] But perhaps more important was his selection of sites that he claimed lay two miles underground.[76] The notion of setting up a trail that leads ultimately into a series of dark, bifurcating

tunnels seems to have been extremely important to his overall understanding of the work. It was also central to his conviction that his art "didn't offer any kind of freedom in terms of endless vistas or infinite possibilities".[77] In other words, Smithson's work may have pointed to far-flung locations outside the gallery, but for him this hardly yielded any grand sense of possibility. The process of viewing would be just as artificial and mediated in these sites as it would in a museum. "There is no exit", he added, "no road to utopia, no great beyond in terms of exhibition space".[78]

Yet, however insistent Smithson might have sounded, the ideal of art's unbridled extension was becoming ever more alluring a prospect at precisely this moment. In March 1969, Robert Barry travelled to the Mohave Desert in Southern California and released into the air a series of inert gases. It was a profoundly unspectacular gesture, as Barry was well aware. In fact, as he said, there was no sign of anything happening other than a whistling sound emanating from the nozzle of the bottle in the middle of nowhere.[79] But, symbolically, it was an act that celebrated, in his words, the return of the gas into "the atmosphere from where it came"; it "continues to expand forever", he added.[80] Part of the appeal of such work was that it seemed to transcend so effectively the notion of a contained and limited exhibition space. In fact, initially the work was not advertised visually, but with a poster containing only a single line of text that was mailed to various potentially interested parties, thus neatly bypassing any particular institution.[81] In this sense, the art existed merely as a media event.

Works such as Robert Barry's *Inert Gas Series* gave credence to the assumption that if artworks did not displace any physical or perceptible space in a gallery, then buyers and collectors might leave them to roam unhindered. Such principles were also associated with time-based performance art. John Perreault, for instance, felt that artists' "Street Works" (by which he meant anything "that takes place in the street or is placed in the street") possessed unavoidable political overtones, not because the art assumed any "directly political" content, but because this work "by its very nature exists outside the gallery-museum economic structure".[82] Why? Because the pieces by these artists could neither be bought nor collected. In this context, the Minimalists, whose neat arrangements of industrially-sourced materials had still seemed so challenging in 1968, were, by 1969, beginning to seem the new conservatives: "entrepreneurs of the new establishment" was how Ursula Meyer described them in one of her articles.[83] Of course, as Ian Burn later pointed out, in societies like ours you do not need to have an object to have a marketable product and 'ideas' can make especially good commodities.[84] Yet, despite this, it appeared much more morally virtuous, much more upright, for artists to refuse to recognise any value in the physical qualities of their art objects. Hence, when Robert Barry was asked how collectors 'dealt' with his art, he simply insisted that there were no collectors. He was not necessarily implying his works were not selling, simply that his art did not involve anything that could be collected.[85] In turn, the artist Lawrence Weiner argued that if you cannot do art without leaving a permanent imprint on the physical aspect of the world, then art was simply not worth making.[86]

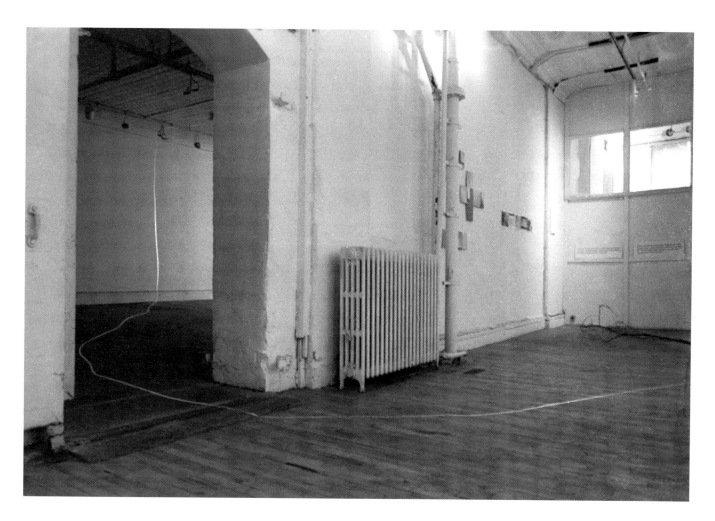

75

Needless to say, the reality was considerably untidier. The exhibition organised by Lucy Lippard at the newly-formed Paula Cooper Gallery in May 1969 gives some indication of just how involved the relations between art, commodities and institutions were at this moment. It was, by any account, a significant show, and is frequently referenced in histories of conceptual and Post-Minimal art. Perreault, who reviewed it in *The Village Voice*, reported that the front room appeared empty, although added that in actuality it was literally teeming with works.[87] Hans Haacke had ensured a constant stream of air through the space with the assistance of a small electric fan, Robert Barry set up a magnetic field, Bob Huot laid claim to the room's shadows, whilst Weiner took on one of the walls, discharging into it a single air rifle shot as a physical manifestation of one of his previous works. Richard Artschwager included a black marker from his *Location* series, whilst other similar 'blps' decorated the street outside. On the floor Carl Andre aligned 18 short segments of slightly bent lead rods: "One has almost to step on it before realising that it is there", reported Perreault.[88] The art continued into the back room. Here again were Robert Smithson's photographs from the Cayuga Salt Mine, displayed on this occasion alongside a wall drawing by Sol LeWitt, a Bill Bollinger sculpture, a lead splashing piece by Richard Serra (which was described by Lippard as incomplete), a line on the wall marked as measuring 48 inches by Mel Bochner, instructions on wall labels from Joseph Kosuth, and, snaking across the floor and up the wall, an undulating line of aluminium tape by Rosemarie Castoro [Fig. 75].[89] Yet this was not quite everything, because on the table in the hallway were works by 24 other artists in the form of books and various other kinds of documentation. In addition, Bruce Nauman sent in a tape recording, whilst NE Thing Co. Ltd. submitted reports via a Telex machine. Yet all of these works, however unsaleable they might have appeared, were nonetheless all priced and available for purchase. The exhibition was, in fact, intended as a benefit show for the newly-formed Art Workers' Coalition.

Needless to say, the unintentional irony of this gesture did not go unnoticed, and Lippard's exhibition was not without its dissenters. Included amongst her papers in the *Archives of American Art* is a loose Xeroxed flyer, plastered with bitter invective at the exhibition's organising principles. Adorning the names of the artists listed on the show's announcement card are little clippings that read "we will pay cash" and "inner circle".[90] Lippard's decision to invoke the cause of the Art Workers' Coalition in the context of an exhibition of named artists in a commercial gallery clearly was not going to go unquestioned. One presumes this flyer derived from members of the Coalition who happened not to be represented by this exhibition. For them, their exclusion must have been especially bitter, particularly since the Coalition at this moment was busy lobbying the Museum of Modern Art to display works of artists not currently represented by commercial galleries.[91] The Coalition had invoked a notion of solidarity; all artists were to work together for collective ends. But this exhibition drew attention to a harder truth: that art practices were not all equally important, and certain were worthier of exhibition than others. That these works had even the potential to be sold, let alone the possibility of raising funds so that the cause of the coalition might be advanced, must have felt ironic indeed. From this perspective, then, the advocacy of art that claimed to move beyond the capacity to be marketed commercially begins to look especially evasive.

As for the works by the artists inside: how should their contribution be regarded? The art may well be too diverse to discuss collectively, so I shall single out just one piece which I think epitomises the anti-establishment longings of the moment with impressive succinctness. The work is Rosemarie Castoro's *Room Cracking*; the title alone turns her line of aluminium tape into something much more than just that. It imagines the breaking open of the institutional space, as though through that silvery chink, art, undamaged and still pure, might slip out and become free. Smithson, on the other hand, tolerated no such wish-fulfilment. For his art, this world was good enough.

ENDNOTES

1 I am thinking in particular of Jennifer L Roberts' *Mirror-Travels: Robert Smithson and History*, New Haven and London: Yale University Press, 2004 and Blake Stimson's "Conceptual Work and Conceptual Waste", Michael Corris ed., *Conceptual Art: Theory, Myth, and Practice*, Cambridge: Cambridge University Press, 2004.

2 Smithson, Robert, "Conversation with Robert Smithson", *Robert Smithson, The Collected Writings*, Jack Flam ed., Berkeley, Los Angeles and London: University of California Press, 1996, p. 263. The interview was first published in *The Fox* in 1975.

3 Smithson, Robert, "The Artist and Politics: A Symposium", *The Collected Writings*, p. 134.

4 Graham, Dan, "Interview with Eugenie Tsai", *Robert Smithson: Zeichnungen aus dem Nachlass (Drawings from the Estate)*, Münster: Westfälisches Landesmuseum für Kunst und Kulturgeschichte, 1989, p. 14.

5 Graham, "Interview with Eugenie Tsai", p. 16.

6 Andre, Carl, "Robert Smithson: He always reminded us of the questions we ought to have asked ourselves", *Arts Magazine*, Vol. 52, No. 9, May 1978, p. 102.

7 Greenberg, Clement, "Avant-Garde and Kitsch", *The Collected Essays and Criticism: Vol. 1. Perceptions and Judgments 1939–1944*, John O'Brian ed., Chicago and London: University of Chicago Press, 1986, p. 7.

8 Greenberg, "Avant-Garde and Kitsch", p. 9.

9 I am condensing a much larger debate here, and Smithson was certainly not alone in the late 1960s in voicing his opposition to Modernism. These narratives are well rehearsed elsewhere. See, for instance, Harrison, Charles, "Modernism", *Critical Terms for Art History*, Robert S Nelson and Richard Shiff eds., Chicago and London: University of Chicago Press, 1996.

10 Smithson, Robert, "Can Man Survive?", *Robert Smithson, The Collected Writings*, p. 368.

11 See, for instance, Gust, Dodie, "Andre: Art of Transportation", *About Carl Andre: Critical Texts since 1965*, Paula Feldman, Alistair Rider and Karsten Schubert eds., London: Ridinghouse, 2006, p. 61. This text was first published in *Aspen Times* in 1968.

12 Carl Andre in Rose, Barbara and Irving Sandler, "Sensibility of the Sixties", *Art in America*, Vol. 9, No. 1, January–February 1967, pp. 49.

13 Kosuth, Joseph, "Two Comments from Oscar Wilde", statement delivered at the Art Workers' Coalition Open Hearing, New York School of Visual Arts, 10 April 1969, Art Workers' Coalition, *Open Hearing*: New York, 1969, p. 6.

14 Robert Barry, statement delivered at the Art Workers' Coalition Open Hearing, New York School of Visual Arts, 10 April 1969, Art Workers' Coalition, *Open Hearing*, p. 69.

15 Barry, statement, *Open Hearing*, p. 69.

16 Battcock, Gregory, "Monuments to Technology", *Art and Artists*, Vol. 5, No. 2, May 1970, p. 55.

17 Battcock, "Monuments to Technology", p. 55.

18 Rockefeller, Nelson A, Preface, *Twentieth Century Art from the Nelson Aldrich Rockefeller Collection*, New York: The Museum of Modern Art, 1969, p. 8.

19 Swenson, Gene, "The Corporate Structure of the American Art World", *New York Free Press*, 25 April 1968.

20 Burnham, Sophy, "The Manhattan Arrangement of Art and Money", *New York Magazine*, 8 December 1969.

21 Baranik, Rudolf, "A Painter's Radicalization", *New York Element*, Vol. 1, No. 6, February–March 1970, p. 7.

22 Gross, Alex, "Is the Museum a Museum Piece?", *East Village Other*, Vol. 4, No. 14, 7 March 1969, p. 8.

23 Siegel, Jeanne, "Carl Andre: Artworker", *Studio International*, Vol. 180, No. 927, November 1970, p. 177.

24 Siegel, "Carl Andre: Artworker", p. 177.

25 Siegel, "Carl Andre: Artworker", p. 177.

26 Reprinted in Art Workers Coalition, *Documents I*, New York, 1969, p. 37.

27 See Andrews, Benny, "The BECC: Black Emergency Cultural Coalition", *Arts*, Vol. 44, No. 8, Summer 1970.

28 Michael Corris articulates this point clearly in his essay "The Limit of the Social", *Conceptual Art: Theory, Myth, and Practice*.

29 Perreault, John, "Whose Art?", *The Village Voice*, 9 January 1969, p. 16.

30 Takis, cited in Perreault, "Whose Art?", p. 16.

31 Takis, cited in Perreault, "Whose Art?", p. 16.

32 See Gross, Alex, "Artists Attack MoMA", Art Workers' Coalition, *Documents 1*, p. 10. This text was first published in *East Village Other* in 1969.

33 See Ault, Julie, "A Chronology of Selected Alternative Structures, Spaces, Artists' Groups, and Organizations in New York City, 1965–1985", *Alternative Art Spaces*, Julie Ault ed., New York, Minneapolis and London: University of Minnesota Press, 2002. See also Lippard, Lucy, "Biting the Hand: Artists and Museums in New York since 1969", in the same volume. For an additional perspective see Patton, Phil, "Other Voices, Other Rooms: The Rise of the Alternative Space", *Art in America*, Vol. 65, No. 4, July–August 1977.

34 *New York Element*, Vol. 1, No. 3, 21 March 1969, p. 15.

35 *New York Element*, p. 15.

36 Art Workers' Coalition, *Documents 1*, p. 3.

37 Roberts, Corinne, "The NY Art Strike", *Arts Magazine*, Vol. 45, No. 1, September–October 1970, p. 27.

38 Battcock, Gregory, "The Art Critic as a Social Reformer—With a Question Mark", *Gene Swenson: Retrospective for a Critic*, Kansas: University of Kansas Museum of Art, 1971, p. 14. This text was first published in *Art in America* in 1971. Swenson, Gene, "From the International Liberation Front", statement delivered at the Art Workers' Coalition Open Hearing, New York School of Visual Arts, 10 April 1969, Art Workers' Coalition, *Open Hearing*.

39 Swenson, Gene, "From the International Liberation Front", p. 12.

40 Swenson, "From the International Liberation Front", p. 12.

41 Swenson, "From the International Liberation Front", p. 12.

42 Swenson, "From the International Liberation Front", p. 12.

43 Marcuse, Herbert, "Art as a Form of Reality", *On the*

Future of Art, Edward Fry ed., New York: Viking, 1970, pp. 124.

44 Marcuse, "Art as a Form of Reality", p. 130. See also his text of 1969, *An Essay on Liberation*, Harmondsworth: Penguin, 1972, p. 48. For a history of the activities of the Living Theater, see Martin, Bradford D, *The Theater is in the Street: Politics and Performance in Sixties America*, Amherst and Boston: University of Massachusetts Press, 2004, pp. 49–85.

45 Marcuse, *An Essay on Liberation*, p. 53.

46 Marcuse, *An Essay on Liberation*, p. 131.

47 Marcuse, *An Essay on Liberation*, pp. 34–35.

48 Marcuse, *An Essay on Liberation*, p. 54.

49 When Marcuse refers to contemporary art, his reference points tended to be to high Modernist experimental art forms that were already at least two or three decades old. For instance, in a passage in *An Essay on Liberation* (p. 45) he mentions non-objective abstract painting, stream-of-consciousness literature and twelve-tone composition. He also alludes to blues and jazz.

50 Battcock, Gregory, "Marcuse and Anti-Art", *Arts Magazine*, Vol. 43, No. 8, Summer 1969.

51 Marcuse, *An Essay on Liberation*, p. 53.

52 Battcock, "Marcuse and Anti-Art", p. 18.

53 Battcock, "Marcuse and Anti-Art", p. 18.

54 Battcock, "Marcuse and Anti-Art", p. 19.

55 Lippard, Lucy, "The Art Workers' Coalition: Not a History", *Studio International*, Vol. 180, No. 927, November 1970, p. 72.

56 Smithson, Robert, "Earth", *The Collected Writings*, p. 187. This text consists of excerpts from a symposium held on the occasion of the *Earth Art* exhibition; a transcript of the symposium was published in Andrew Dickson White Museum of Art, *Earth Art*, in 1969.

57 Smithson, "Conversation with Robert Smithson", p. 262.

58 The two final chapters of O'Doherty, Brian, *Inside the White Cube: The Ideology of the Gallery Space*, Berkeley, Los Angeles and London: University of California Press, 1986, offer a now classic account of the implications of the artists' various interrogations of the physical dimensions of the gallery space.

59 See for instance Morris, Robert, "Notes on Sculpture, Part 2", *Continuous Project Altered Daily: The Writings of Robert Morris*, Cambridge, Massachusetts and London: MIT Press, 1995. This essay first appeared in *Artforum* in 1966. See also Foster, Hal, Rosalind Krauss, Yve-Alain Bois and Benjamin HD Buchloh, *Art Since 1900: Modernism, Antimodernism, Postmodernism*, London: Thames and Hudson, 2004, p. 540.

60 For a further account of Smithson's exchange with Kaprow see Margaroni, Maria, "Postmodern Crises of Mediation and the Passing of the Museum", *parallax*, Vol. 11, No. 4, 2005.

61 Kaprow, Allan, and Smithson, Robert, "What is a Museum?", *The Collected Writings*. The dialogue was first published in the *Arts Yearbook* for 1967.

62 Kaprow and Smithson, "What is a Museum?", p. 44.

63 Kaprow and Smithson, "What is a Museum?", p. 44.

64 Kaprow and Smithson, "What is a Museum?", p. 49.

65 Smithson, Robert, "Some Void Thoughts on Museums", *The Collected Writings*, p. 42. This essay was first published in *Arts Magazine*.

66 Smithson, "Some Void Thoughts on Museums", p. 42.

67 See Siegelaub, Seth, *March 1–31, 1969*, New York, 1969.

68 Battcock, Gregory, "10 Downtown", *Arts Magazine*, Vol. 43, No. 6, April 1969.

69 Perreault, John, "Outside the Museum", *The Village Voice*, 6 March 1969, p. 13.

70 Picard, Lil, "Art", *East Village Other*, No. 4, Vol. 4, 7 March 1969, p. 4.

71 Perreault, "Outside the Museum", p. 13.

72 Smithson, Robert, "A Sedimentation of the Mind: Earth Projects", *The Collected Writings*.

73 Reynolds, Ann, *Robert Smithson: Learning from New Jersey and Elsewhere*, Cambridge, Massachusetts and London: MIT Press, 2003, p. 199.

74 One of the best descriptions of this complex work is that of Robert Hobbs in *Robert Smithson: Sculpture*, Ithaca and London: Cornell University Press, 1981, pp. 132–138.

75 Smithson, Robert, "Four Conversations between Dennis Wheeler and Robert Smithson", *The Collected Writings*, p. 190.

76 Smithson, "Four Conversations between Dennis Wheeler and Robert Smithson", p. 223.

77 Smithson, "Four Conversations between Dennis Wheeler and Robert Smithson", p. 190.

78 Smithson, "Four Conversations between Dennis Wheeler and Robert Smithson", p. 190.

79 Barry, Robert, "October 12, 1969", Ursula Meyer ed., *Conceptual Art*, New York: Dutton, 1972.

80 Barry, "October 12, 1969", p. 39.

81 For a discussion of the implications of Barry's Inert Gas Series see Alberro, Alexander, *Conceptual Art and the Politics of Publicity*, Cambridge, Massachusetts and London: MIT Press, 2003, pp. 118–121.

82 Perreault, John, "Critique: Street Works", *Arts Magazine*, Vol. 44, No. 3, December 1969, p. 18.

83 Meyer, Ursula, "De-Objectification of the Art Object", *Arts Magazine*, Vol. 43, No. 8, Summer 1969, p. 21.

84 Burn, Ian, "The Sixties: Crisis and Aftermath (or The Memoirs of an Ex-conceptual Artist)", Alexander Alberro and Blake Stimson eds., *Conceptual Art: A Critical Anthology*, Cambridge, Massachusetts and London: MIT Press, 1999, p. 403. This essay first appeared in *Art & Text*, 1981.

85 Barry, "October 12, 1969", p. 40.

86 Weiner, Lawrence, "October 12, 1969", Meyer, 1972, p. 217.

87 Perreault, John, "Para-Visual", *The Village Voice*, 5 June 1969.

88 Perreault, "Para-Visual", p. 15.

89 Lippard, Lucy ed., *Six Years: The Dematerialization of the Art Object from 1966 to 1972*, Berkeley, Los Angeles, London: University of California Press, 1997, p. 100.

90 Lippard, Lucy, *Papers, 1940s–2006 (bulk 1968–1990)*, Archives of American Art, Smithsonian Institution.

91 At the start of February 1969, artists had drawn up a list of 13 demands which they had put to the Museum of Modern Art. Point 11 reads: "A Section of the museum should be permanently devoted to showing the work of artists without galleries." See Gross, Alex, "Ultimatum at the Modern Museum", *East Village Other*, Vol. 4, No. 11, 14 February 1969, p. 3. However, by 1970, this demand had been dropped.

1970-1978

76
Robert Smithson, *Torn Photograph from the second stop (rubble). Second mountain of 6 stops on a section*, 1969–1970. From the portfolio *Artists and Photographs*, Multiples Inc., New York, 1970, 29 x 29 cm. Courtesy of Tate Archive. Copyright Estate of Robert Smithson, DACS and VAGA 2008.

77

Vito Acconci; 102 Christopher St., NYC; b. Jan. 24, 1940

untitled; 28"x34"; materials: calendar, postcards;
date: exhibition dates

A postcard sent, for the duration of the exhibition, at
the same time each day, from the same mailbox in New York
City, to the exhibition site; the postcard, when received
placed on a calendar, on the date-rectangle of the day
it is received.

1. Performing; forming; transforming. 2. Day by day;
from day to day; the other day. 3. End of an action; an
action without an end. 4. "Place" (specific locality;
an indeterminate region or expanse). 5. "Post" (to mail;
to station in a given place). 6. "Point" (a particular
place; a particular narrowly limited step, stage, or de-
gree in the condition or development of something; a run
— as a cross-country run — made straight from one place
to another; to cause to be turned in a particular direc-
tion or toward a particular thing). 7. "Points of view"
(view of the sender; view of the sender).

79–80
Vito Acconci, *Untitled (Postcard piece)*, 1970. Filing card from a series of loose cards constituting the exhibition catalogue 955,000, Vancouver Art Gallery, University of British Columbia, Vancouver, 1970. Courtesy of Tate Archive. Copyright the artist 2008.

81–84
Jan Dibbets, *Art & Project: Bulletin 15*, 1970. As published in *Studio International*, July–August 1970. Photograph: Pete Huggins, Camera Techniques. Copyright ARS and DACS 2008. Dibbets sent bulletins from the Art & Project gallery to a number of contacts and requested that these be returned to him; the resulting correspondence was recorded on a series of maps. For the artist this was a means of visualising patterns of thought.

81

82

83

84

KLAUS GROH:

projekt"wasser-land-transplantation"
katingsiel-formentera/1970.

fotos:friedemann singer

KLAUS GROH:

LAND-
TRANSPLAN-
TATION

SAND AUS
SPANIEN

85
Klaus Groh, Projekt: 'Wasser-Land
Transplantation', Katingsiel-Formentera
(Project: 'Water-Land Transplantation',
Katingsiel-Formentera), 1970. From Aue,
Walter ed., PCA: Projecte, Concepte &
Actionen, Verlag M DuMont Schauberg,
Köln, 1971. Private Collection. Photograph:
Pete Huggins, Camera Techniques.
Copyright the artist 2008.

86
Wolfgang Ernst, Fragmente eines
Fussballfeldes (aus dem Boden gegraben,
über Europa), (Fragments of a Football
Field (dug out of the ground, over
Europe)), 1970, as published in Aue,
Walter ed., PCA: Projecte, Concepte &
Actionen, Verlag M DuMont Schauberg,
Köln 1971. Private Collection. Photograph:
Pete Huggins, Camera Techniques.
Copyright DACS 2008.

85

"FRAGMENTE EINES FUSSBALLFELDES"
AUS DEM BODEN GEGRABEN / ÜBER EUROPA

1., WIEN 2., MÜNCHEN 3., FRANKENWALD
 ÖSTERREICH BRD DDR

4., RIESENGEB. 5., SCHNEIDEMÜHL 6., LÜNEBURGER HEIDE
 POLEN POLEN BRD

MITTELEUROPA NOV. 1970

86

JAN DIBBETS: JUNI 1970.

87
Jan Dibbets, *Untitled*, project for
Kunstkreis, 'Umwelt-Akzente: Die Expansion
der Kinst', Monschau. From Aue, Walter
ed., *PCA: Projecte, Concepte & Actionen*,
Verlag M DuMont Schauberg, Köln,
1971. Private Collection. Photograph:
Pete Huggins, Camera Techniques.
Copyright ARS and DACS 2008.

88–93
Bill Vazan, *World Line* (details), 1971.
Documentation book. Courtesy of the
artist. Copyright the artist 2008.

87

88

89

reduce to 8½ X 11 - LONDON British mail strike

bleed on all sides

WESTERN UNION INTERNATIONAL, INC.
ANGLO-AMERICAN TELEGRAPH
140 OUEST, RUE NOTRE DAME STREET WEST, MONTREAL 126 — 849-4241

LT A
BRIAN CROFT OR JASIA REICHARDT
CONTEMPART LONDONSW1

WRITTEN INSTRUCTIONS IN MAIL STOP WE ARE 25 LOCATIONS MAKING
WORLD LINE STOP YOUR TAPE MUST BE PLACED ON MARCH 5 1971
STOP INSTRUCTIONS FOLLOW — IN YOUR CONCOURSE (CAFETERIA AREA)
FIRST DETERMINE LINE (CONCOURSE LINE) ON THE FLOOR PARALLEL TO SIDE OF
YOUR BUILDING FRONTING THE MALL STOP USE A PROTRACTOR AND FROM
A POINT ON THE CONCOURSE LINE NEAR THE STORE AND FACING TRAFALGA
SQUARE MARK OFF 67-1/4 DEGREES CLOCKWISE AND THEN AN ADDITIONAL
45 DEGREES CLOCKWISE STOP

EXTEND THESE TWO LINES BY PENCIL AND FINALLY ALONGSIDE OK THEM
LAY DOWN YOUR TAPE — ALL 45 FEET STOP FIRST TAPE POINTS TO PARIS
AND SECOND TO KABALA SIERRALEONE STOP PLEASE ACKNOWLEGE THIS
TELEGRAM
VAZAN

CONFIRMATION

WILLIAM VAZAN 5171 ORLEANS AVE MTL406 725-3232

Western Union International, Inc.
WUI CABLEGRAM-CABLOGRAMME
ANGLO-AMERICAN
E. A. GALLAGHER, PRESIDENT
11 AM 8 49

Via WUI-Anglo 140 OUEST NOTRE DAME WEST, MONTREAL TEL. 849-4241

=ANB043 CX15 ZL LONDON VIA WUI 11 11 1303.=
=WILLIAM VAZAN.
=5171 ORLEANS AVENUE.=MTL.:
==TELEGRAM RECEIVED NO COMPLICATIONS.=
CROFT.=

Western Union International, Inc.
WUI CABLEGRAM-CABLOGRAMME
ANGLO-AMERICAN
E. A. GALLAGHER, PRESIDENT
WUI

1971

Via WUI-Anglo 140 OUEST NOTRE DAME WEST, MONTREAL TEL.

=ANA333 CX93 ZL LONDON 11 11 1805.==
=VAZAN 5171 ORLEANS AVE.=MTL 406 .=
:TAPE INSTALLED PER YOUR INSTRUCTIONS.=
CROFT.==

COLL 5174 406 .=======.

725-3232

90

166

91

167

KODAK GRAY SCALE

Red-Filter Negative
Cyan Printer

.10
.20
.30

M

Green-Filter Negative
Magenta Printer

.50
.70 M
1.00

Y

Blue-Filter Negative
Yellow Printer

1.30
1.60 B
1.90

SERIES VI

93

94

94
Alan Sonfist, *Twigs Become Photograph*,
1971. Mixed media, 2.5 x 25.4 x 15.2
cm. Natural Cultural Inc., New York.
Copyright the artist 2008.

95
Alan Sonfist, *Autobiography of a Time
Landscape*, 1969 onwards, photograph,
text and found materials, 149 x 118
cm. Natural Cultural Inc., New York.
Copyright the artist 2008.

95

96
Douwe Jan Bakker, *Projects for two contexts and a third one*, 1971. From *Sonsbeek 71: Sonsbeek buiten de perken*, Beeren, Wim ed., Arnhem: Park Sonsbeek, 1971. Courtesy of Tate Archive. Copyright the artist 2008.

97
George Brecht, *Relocation*. From *Water Yam*, London: John Gosling, 1973. Originally produced by Fluxus, New York. 96 cards and one object in paper envelope in black plastic box, 14 x 23 x 6 cm. Courtesy of Tate Archive. Copyright the artist 2008.

96

RELOCATION

(limited to five per year. A signed and numbered Certificate of Relocation is provided with each realization of the work.)

Bounds (which may be of any extent) are set by the subscriber. Once set, a relocation within the bounds is arranged.

Inquiries: G.Brecht, Fluxus, P.O.Box 180 New York 13, N.Y.

97

98

99

98
Anne and Patrick Poirier, *Ostia Antica*, 1971–1972, herbal with pressings, Museum moderner Kunst Stiftung Ludwig Wien, Leihgabe der Österreichischen Ludwig Stiftung. This book is one part of the artist's meditation on the ancient port of Rome. Besides other books, related works include paper impressions of monuments and a large model of the site in terracotta. Copyright ADAGP and DACS 2008.

99
Anne and Patrick Poirier, *Isola Sacra*, 1973, herbal with pressings, Sonnabend Collection, New York. Copyright ADAGP and DACS 2008.

100
Anne and Patrick Poirier, *Isola Sacra*, 1973, medallion, photograph on porcelain and found objects, 20 x 15 cm. Poirier Collection, Paris. Copyright ADAGP and DACS 2008.

100

Robert Watts, *Fluxatlas*, 1973. Mixed media.
The Gilbert and Lila Silverman Fluxus
Collection, Detroit. Copyright the artist
2008. Various editions of the *Fluxatlas* are
shown here; the version in the foreground
is from the *Flux Year Box 2*. The atlas
contained stones and pebbles gathered
from around the world, each carefully
labelled to indicate its original location.

102

102
Joseph Beuys, *Ausfegen (Sweeping Up)*, 1972–1985. Vitrine with sound recording and detritus, including paper, sand, glass, broom and Beuys pamphlets printed on plastic bags: vitrine 202 x 233 x 61.5 cm. René Block Collection, on deposit at the Neues Museum, Nürnberg. Copyright DACS 2008. On 1 May 1972, Beuys, a Korean student and an African student swept the Karl-Marx-Platz after the May Day demonstration. The materials gathered are preserved in the vitrine along with a sound recording of the action, playing on a loop.

Within the collage image, the following handwritten and typed text is visible:

SPECIAL AREAS 1936

Grotto at Cleator
Built by voluntary labour
many of whom are miners.

'THE BLOODTUB'
was a voluntary scheme where
unemployed miners made 'crosses'
and souvenirs from rocks
an example is shown above

Slag Bank at
Cleator Moor.

103

Conrad Atkinson, *Iron Ore* (detail), 1977. Mixed media, originally 13 panels. This panel 81.5 x 54.5 x 5.5 cm. Acquired by Northern Arts for Cleator Moor Community Centre. Courtesy of the artist. Copyright the artist 2008. Conrad Atkinson Shows courtesy Ronald Feldman Fine Art, New York. This work uses photographs of Cleator Moor and the Florence-Beckermet mine and ore from that mine. *Iron Ore* presents the case of the miner Billy Hunter, who suffered from chest diseases as a result of his work but was not eligible for compensation.

104

Robert Filliou, *Poussière de Poussière de l'effet Frans Hals 'La Bohèmienne' (Dust to Dust of the impression of Frans Hals 'The Gypsy Girl'),* 1977.

105

Robert Filliou, *Poussière de Poussière de l'effet Cimabue 'Vierge aux Anges' (Dust to Dust of the impression of Cimabue's 'Virgin with Angels'),* 1977.

Cardboard boxes with cloth dusters and Polaroids, 12 x 16.5 x 6 cm. Andersch Collection, Neuss, Germany, except 107: Feelisch Collection, Remsheid. From *The Museum as Muse: Artists Reflect,* Kynaston McShine, Harry N Abrams, 1999. All images copyright Estate of Robert Filliou 2008.

Filliou cleaned works of art in public collections in Paris and then presented the dirtied cloths along with a record of his actions as if the aura of the original work could be preserved as a relic.

104

105

106

107

106
Robert Filliou, *Poussière de Poussière de l'effet Fra Angelico 'La Couronnement de la vierge'* (Dust to Dust of the impression of Fra Angelico 'The Coronation of the Virgin'), 1977.

107
Robert Filliou, *Poussière de Poussière de l'effet Da Vinci 'La Sainte Anne'* (Dust to Dust of the impression of Da Vinci 'Saint Anne'), 1977.

108
Boyle Family, *Sardinia Elemental Study (Brown Scarp), World Series*, 1978. Mixed media, resin and fibreglass, 183 x 183 cm., Collection Boyle Family. Image courtesy of Boyle Family. Copyright Boyle Family and DACS 2008. All rights reserved.

108

SELECTED BIBLIOGRAPHY

Please note that this bibliography contains only material cited in the texts. For a bibliography on Smithson covering the period to 1980 see Hobbs, *Robert Smithson*; for the period 1981 to 2003 see Tsai, Eugenie with Cornelia Butler eds., *Robert Smithson*.

Alberro, Alexander, *Conceptual Art and the Politics of Publicity*, Cambridge, Massachusetts and London: MIT Press, 2003.

Alberro, Alexander and Patricia Norvell eds., *Recording Conceptual Art: Early Interviews with Barry, Huebler, Kaltenbach, LeWitt, Morris, Oppenheim, Siegelaub, Smithson, Weiner*, Berkeley, Los Angeles and London: University of California Press, 2001.

Andre, Carl, "Robert Smithson: He always reminded us of the questions we ought to have asked ourselves", *Arts Magazine*, Vol. 52, No. 9, May 1978, p. 102.

Andrew Dickson White Museum of Art, *Earth Art*, Ithaca, 1969.

Andrews, Benny, "The BECC: Black Emergency Cultural Coalition", *Arts*, Vol. 44, No. 8, Summer 1970, pp. 18–20.

Antin, David, "Have Mind, Will Travel", Thomas Krens ed., *Robert Morris*, pp. 34–49.

Arnold, Grant, ed., *Robert Smithson in Vancouver: Fragmentation of a Greater Fragmentation*, Vancouver: Vancouver Art Gallery, 2004. Art Workers Coalition, *Documents I*, New York, 1969.

Ault, Julie, "A Chronology of Selected Alternative Structures, Spaces, Artists' Groups, and Organizations in New York City, 1965–1985", *Alternative Art Spaces*, Julie Ault ed., New York, Minneapolis and London: University of Minnesota Press, 2002, pp. 17–76.

Bann, Stephen, "Unity and Diversity in Kinetic Art", Bann, Stephen, Reg Gadney, Frank Popper and Philip Steadman, *Kinetic Art: Four Essays*, St Albans: Motion Books, 1966, pp. 49–66.

Baranik, Rudolf, "A Painter's Radicalization", *New York Element*, Vol. 1, No. 6, February–March 1970, p. 7.

Barry, Robert, "October 12, 1969", Ursula Meyer ed., *Conceptual Art*, New York: Dutton, 1972, pp. 34–41.

Barry, Robert, statement delivered at the Art Workers' Coalition Open Hearing, New York School of Visual Arts, 10 April 1969, Art Workers' Coalition, *Open Hearing*, New York, 1969, p. 69.

Battcock, Gregory, "The Art Critic as a Social Reformer— With a Question Mark", *Gene Swenson: Retrospective for a Critic*, Kansas: University of Kansas Museum of Art, 1971, p. 14.

Battcock, Gregory, "Marcuse and Anti-Art", *Arts Magazine*, Vol. 43, No. 8, Summer 1969, pp. 17–19.

Battcock, Gregory, "Monuments to Technology", *Art and Artists*, Vol. 5, No. 2, May 1970, pp. 52–55.

Battcock, Gregory, "10 Downtown", *Arts Magazine*, Vol. 43, No. 6, April 1969, p. 23.

Baudelaire, Charles, "The Painter of Modern Life", *The Painter of Modern Life and Other Essays*, Jonathan Mayne trans., London: Phaidon Press, 1964, pp. 1–40.

Becq, Annie, *Genèse de l'esthétique française moderne: De la Raison classique à l'imagination créatrice 1680–1814*, Vols. 1–2, Pisa: Pacini, 1984.

Benjamin, Walter, "The Work of Art in the Age of Its Technological Reproducibility", *Selected Writings: Vol. 3, 1935–1938*, Edmund Jephcott et al., trans., Cambridge, Massachusetts and London: The Belknap Press of Harvard University Press, 2002, pp. 101–133.

Boettger, Suzaan, *Earthworks: Art and the Landscape of the Sixties*, Berkeley, Los Angeles and London: University of California Press, 2002.

Bourdon, David, "The Razed Sites of Carl Andre", *Artforum*, Vol. 5. No. 2. October 1966, pp. 15–17.

Burn, Ian, "The Sixties: Crisis and Aftermath (or The Memoirs of an Ex-Conceptual Artist)", Alexander Alberro and Blake Stimson eds., *Conceptual Art: A Critical Anthology*, Cambridge, Massachusetts and London: MIT Press, 1999, pp. 392–408.

Burnham, Jack, *Beyond Modern Sculpture: The Effects of Science and Technology on the Sculpture of this Century*, London: The Penguin Press, 1968.

Burnham, Jack, "Systems Esthetics", *Artforum*, Vol. 7, No. 1, September 1968, pp. 31–35.

Burnham, Sophy, "The Manhattan Arrangement of Art and Money", *New York Magazine*, 8 December 1969.

Burgy, Donald, *Art Ideas for the Year 4,000*, Andover: Addison Gallery of American Art, 1970.

Cage, John, "On Robert Rauschenberg, Artist, and his Work", *Silence: Lectures and Writings*, Cambridge, Massachusetts and London: MIT Press, 1966, pp. 98–108.

Celant, Germano, ed., *Conceptual art arte povera land art*, Turin: Galleria civica d'arte moderna, 1970.

Centre Georges Pompidou, *Yves Klein: Corps, couleur, immatériel*, Paris, 2006.

Corris, Michael, ed., *Conceptual Art: Theory, Myth, and Practice*, Cambridge: Cambridge University Press, 2004.

Corris, Michael, "The Limit of the Social", Michael Corris, ed., *Conceptual Art*, pp. 269–281.

Crow, Thomas, "Cosmic Exile: Prophetic Turns in the Life and Art of Robert Smithson", Eugenie Tsai with Cornelia Butler eds., *Robert Smithson*, pp. 33–56.

De Salvo, Donna, ed., *Open Systems: Rethinking Art circa 1970*, London: Tate Publishing, 2005.

Ehrenzweig, Anton, *The Hidden Order of Art: A Study in the Psychology of Artistic Imagination*, London: Weidenfeld and Nicolson, 1967.

Ellin, Everett "Museums as Media", *ICA Bulletin*, May 1967, pp. 13–15.

Elliott, Patrick, "Presenting Reality: An Introduction to Boyle Family", *Boyle Family*, Edinburgh: National Galleries of Scotland, 2003, pp. 9–19.

Everson Museum of Art, *Douglas Davis: Events Drawings Objects Videotapes 1967–1972*, Syracuse, 1972.

Foster, Hal, "The Crux of Minimalism", *The Return of the Real*, Cambridge, Massachusetts and London: MIT Press, 1996, pp. 35–70.

Frascina, Francis, "Institutions, Culture, and America's 'Cold War Years': the Making of Greenberg's "Modernist Painting"", *Oxford Art Journal*, Vol. 26, No. 1, 2003, pp. 69–97.

Fried, Michael, "Art and Objecthood", *Art and Objecthood: Essays and Reviews*, Chicago and London: The University of Chicago Press, 1998, pp. 148–172.

Fried, Michael, "New York Letter: Oldenburg, Chamberlain", *Art and Objecthood*, pp. 279–280.

Graham, Dan, "Homes for America", *Arts Magazine*, No. 3, December 1966–January 1967, pp. 21–22.

Graham, Dan, "Interview with Eugenie Tsai", *Robert Smithson: Zeichnungen aus dem Nachlass/Drawings from the Estate*, Münster: Westfälisches Landesmuseum für Kunst und Kulturgeschichte, 1989, pp. 8–23.

Graham, Dan, *Two-Way Mirror Power: Selected Writings by Dan Graham on His Art*, Alexander Alberro ed. Cambridge, Massachusetts and London: MIT Press, 1999.

Greenberg, Clement, "Abstract and Representational", *The Collected Essays and Criticism: Vol. 3. Affirmations and Refusals 1950–1956*, John O'Brian ed., Chicago and London: University of Chicago Press, 1993, pp. 187–193.

Greenberg, Clement, "Avant-Garde and Kitsch", *The Collected Essays and Criticism: Vol. 1. Perceptions and Judgments 1939–1944*, John O'Brian ed., Chicago and London: University of Chicago Press, 1986, pp. 5–22.

Greenberg, Clement, "The Case for Abstract Art", *The Collected Essays and Criticism: Vol. 4 Modernism with a Vengeance 1957–1969*, John O'Brian ed., Chicago and London: University of Chicago Press, 1993, pp. 75–84.

Greenberg, Clement, "Modernist Painting", *The Collected Essays and Criticism: Vol. 4 Modernism with a Vengeance 1957–1969*, John O'Brian ed., Chicago and London: University of Chicago Press, 1993, p. 85–94.

Greenberg, Clement, "Recentness of Sculpture", *The Collected Essays and Criticism: Vol. 4 Modernism with a Vengeance 1957–1969*, John O'Brian ed., Chicago and London: University of Chicago Press, 1993, pp. 250–256.

Greenberg, Clement, "Towards a Newer Laocoon", *The Collected Essays and Criticism: Vol. 1. Perceptions and Judgments 1939–1944*, John O'Brian ed., Chicago and London: University of Chicago Press, 1986, pp. 23–38.

Groos, Ulrike, Barbara Hess and Ursula Wevers eds., *Ready to Shoot: Fernsehgalerie Gerry Schum, videogalerie schum*, Cologne: Snoeck, 2004.

Gross, Alex, "Artists Attack MoMA", Art Workers' Coalition, *Documents 1*, pp. 9–10.

Gross, Alex, "Is the Museum a Museum Piece?", *East Village Other*, Vol. 4, No. 14, 7 March 1969, p. 8.

Gross, Alex, "Ultimatum at the Modern Museum", *East Village Other*, Vol. 4, No. 11, 14 February 1969, p. 3.

Gust, Dodie, "Andre: Art of Transportation", Paula Feldman, Alistair Rider and Karsten Schubert eds., *About Carl Andre: Critical Texts since 1965*, London: Ridinghouse, 2006, pp. 60–65.

Haags Gemeentemuseum, *Journey to the Surface of the Earth: Mark Boyle's Atlas and Manual*, Cologne, London and Reykjavik: Edition Hansjorg Meyer, 1970.

Hamilton, George Heard, and Richard Hamilton, *The Bride Stripped Bare by Her Bachelors, Even... A Typographical Version By Richard Hamilton of Marcel Duchamp's Green Box*, New York: Wittenborn, 1960

Harrison, Charles, "Modernism", *Critical Terms for Art History*, Robert S Nelson and Richard Shiff eds., Chicago and London: University of Chicago Press, 1996, pp. 142–155.

Hillings, Valerie L, "Concrete Territory: Geometric Art, Group Formation, and Self-Definition", Lynn Zelevansky ed., *Beyond Geometry: Experiments in Form, 1940s–70s*, Los Angeles County Museum of Art, Cambridge, Massachusetts and London: MIT Press, 2004, pp. 49–75.

Hobbs, Robert, *Robert Smithson: Sculpture*, Ithaca and London: Cornell University Press, 1981.

Jachec, Nancy, "Modernism, Enlightenment Values, and Clement Greenberg", *Oxford Art Journal*, Vol. 21, No. 2, 1998, pp. 121–132.

Jewish Museum, *Software: Information Technology: Its New Meaning for Art*, New York, 1970.

Johnson, Ellen H, "The Living Object", *Art International*, Vol. 7, No. 1, January 1963, pp. 42–45.

Judd, Donald, "In the Galleries: Robert Morris", *Complete Writings: 1959–1975: Gallery Reviews, Book Reviews, Articles, Letters to the Editor, Reports, Statements, Complaints*, Halifax and New York: The Press of the Nova Scotia College of Art and Design and New York University Press, 1975, pp. 160–165.

Judd, Donald, "Specific Objects", *Complete Writings*, pp. 181–189.

Kaprow, Allan, "The Legacy of Jackson Pollock", *Essays on the Blurring of Art and Life*, Jeff Kelley ed., Berkeley, Los Angeles and London: University of California Press, 1996, pp. 1–9.

Karmel, Pepe, "Robert Morris: Formal Disclosures", *Art in America*, Vol. 83, No. 6, June 1995, pp. 88–95 and pp. 117–119.

Klein, Yves, "Truth Becomes Reality", Otto Piene and Heinz Mack, eds., *Zero*, pp. 91–95.

Kostelanetz, Richard, *The Theatre of Mixed Means: An Introduction to Happenings, Kinetic Environments and Other Mixed-Means Performances*, London: Pitman Publishing, 1970.

Kosuth, Joseph, "Two Comments from Oscar Wilde", statement delivered at the Art Workers' Coalition Open Hearing, New York School of Visual Arts, 10 April 1969, Art Workers' Coalition, *Open Hearing*, New York, 1969, p. 6.

Krens, Thomas, ed., *Robert Morris: The Mind/Body Problem*, New York: Solomon R Guggenheim Foundation, 1994.

Kurtz, Bruce, "Conversation with Robert Smithson on 22 April 1972", *The Fox*, No. 2, 1975, pp. 72–76.

Levine, Les, "Systems Burn-off X Residual Software", Jewish Museum, *Software*, pp. 60–61.

LeWitt, Sol, "Paragraphs on Conceptual Art", *Artforum*, Vol. 5, No. 10, Summer 1967, pp 79–83.

Lippard, Lucy, "The Art Workers' Coalition: Not a History", *Studio International*, Vol. 180, No. 927, November 1970, pp. 171–174.

Lippard, Lucy, "Biting the Hand: Artists and Museums in New York since 1969", Julie Ault ed., *Alternative Art Spaces*, pp. 79–120.

Lippard, Lucy, ed., *Six Years: The Dematerialization of the Art Object from 1966 to 1972*, Berkeley, Los Angeles, London: University of California Press, 1997.

Lippard, Lucy and John Chandler, "The Dematerialization of Art", *Art International*, Vol. 12, No. 2, February 1968, pp. 31–36.

Malraux, André, "The Imaginary Museum", *The Voices of Silence*, Stuart Gilbert trans., London: Secker and Warburg, 1956, pp. 13–127.

Marcuse, Herbert, "Art as a Form of Reality", *On the Future of Art*, Edward Fry ed., New York: Viking, 1970, pp. 123–134.

Marcuse, Herbert, *An Essay on Liberation*, Harmondsworth: Penguin, 1972.

Margaroni, Maria, "Postmodern Crises of Mediation and the Passing of the Museum", *parallax*, Vol. 11, No. 4, 2005, pp. 96–97.

McLuhan, Marshall, *The Gutenberg Galaxy: The Making of Typographic Man*, London: Routledge and Kegan, Paul, 1962.

McLuhan, Marshall, "The Relation of Environment to Anti-Environment", *University of Windsor Review*, Vol. 1, No. 11, Fall 1966, pp. 1–10.

McLuhan, Marshall, *Understanding Media: The Extensions of Man*, London: Sphere Books Limited, 1967.

McLuhan, Marshall and Quentin Fiore, *The Medium is the Massage: An Inventory of Effects*, San Francisco: Hardwired, 1967.

McLuhan, Marshall and Harley Parker, *Through the Vanishing Point: Space in Poetry and Painting*, World Perspectives, Vol. 37, New York, Evanston and London: Harper and Row Publishers, 1968.

McLuhan, Marshall, Harley Parker, Jacques Barzun, *Exploration of the Ways, Means and Values of Museum Communication with the Viewing Public: A Seminar held on October 9 and 10, 1967*, sponsored by the Museum of the City of New York and the New York State Council on the Arts, New York, 1967.

Meyer, James, *Minimalism: Art and Polemics in the 1960s*, New Haven and London: Yale University Press, 2001.

Meyer, Ursula, "The De-Objectification of the Object", *Arts Magazine*, Summer 1969, Vol. 43, No. 8, pp. 20–22.

Morris, Robert, "Aligned with Nazca", *Continuous Project Altered Daily: The Writings of Robert Morris*, Cambridge, Massachusetts and London: MIT Press, 199, pp. 143–173.

Morris, Robert, "Anti Form", *Continuous Project Altered Daily*, pp. 41–49.

Morris, Robert, "Notes on Sculpture", *Continuous Project Altered Daily*, pp. 1–9.

Morris, Robert, "Notes on Sculpture, Part 2", *Continuous Project Altered Daily*, pp. 11–23.

Morris, Robert, "Notes on Sculpture, Part 3: Notes and Non Sequiturs", Continuous Project Altered Daily, pp. 23–39.

Morris, Robert, "Notes on Sculpture, Part 4: Beyond Objects", Continuous Project Altered Daily, pp. 51–70.

Morris, Robert, "Some Notes on the Phenomenology of Making: The Search for the Motivated", Continuous Project Altered Daily, pp. 71–93.

Morris, Robert, "Some Splashes in the Ebb Tide", Continuous Project Altered Daily, pp. 119–141.

Museum of Contemporary Art, Art by Telephone, Chicago, 1969.

NE Thing Co. Ltd, Trans VSI Connection NSCAD–NFTCO 15 September–5 October 1969, Halifax: Nova Scotia College of Art and Design, 1970.

Newman, Amy, Challenging Art: Artforum 1962–1974, New York: Soho Press, 2000.

O'Doherty, Brian, Inside the White Cube: The Ideology of the Gallery Space, Berkeley, Los Angeles and London: University of California Press, 1986.

Ohff, Heinz, Anti-Kunst, Düsseldorf: Droste Verlag, 1973.

Oldenburg, Claes, "Extracts from the Studio Notes (1962–1964)", Artforum, Vol. 4, No. 5, January 1966, pp. 32–33.

Paice, Kimberly, "Arizona", Thomas Krens ed. Robert Morris, pp. 158–159.

Paice, Kimberly, "Continuous Project Altered Daily", Thomas Krens ed. Robert Morris, pp. 234–237.

Paice, Kimberly, "Dirt", Thomas Krens ed. Robert Morris, p. 230.

Paice, Kimberly, "Early Minimalism", Thomas Krens ed., Robert Morris, pp. 106–111.

Paice, Kimberly, "Green Gallery Show, 1964–1965", Thomas Krens ed. Robert Morris, pp. 170–171.

Paice, Kimberly, "Leads", Thomas Krens ed. Robert Morris, pp. 192–201.

Paice, Kimberly, "Permutations", Thomas Krens ed. Robert Morris, pp. 180–183.

Paice, Kimberly, "Site", Thomas Krens ed. Robert Morris, pp. 168–169.

Paice, Kimberly, "Waterman Switch", Thomas Krens ed., Robert Morris, pp. 178–179.

Parker, Harley, "The Waning of the Visual", Art International, May 1968, Vol. 12, No. 5, p. 27–29.

Patton, Phil, "Other Voices, Other Rooms: The Rise of the Alternative Space", Art in America, Vol. 65, No. 4, July–August, 1977, pp. 80–89.

Perreault, John, "Critique: Street Works", Arts Magazine, Vol. 44, No. 3, December 1969, p. 18.

Perreault, John, "Outside the Museum", The Village Voice, 6 March 1969, p. 13.

Perreault, John, "Para-Visual", The Village Voice, 5 June 1969, p.15.

Perreault, John, "Whose Art?", The Village Voice, 9 January 1969, p. 16.

Piene, Otto, "The Development of the Group Zero", Times Literary Supplement, 3 September 1964, pp. 812–813, reprinted in Piene, Otto and Heinz Mack eds. Zero, 1973, pp. xx–xxii.

Piene, Otto and Heinz Mack eds. Zero, Cambridge, Massachusetts and London: MIT Press, 1973.

Puttfarken, Thomas, The Discovery of Pictorial Composition: Theories of Visual Order in Painting 1400–1800, New Haven and London: Yale University Press, 2000.

Reichardt, Jasia, "On Chance and Mark Boyle", Studio International, Vol. 172, No. 882, October 1966, pp. 164–165.

Restany, Pierre, "A quarante degrés au-dessus de Dada (2e manifeste)", Le nouveau réalisme, Paris: Union Générale d'Éditions, 1978, pp. 283–285.

Restany, Pierre, "La Minute de vérité", invitation card to the exhibition Yves, Propositions Monochromes, Galerie Colette Allendy, 21 February–7 March 1956. Reproduced in Centre Georges Pompidou, Yves Klein Corps, couleur, immatériel, Paris, 2006, p. 288.

Restany, Pierre, "Le nouveau réalisme: que faut-il en penser? (3e manifeste), Le nouveau réalisme, Paris: Union Générale d'Éditions, 1978, pp. 285–291.

Restany, Pierre, "Un nouveau sens de la nature", Le nouveau réalisme, Paris: Union Générale d'Éditions, 1978, pp. 294–298.

Reynolds, Ann, "Enantiomorphic Chambers", Eugenie Tsai with Cornelia Butler eds. Robert Smithson, pp. 137–140.

Reynolds, Ann, Robert Smithson: Learning from New Jersey and Elsewhere, Cambridge, Massachusetts and London: MIT Press, 2003.

Roberts, Corinne, "The NY Art Strike", Arts Magazine, Vol. 45, No. 1, September–October 1970, pp. 27–28.

Roberts, Jennifer L, Mirror-Travels: Robert Smithson and History, New Haven and London: Yale University Press, 2004.

Rockefeller, Nelson A, Preface, Twentieth Century Art from the Nelson Aldrich Rockefeller Collection, New York: The Museum of Modern Art, 1969, p. 8.

Rose, Barbara, Claes Oldenburg, New York: Museum of Modern Art, 1970.

Rose, Barbara, "Claes Oldenburg's Soft Machines", Artforum, Vol. 5, No. 10, Summer 1967, pp. 30–35.

Rose, Barbara and Irving Sandler, "Sensibility of the Sixties", Art in America, Vol. 9, No. 1, January–February 1967, pp. 44–57.

Rosenberg, Harold, The Anxious Object, Chicago and London: The University of Chicago Press, 1966.

Schjeldahl, Peter, "Systems '66", The Village Voice, 15 September 1966, p. 4.

Seitz, William C ed., The Art of Assemblage, New York: Museum of Modern Art, 1961.

Siegel, Jeanne, "Carl Andre: Artworker", Studio International, Vol. 180, No. 927, November 1970, pp. 175–179.

Siegelaub, Seth, March 1–31, 1969, New York, 1969.

Smith, Roberta, "A Hypersensitive Nose for the Next Big Thing", The New York Times, 20 January 1991, Section H.

Smithson, Robert, "Aerial Art", The Collected Writings, Jack Flam ed., Berkeley, Los Angeles and London: University of California Press, 1996, pp. 116–118.

Smithson, Robert, "The Artist and Politics: A Symposium", The Collected Writings, pp. 134–135.

Smithson, Robert, "Can Man Survive?", The Collected Writings, pp. 367–368.

Smithson, Robert, "Conversation in Salt Lake City", The Collected Writings, pp. 297–300.

Smithson, Robert, "Cultural Confinement", The Collected Writings, pp. 154–156.

Smithson, Robert, "Earth", The Collected Writings, pp. 177–187.

Smithson, Robert, "Entropy and the New Monuments", The Collected Writings, pp. 10–23.

Smithson, Robert, "Four Conversations between Dennis Wheeler and Robert Smithson", The Collected Writings, pp. 196–233.

Smithson, Robert, "Fragments of a Conversation", The Collected Writings, pp. 188–191.

Smithson, Robert, "Interpolation of the Enantiomorphic Chambers", The Collected Writings, pp. 39–40.

Smithson, Robert, "Interview with Moira Roth", Eugenie Tsai with Cornelia Butler eds., Robert Smithson, pp. 81–95.

Smithson, Robert, "Interview with Robert Smithson", The Collected Writings, pp. 234–241.

Smithson, Robert, "Interview with Robert Smithson for the Archives of American Art/Smithsonian Institution", The Collected Writings, pp. 270–296.

Smithson, Robert, "Language to be Looked at and/or Things to be Read", The Collected Writings, p. 61.

Smithson, Robert, "Letter to the Editor", The Collected Writings, pp. 66–67.

Smithson, Robert, "A Museum of Language in the Vicinity of Art", The Collected Writings, pp. 78–94.

Smithson, Robert, "A Provisional Theory of Non-Sites", The Collected Writings, p. 364.

Smithson, Robert, "Quasi-Infinities and the Waning of Space", The Collected Writings, pp. 34–37.

Smithson, Robert, "A Rejoinder to Environmental Critics", Collapse, No. 2, 1996, p. 124.

Smithson, Robert, "A Sedimentation of the Mind: Earth Projects", The Collected Writings, pp. 100–113.

Smithson, Robert, "Smithson's Non-Site Sights: An Interview with Anthony Robbins", The Collected Writings, p. 175.

Smithson, Robert, "Some Void Thoughts on Museums", The Collected Writings, pp. 41–42.

Smithson, Robert, "The Spiral Jetty", The Collected Writings, pp. 143–153.

Smithson, Robert, "Towards the Development of an Air Terminal Site", The Collected Writings, pp. 52–60.

Smithson, Robert and Mel Bochner, "The Domain of the Great Bear", The Collected Writings, pp. 26–33.

Smithson, Robert and Allan Kaprow, "What is a Museum?", The Collected Writings, pp. 43–51.

Steinberg, Leo, "Other Criteria", Other Criteria: Confrontations with Twentieth Century Art, Oxford and New York: Oxford University Press, 1972, pp. 55–91.

Stimson, Blake, "An Art and Its Public—A Public and Its Art: Robert Smithson versus the Environmentalists", Collapse, No. 2, 1996, pp. 126–136.

Summers, David, Real Spaces: World Art History and the Rise of Western Modernism, London: Phaidon, 2003.

Stimson, Blake, "Conceptual Work and Conceptual Waste", Michael Corris ed., Conceptual Art, pp. 282–304.

Wrigley, Richard, *The Origins of French Art Criticism: From the Ancien Régime to the Restoration*, Oxford: Clarendon Press, 1993.

Weiner, Lawrence, "October 12, 1969", Ursula Meyer ed., *Conceptual Art*, New York: Dutton, 1972, pp. 216–219.

Vasarely, Victor, *Notes brutes*, Paris: Éditions Denoël, 1972.

Tsai, Eugenie with Cornelia Butler eds., *Robert Smithson*, Museum of Contemporary Art, Berkeley, Los Angeles and London: University of California Press, 2004.

Thompson, David, "Object, experience, drama", *Studio International*, Vol. 177, No. 912, June 1969, pp. 276–279.

Taylor, Brandon, "Revulsion/Matter's Limits", *Sculpture and Psychoanalysis*, Aldershot, Ashgate, 2006, pp. 213–231.

Swenson, Gene, "From the International Liberation Front", statement delivered at the Art Workers' Coalition Open Hearing, New York School of Visual Arts, 10 April 1969, *Art Workers' Coalition Open Hearing*, New York, 1969, pp. 12–14.

Swenson, Gene, "The Corporate Structure of the American Art World", *New York Free Press*, 25 April 1968.

On Location

Acknowledgements

ACKNOWLEDGEMENTS

I am grateful to the following for their advice and encouragement: Sarah Bartholomew, Elisabeth de Bièvre, Joshua Bell, Kate Carreno, Jo Clarke, Neil Cox, Steve Gardam, Amanda Geitner, Sandy Heslop, Pat Hewitt, David Hulks, Nichola Johnson, Ferdinand de Jong, George Lau, John Mack, John Mitchell, Lynda Morris, John Onians, Christina Riggs, Alistair Rider, Dan Rycroft, Chas Savin, Clive Scott, Margit Thøfner, Nicholas Warr, Helen Wood, Ruth Wood and William Wood.

The material addressed in this book was the subject of different modules taught in the School of World Art Studies and Museology. I am particularly grateful to the following students for their contributions: Astrid Boorman, Jo Bulmer, Rebekah Bull, Neil Cave, Hepzibah Cheek, Emily Crane, Suzanna Cullen, Clarissa Datnow, Dino Dimopoulos, Katie Downey, Annie Edwards, Simin Eldem, Catherine Gillion, Lily Hall, Rebecca Hawthorne, Hannah Higgins, Sophie Holme, Francesca Hunt, Emma Jonathan, Stephanie Kneath, Grace McFaull, Anna Meek, Ellie Morgan, Katie O'Donoghue, Amy Oldman, Sam Rix, Chris Scott, Oliver Sharp, Katherine Spooner, Ruth Stone, Sally Sutton, Tom Walker, Lizzie Watson.

Simon Dell

WORLD ART
COLLECTIONS
EXHIBITIONS
SAINSBURY CENTRE
for Visual Arts

This book is published in association with the exhibition:
On Location: Art, Space and Place in the 1960s.
Sainsbury Centre for Visual Arts, University of East Anglia, Norwich, 2008.
www.scva.ac.uk

Dr Simon Dell's research for this book and the exhibition, *On Location*, was supported by the UEA World Art Forum Fellowship.

This publication is supported by:

The Sainsbury Centre for Visual Arts is supported by:

Arts & Humanities
Research Council

The **Gatsby** Charitable Foundation

University of
East Anglia

black dog publishing

architecture art design
fashion photography history
theory and things

London UK

www.blackdogonline.com

reduce
reuse
recycle

Black Dog Publishing Limited
10A Acton Street
London WC1X 9NG
United Kingdom

Tel: + 44 (0) 207 713 5097
Fax: + 44 (0) 207 713 8682
info@blackdogonline.com
www.blackdogonline.com

ISBN: 978 1 906155 59 9

Editor: Raven Smith at Black Dog Publishing
Designer: Josh Baker at Black Dog Publishing
Text: Simon Dell, Alistair Rider, William Wood.

British Library Cataloguing-in-Publication Data.

A CIP record for this book is available from the British Library.

Black Dog Publishing Limited, London, UK, is an environmentally
responsible company.

On Location: Siting Robert Smithson and his Contemporaries
is printed on Multiart.